PRO TECHNIQUES

How to
Photograph the
Human
Figure

by Robert & Sheila Hurth

HPBooks
a division of
PRICE STERN SLOAN
Los Angeles

Published by HPBooks, a division of Price Stern Sloan, Inc.
11150 Olympic Boulevard, Suite 650
Los Angeles, California 90064
© 1991 Robert & Sheila Hurth

10 9 8 7 6 5 4 3 2 1
First Printing
Printed in the United States of America

Library of Congress Cataloging-in-Publication Data

Hurth, Robert.
 How to photograph the human figure : the art & technique of
 photographing the nude / by Robert & Sheila Hurth.
 p. cm. — (Pro techniques)
 ISBN 1-55788-031-X
 1. Photography of the nude. I. Hurth, Sheila. II. Title.
 III. Series.
 TR674.H87 1991 91-12912
 778.9'21—dc20 CIP

This book is printed on acid-free paper.

CONTENTS

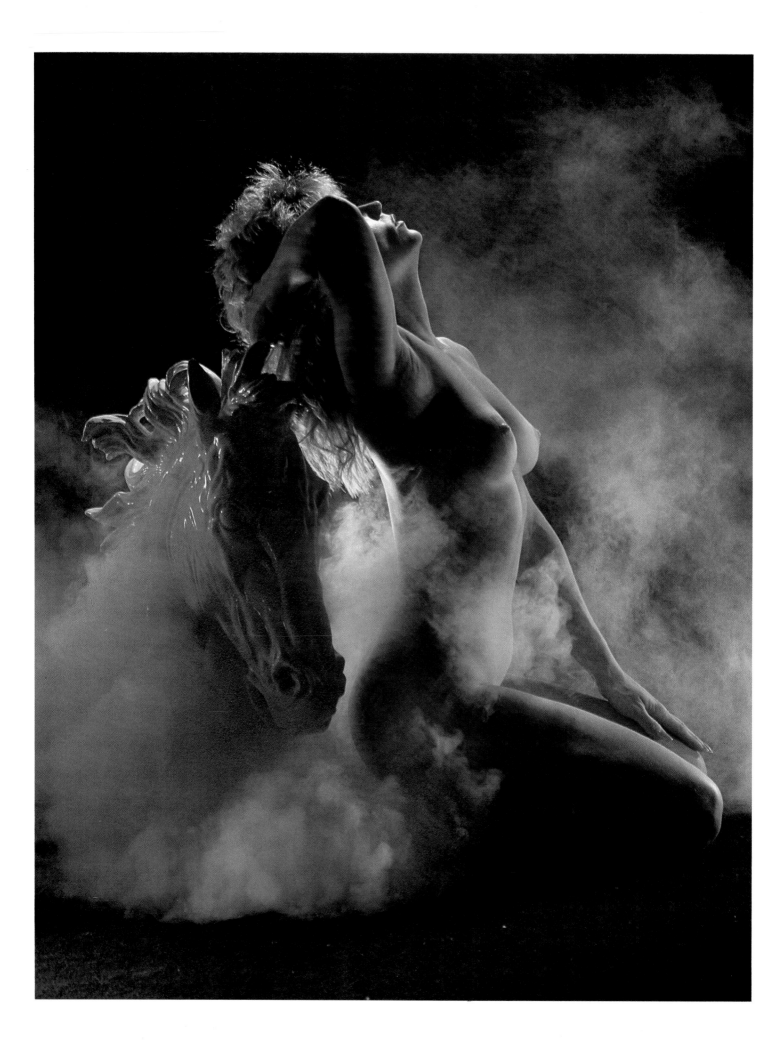

INTRODUCTION

The human form has captivated the imagination since the beginning of recorded art history. Recording of the human figure—especially the female figure—has been one of the most popular aspects of the creative visual arts for as long a time. For the past century and a half, photography has played a prominent part in this field.

Traditionally, the social status of the male has often been considered more important than his physical appearance. By contrast, the female has usually been valued and depicted more for her physical attributes. Although this condition has undergone marked change during the latter half of the twentieth century, to some extent it still exists today. It is still clearly apparent in most forms of art that depict the human body.

The extent of interest in and demand for nude imagery has varied through the ages. Today many people, and perhaps especially women, are health and fitness conscious, acutely aware of their bodies and proud of the way they feel and look. This, together with the relaxation of many sexual taboos, both in life and the written and visual arts, has made photography of the human form more popular and unrestricted than ever.

While there are many books on nude photography on the market, most are a compilation of photos, with no clear information or instruction as to how the photographs were conceived and made. They are intended mainly for those who enjoy viewing this art form rather than those who want to practice it themselves. This book was produced to satisfy the needs of the aspiring photographer of the human form.

My wife Sheila and I have had the privilege of authoring three other books for Price Stern Sloan under the HPBooks imprint—*Pro Techniques of Wedding Photography*, *How to Videotape Weddings* and *Secrets of Boudoir Photography*. Each of these books was produced with a deep sense of style, class and integrity. Because this book deals with a much more "daring" and sensitive subject matter than our other books—even including the book on boudoir photography—it was created with a special sense of responsibility.

You will find many parallels between this book and our book on boudoir photography in ideas, concepts and techniques. Some of these parallels are subtle; others are more obvious. Whether the similarities are great or small, this book has the same basic goal: to help you produce stunning and tastefully executed images of the human form.

Reading our book on boudoir photography will be of great help to you. It will give you many insights and equip you with strong basics and a sound foundation for photographing the human form. However, the information in this book is intended very specifically for the photographer of the nude, and much of this information is unique to this field. It will give you the additional knowledge needed to enable you to competently engage in this very specialized form of photography.

For Sheila and me, boudoir photography is very much a commercial endeavor. Most of the images are made for paying clients. We shoot to please the client and the intended recipient of the images. By contrast, our nude photography is much more in the form of pure art. We shoot for our own creative pleasure and fulfillment. This, we are sure, will be the case with the average reader of this book.

Sheila and I have been involved with photography for many years. We have owned and operated Tiffany Photo Studio in Fort Lauderdale, Florida, for a number of years now. We did not become truly

involved with figure photography until more recently, about the time when we first started doing serious boudoir photography.

Figure photography—a natural and logical extension of our boudoir work—has extended our experience, fulfillment and reputation as creative photographers. It enables us to now offer a greater pictorial variety for some of our boudoir subjects.

This book presents nude studies in both traditional and contemporary styles. Many of the images reproduced follow in the tradition of the great sculptors and painters of the past. However, we have also attempted to blaze new trails and to deviate somewhat from the accepted norm. That's what creativity and art are all about! We would like you to treat this book as a guide through a learning adventure. Its purpose is to teach you—the amateur and the pro alike—how to execute this sensitive form of photography and to spare you some growing pains while you learn.

We assume that most readers will own and use 35mm SLR camera equipment. We use both medium-format cameras of the Hasselblad type and 35mm SLRs. You can rest assured that the information provided in this book is not affected by the specific camera equipment you choose to use. So, whether you're a typical 35mm enthusiast or prefer the larger formats—even up to 4x5 and 8x10—we invite you to read on and follow us through the adventure.

There are many different types of figure or nude photography. To better understand and appreciate them, you should become acquainted with some preliminary considerations.

In the world of art, photography is the "new kid on the block." Although it is not as time-honored as some of its older brothers, such as painting and sculpture, which date back to ancient times, photography has become a legitimate art form. This does not mean that all photographs are automatically art—but neither are all paintings or pieces of sculpture.

What definitively makes a painting, a piece of sculpture or a photographic image a work of art is generally open to debate. It certainly does not depend on the nature of the subject matter half as much as on the skill, insight and sensitivity used in conceiving and making the image.

Like paintings and sculpture, photographic art can be thought of as falling into two major categories: the classical and the contemporary. Within these two major categories lie numerous minor forms and styles, such as graphic, erotic, romantic, surrealistic, personal, impersonal, abstract or impressionistic figure photography.

The Two Major Categories

To define the terms *classical* and *contemporary* in the context of figure photography, it will be helpful to take a look at the other, conventional arts.

Classical Art—Literally, classic or classical art refers to art of the ancient Greek and Roman eras. For our purposes, however, the definition can be a bit more flexible. For us, classical art need not be exclusively of ancient Greeks and Roman times but can also include European art that has been created up to the late 19th century. It is usually art that has survived the test of time and is thought of as setting a standard from which other, more modern pieces derive much or some of their origins.

The classic art work and its artist represent a style, technique, color selection, posing and light-ing that are seen as a basis for modern artists to follow. Good contemporary art is often based on the traditions established by ancient art.

Although the medium of photography itself is relatively new, photographs that mirror the classic or traditional styles of the old masters are considered to be *classical* photographs.

If a photographer created an image of a full-bodied woman, posed nude in a setting of trees and flowers in the woods, in style, lighting, posing and setting of a Renoir painting, it could be said that the photographer had created a nude photograph in the classic style.

Contemporary Art—Contemporary art is original and new and does not draw upon traditional esthetic standards. Contemporary photography, especially in recent years, has been bold and experimental. In the past two or three decades, creative photography has broken much new ground and shattered many of the traditional rules.

Even a brief and superficial study of photographs made during the latter half of the 19th century will reveal that not only nude photography, but also what we today call boudoir photography, was popular in those times. Nude photography then, as now, was done mainly for the sake of art and personal satisfaction. The boudoir photography of those olden days fell much into the same category. It was, basically, the same thing as nude photography, but not quite as revealing.

The boudoir photography of today is more distinctly commercial—made specifically of a client for presentation to a special person in her life. As we've mentioned before, in spite of the differences of purpose between nude figure photography and boudoir photography, there is sufficient overlap in the techniques involved to make our book, *Secrets of Boudoir Photography*, useful to you.

Naked Versus Nude

There is a distinct difference between a photo of a naked person and a photographic nude study.

The distinction is more than semantic. The dictionary doesn't help. It, basically, defines *naked* as *nude* and *nude* as *naked*! In the context of the visual arts, the words are not interchangeable. To us, the word *naked* has clinical, analytical overtones while the word *nude* suggests an artistic interpretation or treatment of the bare body.

A doctor examining a patient is dealing with a person who is naked, not nude. A bunch of football players in a locker room, preparing to shower after a game, are naked. A photograph revealing some medical information of a human body depicts a naked body. A naked body becomes a nude, in the artistic sense, when that body is posed, lit and depicted, not for clinical or informative purposes, but toward an esthetic, interpretive end.

An inanimate example may help to bring out the point. If you were told to take a photo of a simple product, such as a plain beverage can, the purpose being to reveal how it was made, you would attempt to show clearly the texture of the metal, the various seams, the opening device, the printing, and so on. It would be a clinical, informative image.

However, if you were told to photograph the same can to entice a viewer into buying the product contained in the can, you would use background, object placement, lighting and props creatively. You would not merely place the can on a simple, nondescript table and take a head-on shot, using a single on-camera flash.

You would place the can in an inviting setting, light it creatively, add props and accessories, and do whatever else was necessary to present the product in the most favorable and positive way. The can itself, or a simple record shot of it, is not a work of art. However, even such a simple object can be transformed into art.

In a similar manner, an unimaginative record photo of the female form, no matter how beautiful the subject may be, is not a work of art. It takes an artist—or an artistic photographer—to transform and translate the subject into something higher than an informative record.

Many important details contribute to the creation of a truly artistic figure study. They include the choice of setting, the pose and attitude of the subject, the lighting, the use of props and partial drapes when appropriate—plus that indefinable "extra," the creation of the right overall atmosphere or ambience.

The photos in this book reveal to you the beauty, grace, dignity and glory of womanhood. A medical manual might reveal detailed images of the construction and functions of the human body. Both types of books are important and contribute to the betterment of our lives. But they are very different. Understanding the essential difference is important in the context of understanding what this book is really all about. It is not about the human body in a direct manner. It is about the art of interpreting the beauty and meaning of the human form, not about understanding the mechanics of its functions.

Partial Nudity

A subject for nude figure photography need not always be totally nude. Sometimes partial draping of a subject is desirable, either for esthetic or contextual reasons, or simply to cover a less-than-perfect body part.

The selective revelation or concealment of body parts can be achieved by means other than drapes or articles of clothing. A body part can be "clothed" in deep shadow, so that no detail is shown in that area. Or a body part can be hidden, either behind another part of the body or a separate object.

Not only can a partially clad figure constitute a legitimate nude study, but the frame for such a study need not necessarily contain the entire body. A close-up image of part of a leg, one breast or the small of the back and the buttocks all constitute what is normally understood as nude or figure photography.

If the materials covering a subject are articles of clothing rather than just a drape, and if there is no real nudity, although legs, arms, midriff and even much of the bust may be amply revealed, you're in the sphere of boudoir photography rather than nude photography. The crossover point from one to the other is subtle. By removing or adjusting some of the lingerie worn by a subject, a boudoir image can easily become a partial nude.

It depends a lot on the intent of the photographer and the purpose of the photo. A boudoir image is almost always a personal statement or the revelation of one specific woman to one specific viewer. Artistic figure photography, typically, reveals womanhood in general to the wider public.

Pornography

The dictionary defines pornography as the "portrayal of erotic appearance or behavior." Interestingly, the words "dirty" or "immoral" are not to be found in such a definition. Ultimately, a photographer and the viewers of his images must

determine whether an image is honest art or sexually exploitive and undesirable. The borderline between the two is almost impossible to define, either esthetically or legally. Indeed, even the Supreme Court of the United States has written many pages, attempting to define pornography. For our purposes, the words of one of the late Justices of that court sums it up best: "I don't know exactly what pornography is, nor exactly how to describe it, but I know it when I see it." And I think we all do.

If a painting, piece of sculpture or photograph makes an erotic impact, does this mean it is automatically pornographic in the commonly used sense of the word? Of course not! We believe an image is pornographic when it offends a viewer not merely because eroticism disturbs that viewer but because the image is demeaning to the woman depicted and womanhood in general and exploits, rather than glorifies, the erotic human qualities.

Another reason why fixed definitions are not helpful is that the very concept of what is "pornographic" changes with time, social conditions and trends of thinking. Many terms, acts and deeds that were considered unmentionable just a few years ago are commonplace today.

Although pornography is often associated with visual imagery of the human form, we can assure you that nude photography that is done with honesty, sensitivity and integrity is not only one of the most challenging and difficult art forms, but it is nearly the extreme opposite of anything that might be regarded as obscene.

Pornography's chief goal is usually the exploitation of human beauty and sexuality. By contrast, the photos in this book, and serious photography of the human form in general, idealize and glorify the human figure. The contrast is between *exploitation* on the one hand and *celebration* on the other!

Impersonal, Personal, Erotic and Graphic Nudes

Nude figure photographs are usually made to serve one of the following four basic purposes. Sometimes there is some overlap. For example, a personal nude can also be an erotic one. Let's briefly look at each of these categories.

Impersonal Nude—This is a figure study in which there is no suggested contact or communication between the subject and the viewer. There is usually no eye contact by the model with the camera. Indeed, the subject's face is often hidden or turned away from the camera. The purpose of the impersonal nude is to reveal the basic symbolism of womanhood to a general viewing public.

Personal Nude—As the name implies, this kind of image is designed to make personal, intimate contact between subject and viewer. The photograph is usually made with one specific viewer in mind. In this sense, almost all boudoir images fall into the personal category. The photo is made of one specific woman for one specific viewer. There is generally eye contact by the subject with the camera and therefore the viewer.

Erotic Nude—This kind of image has deliberate sensual and sexual overtones. The pose is such as to dramatize the more erotic body parts, from breast to buttocks and even eyes. In fact, more often than not, there is direct subject eye contact with the camera. For this kind of image to "work" in a tasteful and artistic manner, it is important for the photographer to work with restraint. Sensuality is a powerful thing, and you should reveal it with great subtlety rather than blatantly.

Graphic Nude—The graphic nude exploits and explores the graphic possibilities in the human form. By appropriate posing and lighting, visual poetry is created by the curves and lines of the body. Frequently the most effective graphic nude studies are of selected body parts rather than of the entire subject.

Individual and Combined Figures

Most figure photography is of a single subject, generally female. However, it is not uncommon for two female subjects to be photographed together, or for male subjects to be depicted, either singly or in pairs or groups.

In today's enlightened world, it is even perfectly acceptable to make nude studies of woman and man together. That this can be achieved in an artistic manner has been proven in other art media, most notably, as far as we are concerned, in some of the sculptures of Auguste Rodin.

Of course, the photography of mixed couples puts the greatest artistic demands on both the photographer and the models. The achievement of images that are natural, believable and appealing confronts all the participants with a special challenge. Self-consciousness, triteness, banality and awkwardness must be avoided at all costs. The subjects must be totally comfortable with each other and not feel intimidated by the presence of the camera and photographer.

When you photograph more than one subject, you must determine whether each should be given equal prominence in the image or one should be

the "lead" character while the other, or others, play a secondary part. Obviously, the poses, composition and lighting will be determined based on the way you choose to shoot the combination of the figures.

Referring again to the work of Rodin, his famous and delightful sculpture entitled *The Kiss* is a clear example of two subjects having equal prominence. The couple is interrelating, and neither has prominence over the other.

There are many other examples in art where one figure is dominant and others play a secondary role. In a photograph, the secondary subject or subjects may be farther in the background, they may be lit less brightly, they may be slightly out of focus, or they may be looking away from the camera or at the key subject while the key subject is making eye contact with the camera and, therefore, the viewer.

Whether you are photographing in the classical or contemporary style, mixed nude studies can offer tremendous potential for creativity. However, some value judgments must be made and some pitfalls avoided when doing this kind of work. As already mentioned, when two or more subjects are used for a photographic concept, a decision must be made as to whether one or more subjects are to dominate the scene while the remainder are supporting elements or whether all are going to be equally involved in representing the main theme or idea.

You must also make a value judgment as to the degree of nudity of the subjects. It sometimes helps to emphasize the separation of main and supporting subjects by having the main subject totally nude while the supporting "players" are partially draped, or the other way about. Exactly what you do depends totally on the effect you're trying to achieve, the atmosphere you're trying to create or the story you're trying to tell. There are no hard and fast rules governing this point and you alone must decide which avenue to take, based upon your preconceived idea of the end result.

Female and Male Subjects—We have found that relatively inexperienced, amateur female models are generally more cooperative and less self-conscious than their male counterparts. Men frequently concentrate on assuming the "macho" look. This can be an asset only if it is the look you need to achieve your intended effect.

If you want a variety of other effects, that do not strongly suggest the symbolism of power, strength and virility, you will often have to spend time coaching male subjects into a proper pose and mental attitude in order to achieve your desired result. In other words, the female is generally more versatile in the art of role-playing.

In addition, when working with a photo concept involving two or more non-professional nude subjects—either of the same sex or opposite sexes—you may encounter a situation that we have occasionally faced. One or more of the subjects may become frivolous about the photo session. While this may seem like fun, if it is allowed to go unchecked it could adversely affect the outcome of the entire shoot. This does not mean that you and your subjects should not have fun while doing the shoot. It does, however, mean that you, the photographer, must retain sufficient control and influence to achieve the end effect you're after.

Prime Ingredients

No matter what form of figure studies you intend to create, seriously executed nude photography is always going to involve at least four primary ingredients—a *concept* or idea, a well chosen *subject*, an appropriate *pose* and appropriate *lighting*.

A nude session generally also involves one or more of the secondary ingredients, discussed a little later. These include a suitable *setting*, proper *makeup* and *hairstyling*, and appropriate *props* and *accessories*.

To attain totally satisfying images, all prime ingredients must be present and must interact properly with each other. For example, if a photographer has an excellent subject, with a wonderful pose, but has inappropriate lighting, or if he has ideal lighting but an awkward pose, the shoot will be less than a total success.

Once you have a clear idea of the *concept* you want to record on film, be sure to select a *subject* or model who is appropriate. For example, if the intended basic concept is one of gentleness and vulnerability, don't choose a powerful, muscular model, no matter how attractive she may be in her own right. The model's *pose*, too, must be appropriate to the story you're trying to tell. The gentle, vulnerable model should, clearly, not be posed in an aggressive, defiant, overpowering manner, unless you're aiming to achieve a very specific effect.

For a gentle, soft, feminine effect, soft and diffused *lighting* may be best. If you're trying to make a more bold graphic statement, try a harder, more directional light, yielding distinct shadows.

During a practice session with a subject, work on a dozen or so poses, over and over again. Don't concern yourself with lighting at this point but only with poses. Learn how the various facets of a

subject's body can be affected through minor posing alterations; how the arch of the back, the turn of a leg, the placement of an arm and hands can affect an entire pose and photographic end result.

Then, while staying with one specific pose, practice using six or more different lighting arrangements. Learn what each arrangement can do for a subject and how each can affect an overall mood and final image.

Finally, practice combining the subject's poses with the lighting, to realize on film the concept you had visualized.

Secondary Ingredients

When you use what we call the "secondary" ingredients for a shoot—a special *setting*, *makeup* and *hairstyling*, *props* and *accessories*—you must be as critical of them in terms of selection, lighting, placement, and so on, as you would of each of the primary ingredients. If you are not, they are likely to prove more of a hindrance and handicap than an esthetic asset.

We have given merely a summary of the ingredients—both prime and secondary—that form the vital building blocks for successful figure photography. Don't be deceived by the term *secondary* because those ingredients are not optional afterthoughts. They make an essential supportive contribution to the total process. All of the ingredients mentioned above will be dealt with in greater detail in subsequent chapters.

Model Selection

Before we conclude this chapter on the different types of figure photography, it might be useful to say just a few words about model selection. There is more to selecting a candidate for figure photography than just securing a person who is pretty, well developed and proud of her body. An illustration from our everyday lives will help make the point.

Our thinking is constantly bombarded by stereotypes and symbolisms. Words such as *motherhood*, *doctor*, *war*, *spring day*, *mince pie* and *wedding ring* provide us with mental pictures from which we—in varying degrees and based upon life's experiences—develop specific and detailed mental images.

Correctly or not, our life experiences initially dictate that things are supposed to look the way we have been taught to think of them. Doctors are supposed to look like doctors, judges like judges, and so on. To make a photographic image easily comprehensible, we graphically follow the accepted stereotypes.

For example, when you want to photograph a man to represent the concept of the typical country doctor, you probably will not choose a 20-year-old, baby-faced youth wearing dark sunglasses and a black leather jacket, seated on a motorcycle. While there may actually be a doctor who looks like that, he certainly would not be typical and representative. Such a pictorial representation of the subject would make it difficult to convey the intended message to a viewer of the image.

In a similar manner, not all subjects, no matter how attractive they may be, are suitable candidates for nude photography. Not all women have the talent or inclination to convey on film the symbolic pictorial representation of the beauty and glory of womanhood.

As you view the results of your first attempts at figure photography, you may not understand why you're not getting the images you were hoping for. However, with time and experience you'll see that the problem will often lie with the fact that you have chosen the wrong subject for your photographic interpretation.

We are not suggesting that there can be only one perfect model for any given photographic situation. What we are suggesting is that you can make your job easier and do a better job by selecting a subject that will fit the stereotype that is in line with the image you wish to create rather than trying to use just any pretty woman.

To generate the greatest impact and clearest meaning for your intended viewers, choose a subject who has physical qualities and features that are consistent with your preconceived ideas for the final image. This might sometimes involve selecting a subject who is more mature rather than youthful in appearance, one who is more full-figured than slim, one who is an Afro-American or Oriental rather than Caucasian, a woman who is small-breasted rather than well-endowed, and so on.

2 WHAT'S SPECIAL ABOUT FIGURE PHOTOGRAPHY?

Nude photography represents a very special area in the wider field of people photography. Man has been captivated by the human figure, especially the female figure, since time immemorial. Supposedly, this attraction is partly due to the fact that the bare human body has traditionally been regarded as more or less taboo. Partly, also, the attraction is understandable due to the erotic and sensual powers of womanhood. But there are other important reasons why the human body is of eternal interest—reasons that are esthetic and relate closely to the depiction and recording of the body, whether in paintings, sculpture or photography.

All human figures are not alike, just as all human faces are different. Each face has a pair of eyes, a mouth, a nose, cheeks and a chin. And yet very few faces in this world are totally alike. It's the same with the human body. Each body looks a little different in shape, stature, color and other physical attributes. Each body also moves and behaves in a subtly individual manner.

It's these differences that keep the interest, curiosity and admiration alive. And it's these differences that have fed the creativity of legions of photographers of the human form.

Why the Human Form Captivates

While nudity in painting has been accepted for centuries, the total revelation of the bare human form, although practiced since the beginning of photography itself, has not been widely accepted as serious photographic art until relatively recently.

Today, nude photographic imagery is generally accepted and recognized as being capable of rising to the dignity of true art and takes its own legitimate place among the other accepted visual-art disciplines.

Since all human beings are built to look basically alike, it seems incredible that painters, sculptors and photographers would never cease to be fascinated and challenged by the human figure. Superficially, you might think that, once you have seen one painting, piece of sculpture or photo of the female human form, you have, basically, seen it all. Of course, nothing could be further from the truth. It would be like saying that since you have heard one symphony, there is no longer a reason to listen to music.

There are only 12 notes in the musical scale on the piano—seven white ones and five black ones—yet think of the thousands and thousands of different pieces of music that have been and will be created, all stemming from some combination of just these 12 notes. So it is with the rendition of the nude, human form. An infinite variety of representations can result.

The "Language" of the Human Body—If a good friend were standing in a crowd, you would be able to pick his or her face out from the masses very easily. But you would normally recognize someone known well to you even from a distance at which you could not possibly distinguish facial features. That's because everyone has a distinct "body language" and way of movement and deportment. You recognize distant, small looking figures by their walk, the movement of the head and arms, the stance, and so on.

It's this individual body language which maintains our constant interest. Although all bodies look basically very much alike, there is always that difference that fascinates so much and retains our attention.

The "Graphics" of the Human Body—A second factor that retains our constant interest is the sheer beauty of the graphics of the human form. The body—especially a woman's—exhibits such wonderful combinations of lines, curves, shapes, angles and tones. These combinations change constantly, from one woman to another, one pose to another, with a change in lighting angle and quality, and with camera viewpoint and angle.

The "Mystery" of the Human Body—Most of the time we see people in clothing which conceals most or much of the body. It is this clothing or

concealment which lends such a tantalizing mystery to the body. In essence, we know what lies beneath the cover. However, we are acutely aware of the subtle differences in shape, form, texture, color and movement. We know that under the clothing is concealed this constant mystery. This forms the constant incentive for us to try and see—just one more time.

It also forms the incentive for the artist to discover and record—on canvas, from stone or on film—always just one more time. The constant challenge is to do so artistically and with sensitivity. This means exercising sufficient awareness to capture the individual quality of each subject and enough artistic skill to do so esthetically and with the best of taste.

The Variety Offered by the Human Body

As we have noted, photographic studies which are almost endlessly different and unique can be created from even a single human subject. Each human form has its own beauty, style, strength, weakness, grace and foibles. Each body offers its own problems and challenges and varied interpretations for the artist to explore.

For example, each time a subject's pose or attitude is altered, or the lighting is changed—sometimes even in the slightest degree—a totally different kind of image can be obtained. This condition affords almost limitless creative potential.

The creative potential is compounded further when you also consider that, traditionally and historically, the woman has symbolized numerous and varied concepts, including softness, gentleness, fertility, earth, nature, life, love, beauty, as well as mystery, temptation and lust. These offer a lot of scope for pictorial creativity. But that's not all!

If you were to ask five musicians to independently play the same tune, you would be likely to hear five different variations of the same theme. Similarly, if you were to ask five different models to pose for you, even in the same symbolic concept, you would be sure to get five very different photographic representations. It's this incredible scope for variety that has so captivated artists through the centuries and continues to captivate the figure photographer of modern times.

A Comparison with Other Disciplines

Although Sheila and I make our living from photography that is basically "commercial" and done at the request and to the satisfaction of paying clients, we consider our figure photography—done mainly as "art for art's sake"—a very important and satisfying part of our photographic lives. It is truly a very distinct discipline all unto itself. To understand it a little better, a comparison with some other, allied art forms may be helpful.

Painting and Sculpture—In one major area, the photographic nude study is very different than other representations of the human figure, such as in paintings and sculpture. No painting or piece of sculpture, no matter how carefully executed, can capture the reality of an instant that photography is able to record.

A painting or sculpture of a living, moving model is really a personal interpretation of what the subject looked like to the artist, modified by the artist's skill and talent. Furthermore, the finished product is generally a visual summation of all of the subject's expressions, attitudes and bodily positions during a lengthy sitting or even a series of separate sittings.

While such subjective interpretations can obviously yield wonderful art and even truly bring out a subject's very personal characteristics, it is very different from the objective view provided by a camera.

The real test of artistry for a photographer is to try and inject his personal subjective views and interpretations into a scene that will be recorded with mechanical accuracy in an instant of time. While the painter and sculptor need use the model as no more than a reference point, the photographer must use his model as a very real, concrete subject.

However, even the photographer's subject can be enhanced or interpreted in many ways, using techniques of lighting, posing, selective focus, perspective control, not to mention the actual choice of subject pose and expression.

In a way, these thoughts take us back to a discussion we presented earlier, concerning the difference between *naked* and *nude*. You can legitimately differentiate the two by saying that *naked* implies that a person is recorded exactly as she looks while *nude* implies distinct personal interpretations by the artist or photographer, to yield a very subjective, often evocative image.

The Performing Arts and Sports—The performing arts, whether dancing or acting, and sports such as gymnastics, swimming and skating, for example, display the effectiveness of their grace and beauty through motion and action. The still photographer, of course, can only hint at the motion and action by the way he records a small

fragment of it within the confines of one photographic image.

When a dancer performs a sensuous, erotic dance, the desired effect is gained mainly by the motion of the dancer. To interpret or capture the effect in a single frame of a photographic image, both the dancer and the photographer must be aware of which brief moments within the dance best represent the total effect. The photographer must add his own interpretation, by the use of appropriate lighting, color filtration, camera angle, lens selection, and so on.

The photographer of the human figure model is confronted by the same basic problems. Of course, he has the choice of photographing the model in a static pose or using a carefully selected static pose that strongly suggests motion. Alternatively, he can use a fast shutter speed or electronic flash and shoot a sequence of actual motion.

The photographer must seek out those few motions, body expressions or looks that are representative of the subject's dance or other activity. The photographer does not have the luxury of allowing the totality of the dance to be recorded; the essence of the subject and her performance must be presented within a single frame of film.

Portrait, Glamour and Boudoir Photography— Nude photography is different in several significant ways from portraiture, glamour photography and even boudoir photography. This is not just due to the fact that in one case the subject is nude and in the other disciplines she is clad. The differences go much deeper than this. The goals are often very different, as are the sets or locations, the lightings, the esthetic approach, and so on. The photographic goal for most professional portraits is simple: to create an image of a subject—usually just the face—that is both realistic and flattering.

The boudoir photographer must generally treat a subject's face and figure with equal importance. The images are also generally intended to be more ethereal, dreamlike and sensual than accurate and realistic. They seek to idealize the subject.

Commercial glamour photography, as opposed to personal boudoir photography, is usually done of models who are selected for their perfect figures and features rather than of those women who commission this kind of photography for personal purposes. Glamour photography generally seeks to present womanhood in general at its best rather than a specific individual woman at her best.

While most portraits, boudoir and glamour images are taken primarily for commercial purposes,

nude photography, more often than not, represents "art for art's sake."

Most people photography is created for the limited appeal of the subject or the subject's loved ones, friends or family or for special publicity purposes or glamour publications such as magazines, books or calendars. Nude figure photography is different. It is generally done for a wide range of viewers who are not so much interested in the specific woman depicted as in the universal appeal of womanhood generally. In that sense, it is a kind of "symbolic" photography.

Subject Involvement

A skilled portrait photographer can generally achieve a successful, acceptable photo, even when the subject has exhibited little to no emotional involvement with, or interest in, the session.

With glamour and boudoir photography, the involvement level of a subject must be greater than for a straight portrait session. In nude figure photography, the mutual involvement of photographer and subject in the creative process must be total, if any degree of success is to be expected. Not only must the subject become physically involved with the photo session, since many poses can be very demanding, but she must also be involved emotionally, esthetically, and even intellectually.

For everything at a session to work smoothly, the photographer and model must have total confidence in each other. The photographer must share freely with the model what his artistic aims are for the shoot. He must be honest with her, flattering her constantly while, at the same time pointing out errors that require correction. In our experience, no other form of people photography requires the deep involvement called for in figure work.

Types of Approach

The approach that a photographer takes for producing nude images is different from that adopted in other photographic disciplines. There are several different ways of approaching the photographic study of the nude human form. The major categories are the *literal*, the *experimental* and the *casual* approach. Let's look at each one individually.

The Literal Approach—This technique requires a photographer to work within a fairly realistic framework in an endeavor to achieve a reasonably accurate representation of a subject's figure. With this approach, a photographer is generally well advised to avoid such photographic techniques or gimmicks—in the camera or the darkroom—that

would in any way detract from a realistic representation of the subject.

This approach need not preclude ethereal images, in which a photographer creates images that have a dream-like quality, so long as the basic foundation for the image—the subject's body—is recorded realistically and accurately.

The literal approach has a big advantage. The photographic results are generally predictable and the techniques used to attain the results are usually capable of being applied over and over again with some measure of accuracy and success. Because of this consistency, this is the approach frequently taken in a professional situation where it is necessary to produce a usable image quickly and dependably, on a first attempt.

The Experimental Approach—This approach can yield distortions and other less-than-realistic representations of the human form. Photographers who use this approach often use special camera viewpoints, wide-angle lenses and other diverse techniques, as well as film processing variations.

Experimental images can be made by the creation of multiple exposures, by the deliberate recording of motion blur and by the use of special color effects. Extensive watercolor treatments or other unusual artwork can also be performed on finished images. Those who do their own film processing can also use such techniques as solarization and film reticulation.

We do not usually favor this somewhat surrealistic approach to figure photography, for several reasons. First, the results do not usually conform with the types of images that suit our personal tastes. We like images which, while being "creative," also show the subject fairly realistically and flatteringly. Secondly, the end results frequently cannot be predicted with any measure of consistency. Also, such photos are often incapable of being duplicated with any degree of accuracy. It is often difficult to recreate the same experimental condition or effect with another subject.

Don't misunderstand us: we're all for experimentation. It's fun; it's a learning experience; it can produce wonderful, artistic results. We just don't recommend it in a situation where you must come up with an excellent result on a first attempt, in a limited period of time, and with confidence that you can repeat the achieved effect, if asked to do so.

The Casual Approach—Generally speaking, the word "casual," in this context, may be considered to be synonymous with "candid" or even "snapshot." Such photographs are normally only of interest when either the subject or the photographer are well-known. However, there are times when candid figure photos do rise to the level of legitimate art. It calls for a good eye for a pleasing pose and good composition and for rapid reflexes on the part of the photographer. Usually it also requires the photographer to shoot a relatively large series of images, since the precise result in each case tends to be somewhat unpredictable.

The Power of the Nude Image

Most of us are familiar with the expression, "the face that launched a thousand ships." It is a powerful statement of a condition that has existed since the dawn of man. Men have fought battles, even wars, for the love and conquest of a beautiful woman. And it need not only be the face that has this power, but the figure and bodily attitude of a woman, too.

Is it any wonder then that, through the ages, people have been attracted to paintings and sculpture and, more recently, photographs depicting the nude human form?

Sensuality and sensuousness register most powerfully through the sense of sight. We can never get enough of seeing beauty, either directly or as an artistic representation, and perhaps the greatest beauty we can behold is that of the form of a woman's figure. In this respect the nude figure has a power that is not generally found in other kinds of human "portraiture" or portrayal.

The nude human form—female or male—lends itself to a wide variety of pictorial representations. Just a few of these are suggested by words such as abstract, literal, surreal, cold and austere, sensuous and erotic, serious, humorous, vital, static and symbolic.

If figure photography offers great variety, it also presents a photographer with a fascinating challenge. In this kind of photography, more than any other, the dividing line between a work of art and a totally unacceptable image can be as fine as the edge of a knife. This is one of the aspects that's so special about figure photography. Far from deterring aspiring photo artists, it has spurred them on in the eternal pursuit of the artistic representation of the human form.

A slightly misaligned pose, an inappropriately chosen light quality or direction, might lead to a less-than-perfect conventional portrait but would rarely render it totally useless. In figure photography, more often than not, it would make all the difference in the world.

Success in figure photography demands talent and constant practice, appropriate equipment, a

beautiful and talented model and lots of patience. Not many photographers are prepared to make this kind of investment and, accordingly, good practitioners of this art are not easily found. We believe that the end results achieved justify the investment and we're confident that, on examining the photographs in this book, you'll agree with us and be spurred on to achieve results of similar quality.

Figure photography is an excellent medium for bringing out the artist in us. It allows us to escape the commonplace and to strive for a level of creativity that is hard to achieve in almost any other area of graphic art, including photography. It is, indeed, a very special and powerful art form.

Summary

If we had to choose one single thing that is more special than any other about nude figure photography, we would probably tell you that it is the es-thetic and technical challenge of doing justice to one of the most beautiful creations on earth—woman. Even just one model offers the creative, inventive photographer an infinite number of variations and possibilities.

You can photograph the full figure, a slightly cropped figure, close-up detail of legs, bust, buttocks and so on. You can show the face or hide it; the model can make eye contact with the camera or avoid eye contact. You can emphasize or de-emphasize parts of the figure by appropriate camera viewpoint and lens choice. You can vary your lighting and the model's pose, to suit your previsualized concept of the image. You can create a realistic image or a graphic, abstract one.

In the next chapter, we discuss more fully this most vital ingredient for figure photography—the model. We tell you how to find suitable subjects and how to train and prepare them for appearance before your camera.

FINDING, TRAINING AND PREPARING MODELS **3**

Today, perhaps more than ever before, we have enormous freedom for physical and sensual self-expression. Nudity is commonplace at beaches, in backyards and on rooftops. It is depicted in books and magazines. However, the subject is still sufficiently taboo to make finding a willing model a difficult task. Perhaps because photography is the new kid on the fine-arts block, it seems more difficult to find models to pose for a camera than for a painter or sculptor. It takes special skill and sensitivity to first of all spot a suitable model and then to be able to persuade her to become a partner in your artistic endeavors.

The first thing a photographer needs is credibility. First and foremost, this calls for a pleasing, sensitive and professional manner. A well designed business or personal card is also a great asset. The greatest help of all is a good portfolio of photographs of previous work done by the photographer.

If you haven't done nude photography before, show some examples of glamour photography. If that isn't possible, just show some of your very best work. Without some such evidence of your work, many potential subjects are likely to initially reject your request for them to pose for you. Some may even question your motives and intentions.

You're in an apparent no-win situation here. To find a good model, you need to be able to show your past work. But to produce such work in the first place, you need a model! The more experience you gain, and the more work you do, the easier it will be for you to both spot suitable models and to persuade them to work with you.

Women of varying sizes and shapes, from diverse walks of life and from all age groups, are possible subjects for most forms of portraiture and people photography, even including boudoir photography. Nude photography is much more demanding and restrictive. Because you have to be much more selective and because fewer women are likely to agree to pose nude, the number of subjects available to you is very limited.

Even when a subject is physically suitable and is willing to pose, she may not necessarily have suitable emotional, psychological or artistic qualities. The ideal subject for nude photography needs some rather special and unique qualities, some of which we shall discuss as we go on.

What to Look For

One problem that is unique to the photographer of the nude figure is that he doesn't immediately see everything that he is going to photograph. Thus, your first assessment must be somewhat superficial. On a first encounter, you don't see precisely the figure lines, the body's skin tone, and so on. You must do your diplomatic best at the first encounter. When you have talked with the prospective model, have shown her some of your work and have won her confidence, you should be able to go on to doing some test shots—at first perhaps in a swimsuit or partially draped in some other way.

Every woman's figure is a little different and there is no such thing as the "perfect" figure. Select a figure that is appropriate for the effect you want to create. If you want to create a delicate, ethereal image, don't choose a model with a clearly "powerful" build. If you want to symbolize a stalking tigress in your image, don't select a delicate, slight model.

Apart from these considerations, beauty tends to be largely a matter of fashion. The typical nude female figure in paintings, exemplifying womanhood, used to be plump, with a full face and heavy thighs, arms, legs and waist. Right up to the beginning of the 20th century, thin women were often thought of as being delicate, having little stamina and being incapable of dealing with the rigors of daily life. Robust, full-figured women, on the other hand, were idealized. Today, quite obviously, thin is "in." Tomorrow? Who knows?

Today it is not stylish to be heavy. At the present time, at least, we are a society of figure-conscious weight watchers, seemingly on perpetual diets.

At our studio, our experience has shown that most heavy subjects—even very willing as well as attractive ones—are so self-conscious of their figures that it makes them poor candidates for figure studies. They tend to be so busy worrying about their weight, their bulges and having a less than perfect part of their anatomy prominently displayed in a photograph that they often fail to devote the needed concentration on the photography at hand.

We choose our subjects carefully. As you can see from the photos in this book, most of our subjects are thin, while having well defined and well proportioned bodies. They are generally health and fitness conscious and work hard to get and keep their bodies in good condition and shape. Our models are proud of their bodies and physical appearance and are not ashamed to be seen in a state of nudity. Quite to the contrary, their physical appearance gives them great satisfaction.

This is a very important aspect for success: no matter whom you depict or exactly how you depict her, your model must always feel that she is truly beautiful. If she does, there's a good chance that you will be able to record that beauty successfully on film.

You can certainly use a heavy woman and still produce stunning nude photos. But you must be aware that the heavier subject is likely to be more self-conscious about her body. Current fashion trends are simply against her.

Skin Quality and Tone—When you photograph a nude figure, you're showing a large area of skin. The skin must be of good quality, tone and texture and as free as possible from flaws. Very few bodies are totally free from markings of one kind or another. Such minor flaws can easily be covered by makeup or hidden in shadow or by long hair. However, you should avoid prospective models who have prominent scars, bruises, tattoos or other body markings.

Sometimes you may find a model who is so good in every other respect that you just have to accept some skin imperfections, even if they are fairly prominent. If makeup and concealment through shadows, long hair, or an appropriate pose don't work, you may have to resort to retouching on the final image. However, this can be very expensive.

Skin tone is another important consideration. Skin of a slightly dark tone is often advantageous, not only because it has a good, healthy appearance but because it often tends to keep overall image contrast down. This can be especially important in color photography. In other instances, such as for high-key images where almost everything in the image is of light tonality, a very fair skin is often best.

If a nude model wants to sunbathe, she should do so only in the nude and she should be very careful to get a uniform tan all over. Tan marks from a swimsuit are a definite "no-no" for a figure model.

Physical Agility—For simple portraiture or even boudoir imagery, a subject generally needs little physical agility and flexibility. Most of the poses such subjects assume are quite simple.

In figure photography, by contrast, we must often request unusual and difficult body positions, angles and poses to best bring out certain lines and shapes. This requirement puts much more demand on a subject's physical agility. Since not everyone has the same bodily flexibility, not all make ideal models for figure photography.

To avoid finding out at the last moment that a chosen subject cannot execute any but the simplest of poses, you should—in advance of a photo session—ask some leading questions. Find out about your subject's abilities in dance, gymnastics, swimming and other sports and activities that demand some measure of agility as well as bodily coordination. Inquire if she has ever modeled for a photographer or perhaps at an art school, whether she has had charm-school training or taken ballet lessons. This kind of information could save both you and the intended model a lot of time.

Be aware also that a subject may have none of the above experiences and still be a natural, creative and agile model. Therefore, before you reject her, be sure you're not losing someone who is actually very worthwhile.

Psychological State—Our boudoir photography has taught us that many subjects are initially reluctant to display their scantily clad bodies to a strange photographer. These are not professional models and they are initially often concerned that too much of them is being revealed. They often tend to be shy, somewhat embarrassed and a little guarded.

As a sitting progresses, this anxiety usually fades. Toward session's end most subjects become very willing and even enthusiastic and show an ability to display their figures freely and to assume quite sensuous poses.

Nude photography, obviously, calls for an even greater lack of inhibitions than does boudoir work.

From the inception of the sitting, the subject should, ideally, be uninhibited and comfortable without clothing. She should be able to project the attitude that she is perfectly at ease in this state and prepared to be directed into artistic as well as sensuous and provocative poses.

Not many subjects can attain this state of mind quickly. Some will never achieve it. This, of course, reduces your choice of prospective, suitable models. But that's okay! There are others out there, and they can be found!

Sometimes a prospective nude subject's main concern will be her face. She will tell you that she doesn't believe that she is pretty enough. It is generally not difficult to set aside this misgiving. You can assure the model first of all that she is much more attractive than she thinks she is. Furthermore, you can tell her that in figure photography, after all, it's the figure that's most important. You can inform her that, in some of the most effective nude studies, the face is actually hidden, either by long hair, by being turned away from the camera, by the use of a deep shadow, or by some other deliberately used obstruction.

You can also assure your prospective model that makeup can work wonders in concealing minor flaws as well as in enhancing the major and best features of a face.

Believe it or not, in figure photography a subject's hair is often more important than her face. We'll say a little about hair in the next section.

Hair: Length, Color and Quality—Long hair, without a doubt, provides the most versatility in figure photography. It not only enables a subject's face, or even other body parts, to be selectively concealed but also provides an excellent prop for draping parts of the subject's upper body. When a subject's hair is short, it should be styled well and appropriately for the type of atmosphere or effect you want to depict.

The color of the hair is not generally very important unless, again, you want to create a special effect or atmosphere. For example, you would not want to select a black-haired model if your aim is to produce a high-key image, nor would you select a blonde for a somber, low-key image.

The quality of a model's hair should always be immaculate—unless you're deliberately trying to create a special effect. Regardless of the particular styling, the hair should be clean and sleek.

Where to Find Models

When the photography for this book was initially planned, we thought that we might need to rely totally on professional models. To our amazement, many of our former clients volunteered to pose for us. As a result, all of the subjects shown in this book, with the exception of just one, are non-professional models, totally new to figure work.

This was an ideal situation for us. For you, this chapter is intended as a guide to help you find suitable models without having to resort to the use of professional model agencies. Also, this entire book is essentially about how to take inexperienced women, often with less than perfect features, unaccustomed to being in front of a camera—all the more so without clothing—and produce stunning figure photographs.

You may not be as fortunate as we are in as far as we run a large studio where we meet many camera subjects, including those who come to us for professional boudoir photography—which is only one subtle step removed from figure photography. However, many people come to our studio simply to browse or ask for a price list, to plan a portrait or family shooting session, to have a passport photo made or to buy a gift certificate.

If any one of these casual visitors appears to have the qualities we are looking for in a model, Sheila will not hesitate to ask the subject whether she is willing to pose for us. At least half of the time, subjects will enthusiastically agree and express a feeling of flattery for having been asked. This is true in spite of the fact that nowhere in our studio gallery do we display nude images—only boudoir photos, portraits, wedding pictures, family images, and so on. Of course, the fact that we are an established photographic studio gives us high credibility. But, as indicated earlier, such credibility can also be built up by a professional personal approach, a good business card and some good examples of past work done.

Following are some ideas on where you might most likely find suitable models for figure photography.

Family, Friends and Acquaintances—If you asked among your acquaintances, friends, family members and other loved ones for volunteers to pose for experimental portrait sessions, most would probably agree to do so. If you were to approach suitable candidates in the same crowd and ask them to pose for nude photographs, most would certainly decline to agree. Some may even openly question your motives and intentions.

Artistic figure photography tends to be misunderstood, largely because of the reputation nude photography has received through the abundance of pornographic material in our society. As a result,

you'll often need to spend time convincing and assuring your prospective subjects that your motives and objectives are totally professional and that your end results will be in the best of taste.

Don't give up if you are initially turned down. Try to educate those around you on the history and meaning of nude art in general and figure photography in particular. Those in your immediate circle can be an excellent source for models, especially when you are first starting out.

If absolutely necessary, allow a friend or relative of the prospective model to sit in on the earliest photo session. This will go far in convincing an otherwise hesitant subject that your intentions are legitimate. Normally, however, we do not favor having people sitting in on shoots. They tend to be a distraction to both the photographer and the model.

Based on our experiences, female photographers seem to have an easier time securing female subjects to pose for nude photos than do their male counterparts. A husband-and-wife team, such as Sheila and I, represents the best of both worlds. It gives prospective subjects, both female and male, much more confidence and helps to greatly legitimize the motives.

If you are a male photographer, try to work with a female assistant or partner and be sure to inform your prospective subjects that this will be the case. It is likely to make your acquisition of models much easier. Of course, such problems can be totally avoided if you can secure your own wife or girlfriend as a model.

Former Photo Customers—If you have photographed a subject in the past—at a portrait session, a wedding, in a club group or for a passport photo, for example—do not hesitate to ask her to pose for you, if you think that she is a suitable subject. If you operate or work in a professional studio, this group will often be your best source for models. They are already familiar with you and your work and are most likely to trust your motives. For us, this has certainly been our biggest and best source.

Art Schools—If you are fortunate enough to live in an area that has an art school or a college with an art department, this can be an excellent source for subjects. The fine-art division of such a school will often have excellent figure models at its disposal. Many of these models will be accustomed to posing in the nude, having done so many times for the school's students. Many will also possess the requisite bodily agility that is so important in this kind of work.

These models will generally charge very modest fees, such as perhaps $5 to $10 per hour for their services. Or, they may agree upon a small fee plus one or two photographic prints from any photo session that you have them involved in.

Model Agencies—A reputable model agency can be an easy source for experienced subjects but it is not a source that we favor. Professional models for nude photography can be very expensive—prohibitively so for the average amateur photographer. Also, well trained and experienced models in fashion and advertising work sometimes may lack the freshness and spontaneity of a less experienced but enthusiastic amateur model.

Many agencies will, indeed, be happy to offer you a large selection of fledgling models who are in need of experience at working before a camera and of building a photo portfolio. For their posing services—at least in our area in Florida—it is customary to pay such inexperienced models no money but to give them one or more 8x10 enlargements from each of their photo sessions. However, this relatively "free" service usually applies only if you are seeking models for regular portraiture, fashion or glamour photography. For boudoir or nude photography, not only will the agencies have fewer people to send you, but the charge becomes quite substantial—anywhere from about $50 to $200 per hour. Such charges are generally out of the question for an amateur engaged in mere practice sessions.

Why are the charges for nude modeling so high? First, it may help to ensure the legitimacy of the photographer's motives. It also represents added compensation for the "hazard" of engaging in a form of photography which, even though totally legitimate, is still regarded by many as taboo. If a prospective model is concerned about the exploitation or improper use or publication of her images, be sure to offer her a release form that insures against wrongful use of any images. We'll discuss model releases later in this chapter.

Dance Schools and Dancers—Like art schools, dance schools can be a good source for prospective models. Both dance instructors as well as their students can be excellent candidates.

Although many dance instructors and students may not have the modeling skill that most professional models have, their physical agility, expressiveness and vitality will often more than compensate.

Models from this kind of source will generally be happy to pose in exchange for glamour-type photos, with little or no expectation of financial remu-

neration. It has been our experience that such models will generally not be ready for immediate nude photography. You may need to start with a glamour swimsuit session or two, until she builds up her confidence in both herself, as model, and in you, as her photographer.

Generally speaking, dancers are very uninhibited about their bodies. Once they get into the spirit of a figure photography session, they tend to make the very best models.

Nightclubs—If you have one or more high-caliber nightclubs in your area that feature exotic dancers, they could prove to be an excellent source for subjects. Be sure to take some samples of your best and most appropriate work with you when you visit the clubs, so that you can show prospective subjects the level of your work and prove your legitimacy.

If you want models with true ability and grace, and with real beauty, we urge you to only try clubs of the highest standard. Some of the lower-class clubs seem to have merely two requirements when hiring exotic dancers—that they are female and that they are prepared to appear nude. Such clubs often don't concern themselves with true talent, experience and beauty.

In our experience, many dancers from the higher-class clubs will pose in exchange for just photos, without expectation of other payment. Others will ask for a flat fee of between $50 and $100 for a three to four-hour posing session. With an experienced dancer, who knows how to move gracefully and has no inhibitions about her body, it can be well worthwhile. Whenever we have used such models, they have worked very hard and posed beautifully.

How to Train a Model

Once you have secured a model to pose for you, the next step is preparing her mentally, emotionally and physically to be photographed.

Start Slowly—Photographing a model in the nude has rarely been a problem for us because we spend a lot of time in preparation. We prepare the model both emotionally and physically. By the time we—usually Sheila—are through talking with a subject and gearing her for the photographic events to come, she is generally more than eager to become involved and has few to no reservations about disrobing and being photographed from the very inception of the photo session.

Always start slowly with a new model, either by plenty of pre-shoot preparation or by a shooting session that builds slowly and gradually. Before taking figure studies, start more conservatively, by taking head-and-shoulders portraits with the model fully dressed.

After 20 minutes or so of this type of photography, move on to more revealing boudoir-type head-and-shoulders shots, with clothing or material draped off the subject's shoulder, revealing more of the subject's bust line, and so on.

Following this, suggest that the subject attire herself in a more revealing costume such as a negligee and shoot full-length images. With each ensuing pose, have the subject assume a slightly more daring body position and expose a little more of her body to the camera.

After you have shot one or two rolls of film, have the subject change to a more skimpy outfit—a bra and panties or a bikini bathing suit, for example. Shoot more images, with each new situation being closer to a nude pose than the previous one.

The next step is to have the model remove the garments that cover her but have her hold them up against her body. The body will still be covered to a greater or lesser extent, but more daring images and poses will be possible.

At this juncture, if you feel that the subject is ready, you should have her move the garments from her body altogether. Keep the clothing or other material close to her—just a few inches away. You'll often find that a subject will need to have reasonably close access to the clothing or material, much like a security blanket, until these early nude shots have been concluded.

By now, the subject should be totally relaxed, very confident with both herself and you, and emotionally prepared to be photographed totally nude, without the benefit of any clothing or drape—even close to her body.

This approach, structured to gently ease a new subject into nude photography, is time-consuming. You'll often spend three or four hours with a subject before actually undertaking a nude photo session. Or, you'll find that you have to split the session up over a period of a couple of days. This training approach is sometimes essential for totally inexperienced models who do not feel at ease in front of the camera unclothed. Of course, experienced models don't need this "warm-up" phase. Nor do some newcomers who are naturally more comfortable with their bodies.

In the final analysis, you must be the judge as to how much training and initiation is necessary and how much time you need to spend on it.

Legal Considerations

We would be remiss in concluding this chapter without addressing ourselves to some legal considerations involving models and nude photography. After all, what good is it finding, training and photographing a subject, if you end up endangered by the possibility of a lawsuit or of being prohibited from using your photographic results?

The Value of an Assistant—When a male photographer does figure photography of a female subject, we consider it essential to have at least one female assistant present during the session. Not only will a capable assistant make a sitting go faster and more smoothly for you, but the presence of another female also makes a subject feel more at ease. Most importantly, however, the presence of the assistant gives you some vital legal protection. It affords you a witness in case a subject later claims that you made improper advances or remarks to her during the course of the session.

Even if our subject is one who has posed for us many times in the past, I would never conduct any nude photo session without the presence of at least my wife and one additional female assistant. The nature of nude photography is just too sensitive to allow taking the risk of handling the situation in any other way.

The Model Release—Whether you are a professional photographer or engage in nude photography just for the art and fun of it, an important habit to adopt is to have all of your subjects sign a standard model-release form. Without having a signed release, you should not display, exhibit or otherwise publish any nude photographs that you have created. Even if you cannot discern the subject's face in an image, if there is any way the subject might be identified, obtain a signed release before making any use of the image.

Model-release forms are readily available from most camera or office-supply stores and are inexpensive. Most of your subjects will not hesitate to sign one. However, before you use any general release form, we suggest that you consult an attorney regarding the precise wording.

If you have a willing and perfect subject to pose for you who is not willing to sign a release at all or doesn't want to sign until the session has been concluded and she has seen the results, our advice is to abandon the session and find another subject. If she eventually really decides not to sign, your photos will be totally unusable.

Of course, if you're taking nude photographs purely for your personal fulfillment and enjoyment and plan to make no public use of the images, you really don't need a release. Even then, however, it's not a bad idea to have one signed, if it is at all possible.

Although the laws on releases can differ from state to state, there is generally a common thread. The person signing the release has to receive something in exchange for her posing for you and giving you the right to display or otherwise use the images. Her mere signature on the release is not sufficient.

The "something" that is given in payment does not have to be money, but it does have to have some value—such as a print or two in exchange for posing and signing the release. Without this type of exchange, a signed release is generally not worth the paper it's printed on. It has become common practice for a photographer to simply pay $1 when having a release form signed. Of course, if you're already paying a modeling fee or providing the model with photos, this is not necessary.

Photographing Minors—In the event that you intended to photograph a minor—and what constitutes a "minor" for our purposes here may vary from state to state—you should proceed very cautiously and only under the explicit advice of legal counsel.

In most states, a minor's written consent on a release is valueless. Even if you have the written consent of one or both of the minor's parents, most states allow a minor to disavow any such parental consent within a reasonable length of time after reaching the age of majority.

In practical terms, what this all means to a photographer is simply this: when you deal with a minor, you often do so at your own financial and legal peril.

Physical Preparation

As with boudoir photography or, indeed, other forms of people photography, a subject for nude photography must engage in a certain amount of preparation.

In boudoir photography, paying strict attention to the following details may not be quite as critical because the boudoir subject is often photographed on an elaborate set and in an attention-grabbing costume. The nude subject, on the other hand, is often posed in a simpler setting. Thus, a viewer often has little to distract him, so that all of his attention is directed at the subject and her body.

Makeup and Hair—Although we shall be covering these two topics in Chapter 6, a brief comment is necessary here.

Having a subject's hair styled and makeup applied by an expert is usually critical for nude photography because, as just stated, a viewer's attention will often have only one place to focus upon—the subject. If hair and makeup are not perfect and appropriate for the type of image being shot, their deficiency will be glaringly obvious and this could ruin an otherwise beautifully executed figure study.

Suntan—Many subjects believe that they should lie out in the sun in advance of a photo session, to give their bodies some color. This is wrong thinking. A fresh suntan can leave skin looking reddish, blotchy and unevenly tanned, even when the subject sunbathes in the nude.

It has been our experience that very few people sunbathe nude, and this causes an even worse problem. The parts of the body that were covered by a swimsuit or other clothing will have no tan at all while the exposed parts will. Such markings are unacceptable for most figure photography.

If a subject does sunbathe nude, a problem that often arises is unevenness of the tan. Depending on how a subject exposes herself to the sun, some parts will tan darker than others. This unevenness is also unacceptable. You could create a nude study with dynamic lighting, and yet the image would be less than desirable because of that uneven tan. When giving a subject general advice on preparation for a figure-photography session, advise her against getting a suntan.

Grooming—Advise all of the women who are going to pose for you to groom their bodies well, before appearing in front of the camera. This should include shaving the legs and under the arms, which should be done about 12 to 24 hours before the shoot. If it is done too close to the time of the shoot, the shaved areas may appear reddened or blotchy. Fingernails and toenails should be neat and polished, and so on.

Temporary Body Marks—The wearing of a bra, panties or other tight fitting clothing can cause a subject's body to become marked or creased. Such marks or creases will show prominently in a photograph and be very distracting to a viewer. They can truly spoil an otherwise fine image.

To remove such body markings from a resulting print would require retouching or airbrushing, which takes time, costs money and often deprives an image of a totally natural appearance.

To avoid such body marks, advise your subjects to wear no tight-fitting garments for about 12 to 24 hours prior to a photo session. At home, or even on her way to the studio or shooting location, a model can easily dress quite decently in loose-fitting garments that require no tight fitting underclothing.

Permanent Body Markings—Most subjects have almost insignificant markings, such as birthmarks, scars or even subtle tattoos, somewhere on their bodies. Such markings will generally appear more prominent in a photo than to the eye and will tend to detract from the mood and desired effect of the image.

The markings should be concealed as effectively as possible with makeup, lighting, a well placed prop or piece of material, or by an appropriate pose. Your pre-shoot discussion with the subject should include questions about possible body blemishes, so that appropriate steps can be taken to deal with the problem, and it doesn't first become apparent when you're already on the set for photography.

Some subjects—especially those who have been tattooed—may be proud of the markings and want them displayed in the photos. Be cautious! Most of your potential models will have no idea how prominent such markings can look in a photo. Once they see them in an image, they will often hate them and want them removed. Although this can be done through airbrushing or other retouching methods, such measures are expensive and time-consuming. If a subject insists, we'll take some photos with the body markings displayed and the balance without.

Body Enhancement—If it is part of your photographic intention to add something to the subject's body, such as body makeup, body paint, oil, and so on, be sure to discuss this with the subject well in advance of the photo session. You don't want to confront her with last-minute surprises and thus give her added pangs of uncertainty.

You need prior knowledge of the subject's sensitivity or possible allergic response to any enhancement products you intend to use. An actual photo session is no place to test a subject's skin to such sensitivities. To avoid problems, you may wish to give your subject a sample to take home to try. All of the makeup or other enhancements that we use are hypoallergenic. We recommend that you do the same.

You should be aware that excessive application of paints and other materials that do not allow the body's skin to "breathe" can be very dangerous. This is especially important with products that will cover the subject's entire skin. If the material does not allow the subject's skin to breathe, then it is

possible that the subject may suffocate. Be very sure of your materials and methods! Ideally, consult or use an expert in that field. Any undesirable response on the part of the subject to skin-enhancement products could cause a disgruntled subject at best and disastrous legal consequence at worst.

To enhance a subject's feeling of security, a male photographer should make a special point of informing her that he will be providing a member of her sex to assist in applying the body enhancements. You don't want her to think that a male photographer will be doing this job.

We'll be saying more about body enhancements later, particularly in Chapter 6, where we'll discuss how makeup, hairstyling, props and accessories can contribute to the photography of the human figure. Improper use of these items can be detrimental and ruin a study that may be otherwise perfect. However, the reverse is also true. Proper selection and application of these enhancements can be the difference between a good photo and a great one.

Now, let us turn to two other important considerations for the figure photographer: shooting locations and settings.

SHOOTING LOCATIONS AND SETTINGS 4

Suitable settings for figure photography can be found in many places: a photo studio, a subject's home or your home, or at an outdoor location. The settings can range from the most modest and simple to the highly elaborate.

For most people photography, the selection of an appropriate setting or location is an important element. An otherwise good image could turn out to be less than acceptable, or even ridiculous, if an inappropriate setting was chosen. For example, a setting that might be very appropriate for photographing a child would generally be totally wrong and out of context for portraiture of corporate executives.

A setting must be consistent with the type of photography engaged in and the results sought. For nude studies, finding what might be regarded as an "appropriate" location is generally much less of a problem than for other kinds of people photography. A very wide range of locations can be appropriate for figure photography, from the simplest seamless studio backdrop to the most elaborate setting in a mansion or a deserted spot in a forest.

A photographer of nude studies has an almost unlimited choice of settings, being restricted only by his own judgment, style and taste and the interpretation that he wishes to give to a subject.

The art of figure photography lies in lighting, posing, your directing abilities, the model's skill and sensitivity, your camera skills and your ability to convey on film the mood and atmosphere you want. In most figure work, the subject is the prime ingredient. It's true that you can generate numerous moods and effects with different settings, but your choice of these settings is virtually unlimited.

Control of the Setting

An artistically made nude photo can be the zenith of intimate portraiture. A painting—even an intimate study of a nude—cannot really capture what a skillfully executed photograph can, for one major reason: instant and truthful representation.

A final painting of a nude study is not a representation of what the subject and setting actually looked like on the day when the artist finally concluded the work. To the contrary, the painting is a compilation of interpretations of what the subject and the scene looked like to the painter during the entire session—and it may have taken the artist hours, days or even weeks to finish the work. The painting is a summation of all of the subject's attitudes and expressions during the many posing hours.

When a photographer captures an image on film, it is a precise and exact likeness of the way the subject looked at a specific and brief instant in time. The photographer must study the subject over a period of time, to learn her moods, expressions, characteristics and moves. He then draws on what he has learned, to record—in one brief fraction of a second—what he considers the "basics" that make up that particular subject.

The subject, a living, vital being, can change her expression, pose and attitude constantly. All the photographer need do is to direct her, observe her, and make the exposure at the precise moment when he sees the photographic interpretation or representation that he wants to record on film.

Where the inanimate location is concerned, the painter has an obvious advantage over the photographer. He can place the nude subject in whatever setting he desires—elaborate and extensive, modest and barren, classical or contemporary, and so on. He can choose the setting at the last moment, and it doesn't have to be the real one in which the subject actually posed for him.

Whatever element of a setting the artist feels will convey the required mood, feeling and interpretation, he can add, emphasize, modify or de-emphasize at will as the painting progresses.

In the recording of a location, the photographer has a different problem. His "canvas"—the film in the camera—receives all of the elements of a scene and setting in one moment. This means having a pre-conceived idea of how the subject is to be pre-

sented in relationship to the chosen setting prior to exposure of any film. It also means subtracting unwanted elements from the setting, emphasizing some features and de-emphasizing others.

This can be accomplished in a few different ways. Unwanted items can be moved from the setting or, if this is not possible, they can be hidden. They can also be de-emphasized by the appropriate application of shadow areas. The skillful use of camera angle and lens selection can also help.

Elaborate and Simple Settings

If you are being hired by a client to create a nude study, you may be somewhat bound by the dictates of the person who hired you regarding the nature of the setting and whether it should be elaborate or simple. Aside from such dictates, you alone are responsible for locating or fashioning a setting that will be consistent with the pictorial interpretation you wish to achieve.

Elaborate Setting—An elaborate setting is not the same thing as a cluttered, "busy" setting but rather a location that contains appropriate elements and props in addition to a mere "backdrop." It is an area that provides more than just a background for a photographer to shoot in.

For example, in our studio's fireplace set, featured in some of the photographs in this book, there are several areas within which a subject can be posed and photographed—at or on the bar, on or near the hearth, at or near one of the windows, on the spiral staircase, and so on.

When you use an elaborate setting, you can photograph a subject in one section and then easily and rapidly reposition her at another location in that setting for other poses, providing a different look and mood. This helps to provide pictorial variety and gives both you and the model an added challenge. It is also a safeguard, in case the poses in the initial location didn't suit your subject or your taste and previsualized concept.

For the above reasons, whenever we can, we use fairly elaborate settings for our figure photography. The setting need not be an expensive, especially built one. You can use any well furnished and decorated bedroom, living room or even kitchen.

Simple Setting—A simple setting generally provides only one posing place in which to shoot. At its simplest, it consists of nothing more than a seamless studio background or a plain wall. A single chair or stepladder could be added as a posing prop to enable you to shoot more varied poses.

Don't underestimate the potential power of the simple setting for nude studies. An attractive subject, posed against plain background paper, with well placed and appropriate lighting, can hold a viewer's total attention and yield some terrific pictorial results.

Another nice feature of the simple setting is that, once you have taken the few shots that you want, you can easily abandon or dismantle it and move on to another, equally simple setup with minimal delay and effort. Even if you don't want to move on, you can achieve an astonishing variety of dynamic images within the confines of one simple set. You do it by using changes in pose, expression, camera viewpoint, lighting, and so on.

Subject Attitude and the Setting

With a fully dressed subject, a photographer often has to go to great lengths in making major changes in both the setting being used as well as the lighting, the poses and the clothing, to achieve really noticeable differences from one photograph to the next. With nude studies, a photographer need not resort to such drastic changes. The undraped figure can express herself much more easily through subtle and yet very clear changes in body language.

Just as a face is capable of exhibiting different expressions, so also is a subject's entire body. The tilt of the head in a certain manner, the raising or lowering of an arm at a certain angle, a slight turn of a leg, a slight movement of a hand, even the posing or placement of the fingers, are all examples of the use of body language. It is personal expression through use of the body and can be strongly suggestive of many moods and feelings, such as sensuousness, shyness, defiance, pride, strength, timidity, and so on.

The skillful photographer can use body language to replace the need for an elaborate set or he can integrate the set and the body language to form a coherent, rational and total visual experience. It all depends on what he is trying to convey in his images. One thing is certain: the simple set is more likely to keep viewer attention totally on the posing subject.

Establishing a Mood

Some settings will readily and strongly suggest a certain mood, atmosphere or activity. For example, photographing in a modern home, a museum or a ballroom would all lead to different photo results. Each environment would suggest a specific mood. Natural settings, such as a beach, mountain or forest, tend to be more timeless and unaffected by changes in style. A very simple setting such as a

gray, seamless paper background or dark satin material, may not strongly suggest any specific mood; it will be totally up to the model to provide it with her pose, expression and attitude.

You can inject a mood or the feel for a specific time period, even when shooting in the simplest of settings, by the thoughtful selection and use of suitable props and accessories.

Interrelationship of Subject and Setting

When preparing to create a nude study, quite frequently you will first decide what kind of "look" you want to create—such as classical or contemporary—and then choose the setting accordingly. Sometimes, however, the process will be reversed: you'll come upon an attractive setting first and then decide how to fashion a figure photograph with a pose that will be appropriate for this setting.

Whichever comes first—the concept of the kind of image you want or the actual scene—you must create a credible relationship between the subject and her pose, on the one hand, and the setting, on the other. Just as you wouldn't photograph a company executive in a child's nursery, so you must be sure that the chosen model, her appearance, pose and mood, and the chosen location, "make sense" together.

Of course, the above assumes that you are taking nude photos for your own portfolio or pleasure. If you are being hired to create a figure study for some commercial purpose, you are, by necessity, forced to satisfy the specific needs of your client. After all, the executive may, indeed, be photographed in a nursery, if he happens to be the president of a baby-food company!

Don't ever try to force a model, no matter how beautiful, into a setting that is totally unsuitable for her, simply because the location is there, handy and available. It will almost certainly lead to disappointing photographic results.

A talented and imaginative subject can often help you find suitable locations. But even just her basic nature and appearance will often be a clue. For example, some subjects will look distinctly old-fashioned and conservative while others will look more modern; some will look vampish while others will look elegant and stately. Learn to recognize the basic, essential "look" of each model. It will be a good guide and starting point in your selection of an appropriate shooting location.

Get the Most From Each Location

Whatever location you have chosen or created, learn to "work" your set to its fullest potential. To learn how to do this, you might practice an exercise that one of our mentors taught us.

Start by going out into a large field. Choose some 20x20-foot area within the field as your shooting location. Using a 35mm camera, a 100mm macro lens and natural light, photograph everything that lies within the chosen area—even if it contains nothing more than grass, rocks and twigs. Don't photograph the same thing twice without changing something; take photos from every angle and vantage point that you can. Shoot at least one entire roll of film.

This exercise is excellent for teaching how to "see" photographically. It forces one to stay and work in a limited area and think first, rather than just pointing and shooting.

Many of us get into the habit of locating or constructing a set, taking a few shots from one favorite camera position or angle, using one lighting setup, one lens, and so on, and then moving on to greener pastures. So often, we fail to seize the opportunity to shoot from different camera angles, from different locations within the setting, with different lighting, different lens focal length, and so on.

Few photographers really work a set to its fullest potential. Many fail to exhaust all the possibilities that even a simple or limited setting offers.

Just because we urge you to exploit all of a set's potential, don't be tempted to change your viewpoint or location on the set prematurely. Get all that you can out of each chosen viewpoint and pose, before you move on.

PHOTOGRAPHY IN THE STUDIO

A studio—whether commercial or in your home—offers the greatest control for figure photography. It ensures privacy, always provides all of your equipment at your fingertips and affords you total control over your lighting.

The Advantages of Privacy

Because nude photography is an extremely sensitive photographic area, extra precautionary measures for the subject's well-being and feeling of security should be taken. Outside the subject's own home, your studio or home will generally be the most private location you can find. Privacy is very important to a subject's emotional ease—even to the most liberal—and it can have a very direct and significant bearing on the quality of the photographic outcome.

A subject who is new to figure photography tends to be nervous and doesn't need the additional concern of having strangers looking on. Once a

sitting starts, you should not allow anyone whom the subject has not previously met and expressly approved of to invade the shooting area to watch or interrupt the photo session, except in the case of a true emergency. Breaking this basic rule could cause a sitting to deteriorate very quickly or, at the very least, cause a subject to lose the momentum of the session. Once that momentum is lost, you'll often spend valuable time trying to regain it, if in fact you ever can during that day's session.

Beware of Stagnation

Achieving consistently good photographic results is a goal that most of us seek. By working and photographing over and over again in the same studio, with the same lighting and equipment, and becoming familiar with and solving all the problems that can confront a photographer, one cannot help but eventually attain technically consistent photographic results.

This luxury is often not available when you do location work. Location work offers different challenges and frequently involves the instantaneous solving of problems without advance knowledge of the exact photographic outcome. Even if you have photographed in the same natural location before, time has a way of altering things. This can lead to delays as well as inconsistent results.

Even though studio shooting appears more desirable than location work in this respect, studio photography has at least one big drawback—the danger of stagnation of creativity.

By consistently working in the same environment, with the same tools and lights, "sameness" begins to work its way into the daily procedures and many photographers forget to reach out and experiment, to try new and different things. Growth is sacrificed for comfort. The photo results become technically consistent but often the final images all begin to look alike, even when the subjects are different.

Beware of this trap of stagnation. Nude photography affords tremendous creative license and potential. Familiarity with your environment can seriously retard their development unless you are aware of the danger and make a conscious effort not to be lured into this easy but non-creative condition.

Don't Overwork the Subject

No photographic session should be carried to the point where the model is clearly fatigued. Be especially mindful of this when working with non-professional subjects. When you are shooting in your own home or studio, you're in familiar, comfort-

able territory. There may be a tendency to photograph for longer periods of time than if you were conducting the photo session elsewhere.

Models will tire from the rigors of posing, no matter what or where the location. A professional model may be able to pose for many hours on end and still look fresh and unstrained. However, it's been our experience that non-professional subjects begin to look tired and photograph poorly if they are worked more than two or three hours at any one time.

PHOTOGRAPHY IN THE SUBJECT'S HOME

As with other types of location work, figure photography in a subject's home can afford a photographer great challenge. New settings and props can be incorporated with new photographic concepts, new lighting arrangements and creative new poses. The home also affords an element of privacy. However, there are also some problems to be aware of and deal with.

Working in Unfamiliar Surroundings

Unlike your home or studio, a subject's home will generally be unfamiliar territory to you. You will not know with any degree of certainty what the exact photographic results are going to be until after you have taken the shots. To keep disappointing results down to a minimum, we suggest that you visit the subject's home in advance of the day of the actual photo session.

See for yourself exactly what advantages and disadvantages the home offers. Make notes and sketches of the rooms you will be shooting in. Several rooms may offer the potential for different settings. Note such things as wall colors, room sizes, ceiling heights, location and size of furniture, whether furniture will have to be moved, the theme or style of each room, and so on.

Spend enough time in the home that you can become familiar with it and gain a good impression of what you're going to do when you come back to photograph, where you'll be shooting and how you are going to work with and around certain items in the home that may offer potential problems, such as large, bulky furniture.

Also familiarize yourself with the location of electrical outlets and, if you plan to use daylight, the size of windows and in which direction they face.

Ensure Privacy

In your own home or studio, you have total control over who will be allowed into your shooting area. Photo sessions at a subject's home will not

automatically offer this luxury. A subject's children, spouse, friends or neighbors may come in and out of the shooting site with little to no warning or may wish to stay and watch. This can be very disrupting for both you and the subject and have an adverse effect on the photo results.

Discuss this contingency with your subject well before the actual photo session, so that the potential problem is avoided instead of becoming a reality. At the very least, attempt to have an understanding with your subject to keep such interruptions to a minimum.

Try, at the same time, to get your subject's agreement not to take phone calls during the actual shooting time.

The Setting May Dictate the Mood

Shooting in a subject's home will frequently not give you the choice of first deciding on the type of look you're after—classical or contemporary—and then selecting an appropriate setting. You will usually have little latitude for making drastic changes to someone's home and will generally have to work with the available decor as best you can and irrespective of whether the subject's look fits into the scheme of things.

Obviously, it could be difficult or impossible to create a 19th-century look in a home that is decorated in ultra-modern style. Unless you intend to deliberately create a paradoxical photo statement, you'll often be forced to let the setting of the home—interior or exterior—be the guiding factor for the interpretation of the nude study you're going to do. You'll also be forced to stylize your subject accordingly—through the careful selection of lighting, poses, props and accessories.

PHOTOGRAPHY ON LOCATION

The world is virtually your oyster. You can go almost anywhere—a beach, a park, a deserted farmhouse, a forest, a waterfall or a rocky knoll—and produce beautiful figure studies.

Don't latch onto the first location you encounter. Visit many areas and choose selectively, after giving much thought to the types of images you want to create.

The Challenges

Unlike your studio and home, each new location site will be different and will offer new photographic problems for you to solve. The lighting will constantly be changing, the weather will be a factor, onlookers may present problems, and so on. This is part of the special challenge to location photography.

By thoroughly scouting an area well before the day of an actual shoot, you should be able to go to that site, set up your equipment and pose and photograph your subject with very little delay, doubt or confusion.

It is one thing to ask a subject to pose in the nude in the security and privacy of a studio or home. It's quite another to expect the same thing in public, open surroundings in the big outside world. Some subjects may initially be very reluctant to be photographed in this type of environment.

For others, however, there is often a special challenge and attraction to shooting outdoors. It involves everything from truly communing with nature to a certain charm about doing something that is a little "off-beat" or provocative. As many models can tell you, disrobing and posing nude outdoors can give a wonderful feeling of freedom and sheer exhilaration.

For such models, the outdoor location is often a very real psychological help. It leads to vital, exciting images, often with a wide variety of poses in a short time period. A subject may project a facet of her personality that might be totally concealed during mere studio photography. Take advantage of this condition if and when it occurs. It can lead to some dynamic, stunning and joyful images.

Avoid Intrusions

Be acutely sensitive about a subject's need for privacy when on location. Only seek out areas about which you feel confident, that appear safe, that you feel certain will have no conditions that might cause embarrassment or disruptions during your photographic endeavors. The location should pose no threat to your subject's feeling of well-being.

You cannot afford to have strangers looking on or intruding during a nude photo session or having the police harass you because of your public display.

When shooting in an area that could be accessible to the public, it's advisable to take someone along with you to watch out for possible intruders. This person need not be a witness to the actual shoot but would merely alert you about the approach of anyone.

From time to time, you might well be interrupted by unwitting intruders in even the most remote locations. If this happens, have your model cover herself at once, explain politely

and honestly to the intruders that you are taking artistic figure photographs, and apologize for any embarrassment you may have caused.

Official Approval May be Needed

If you have any doubt about the private or public nature of the outdoor site you have chosen to shoot in, seek out the owner of the property in advance and get permission to photograph on the property. This need for permission, incidentally, includes the national and state parks. All real estate is owned by some person, corporation or other entity.

You don't want to encounter a situation where you have made extensive preparations to shoot, have arrived at the site, spent time setting up all of your gear and preparing the subject, only to learn that you are trespassing and are forced to quit forthwith. Not only does this waste time but it may cause you some embarrassment with your subject, who may not be willing to move on to another location for fear of encountering a similar situation.

Weather Conditions

Many ardent photographers are accustomed to going to great lengths to capture an image. We are no exception. More than once we have braved a storm, photographed in the rain, hung from a tree, perched precariously off the side of a hill, and so on, all in quest of the illusive "great photo." This course of action is all well and good when the subject is an inanimate object or scene. We might even expect the same type of commitment when we work with experienced, professional models who are being paid to help us accomplish a certain photograph. However, when working with inexperienced non-professional subjects, especially in figure photography, one needs to be a little more considerate and lenient.

Subject's Well-Being—When you are doing a professional photo session for a commercial account with experienced, trained models, it is normally expected that either you or the company that has hired you will make available one or more special attendants for the benefit of the models. These assistants usually have one major function—to attend to the needs of the models.

When you are doing nude photos for your own pleasure or portfolio, you alone must be responsible for the comfort and safety of your subjects. It is highly advisable to have a personal assistant with you, not only for legal reasons, but also as a general helper. We enjoy the ideal situation, being a husband-and-wife team. If you're a male photographer and your chosen subject is not from your personal, intimate circle, we strongly suggest that you take along a female helper and companion.

Be considerate of your models' physical well-being and safety also. Do not permit them to become overly exposed to heat, cold, dampness, high wind and insects or other undesirable creatures. Apart from all other considerations, any discomfort caused in such ways would reveal itself adversely in your photo results.

In order to ensure the comfort of a subject when on location, take along a supply of creature-comfort items such as rain gear, a robe, blankets, an umbrella, towels, hot or cold beverages and snacks. During the course of actual photography, have your assistant constantly attend to the needs of your subject. You always want your subject warm, dry and comfortable—at least between shots. You also want to assure her that you are at all times concerned for her welfare and safety.

You'll find it very beneficial if you can take a van, rather than a car, on location. If there is no other spot on site suitable for your subject to retire to, a van is a great private place for her to prepare for the photo session, to disrobe and get dressed again, to freshen up during the course of the day's shoot and to rest and relax between shots.

Illumination—When doing photography outdoors, one of the things you'll have little control over is the natural lighting. The prevailing weather will play a big part in the type of lighting that you will be facing. You can get good images by either exploiting the prevailing conditions or waiting for better weather and more suitable illumination. In Chapter 8 we will deal more extensively with lighting.

In our area, in Southern Florida, it could be raining heavily one minute and bright and sunny the next. Accordingly, when we shoot we have to prepare for a number of different lighting conditions and rapid lighting changes. Both we and our subjects must be easily and rapidly adaptable, so that we can quickly change between different types of photos and atmospheres and moods, depending upon the lighting that the weather affords us at any particular moment.

If we went on site with just one photo concept in mind and the weather changed on us

while we're shooting, we would be out of luck. We find it highly advisable to prepare for several different photo concepts, such as one that would be appropriate in a rainy atmosphere, one for a gray-sky day and one for a sunny day. This way, no matter what the weather does to the lighting condition, we can continue our photo session with little to no loss or delay.

Shooting on location can prove to be a real test of a photographer's technical knowledge. On top of the changing technical considerations—weather, lighting, and so forth—nude location photography presents the special problems of public nudity. Therefore, the nude photographer must be adaptable and flexible while shooting on location, and work quickly. Although location photography can be challenging, excellent results can be achieved.

Now, let's move on to the part photographers enjoy most—the shooting session.

5 THE SHOOTING SESSION

Consistently good and seriously executed figure photography requires a great deal of preparation. Much time, thought and planning should be given to each shot that is to be taken. Such preparation involves not only the photographer's and the subject's mental attitude and artistic aspirations, but also the equipment, the props to be used, and the location itself.

Don't for one moment think that you can grab just any subject, a camera, a few rolls of film, drive to just any area and, within a few minutes of your arrival, produce high-quality figure photographs. You may get a lucky shot or two, but don't expect much more with this kind of approach.

PREPARATION FOR A SHOOT

Although many aspects of your preparatory steps will be discussed in depth in later chapters, it's important to talk about them briefly at this juncture.

The Location

Do not wait until the last moment to ready the shooting area for photography. Non-professional subjects, who may already be nervous, often become even more anxious if they are required to wait for long periods while you prepare a location for photography. Before you consider a location for photography, be sure that it is suitable, both from a physical as well as a purely photographic standpoint. This precaution is necessary, even if your intended shooting area is right in your studio or home.

One of the permanent sets we built in our studio is a shower, with real hot-water capability. When it was first tested, we found ourselves faced with a series of problems. We got no hot water from the shower head; the shower head and floor leaked in several places, flooding a portion of our studio; certain lighting setups that we initially thought could be used, could not be employed because they produced "hot spots" or unwanted reflections on the tile, and so on.

Although the shower set was initially completed and ready for use late one Friday evening, it actually took us about two weeks of additional time, ironing out all of the problems, before the set was finally ready to be used for a serious photo session.

Had we used this new set without first testing it fully, it would have led to interrupted sessions, disgruntled subjects, as well as some disastrous photo results.

When you shoot out on location, you obviously have much less control and predictability than in a studio atmosphere. So it is especially important to make preparations before actually starting serious photography.

We recently did a session at a nearby tourist attraction—a Spanish monastery. We had photographed in that area on prior occasions and knew the best time of day for optimum lighting and the best day of the week for the best chance of privacy. Based on our prior experience, we were also aware of certain unwanted conditions at the site; conditions that had to be corrected prior to the arrival of our subject. For example, ""No Smoking" signs and cigarette-butt containers had to be moved, floors had to be swept and tree branches had to be tied back.

Had we waited until our subject was actually on the site before taking care of all of these details, her patience would certainly have been tried, her mood may have changed, her makeup would not have looked fresh, and so on. All of these things would surely have had an adverse effect on our photographic results.

In the final analysis, and regardless of where a photo session is to take place, check the setting out and prepare the location as much as possible, well in advance of the arrival of your subject.

Admittedly, there will always be last minute-details that must be taken care of and that cannot be dealt with in advance. However, try to start each shoot with conditions that can pretty well ensure that you will be able to direct most of your energies

and attention to being creative and producing technically as well as esthetically fine photographs.

Equipment and Props

Just as your location must be absolutely ready before you start to shoot, so also must your equipment be fully checked and prepared. You should know with reasonable certainty which cameras, lenses, meters, filters and lights are to be used, and you must make sure that all such equipment is complete, clean and functioning properly.

Pack or lay out your equipment so that you know exactly where to find each item. An actual photo session—whether on location, in a studio or a home—is not the time or place to start groping through camera bags, looking for a much-needed filter, lens or accessory. Everything should be at your fingertips, so that delays are held to a minimum.

Unless everyone is aware that a session is to be purely experimental, an actual shoot is not the right occasion for testing equipment or lighting or for using new items with which you are unfamiliar. You must know which items of equipment are compatible for use with each other and the results each item will achieve.

Of course, you must also know your basic photographic technique. If a session may call for some special technique or approach, with which you are not familiar and comfortable, brush up on it well beforehand. Make some practical tests, if possible. An actual photo session is no time to worry about the principles of reciprocity failure or the inverse-square law. It is no time to start debating whether to use an incident-light or a reflected-light meter. These things must happen almost automatically, so that you can concentrate on more important matters that are applicable to the shoot.

Backup Equipment—Most photographers have good reason to believe in "Murphy's law." If something can go wrong, it will—and it will usually happen during an actual photo session. To guard against this, try to always have backup equipment that will enable you to complete your photography, even if your primary equipment failed. This usually means having at least two cameras, spare lights, extra batteries, additional sync cords and power cables, and so on, as well as a good selection of props.

If you have constructed an entire photo session around a simple, single prop, such as a feather boa, and before or during the shooting it was lost, soiled or damaged, the session would have to be abandoned. Be prepared with alternative props and picture concepts.

Two simple words always remind us of the importance of preparation. The words are "What If?" What if, during a shoot, some of our equipment breaks or doesn't work? Do we have backups? What if the place is dirty? Do we have cleaning materials with us? What if the lighting is too blue? Do we have colored gels or filters, to correct the lighting? Admittedly, one could go on forever with speculations and worries such as these, but it is important to be as prepared as is possible, to ensure that you can get the job done with the least amount of time and trouble. Think things through thoroughly and leave little to chance.

Make a Checklist—Especially when you are intending to shoot on location, and until equipment and prop needs become second nature to you, it's a good idea to prepare a checklist of all of the equipment and props you will need. Much of this list will be applicable to most of your shoots. By referring to it, you need not worry about equipment every single time you prepare to go to a shooting location. Simply check off your list of requirements.

Prepare an Outline

It is critical that you have at least a general idea of what you want to achieve and how you want to do it, well in advance of any sitting. You can prepare a written outline or a mental one. This does not mean to say that you cannot deviate from your plan. You can, and often you should. But the outline serves as a general plan to your intended sequence of events while you're behind the camera. The outline is like the notes used by a speaker. An experienced speaker will use notes as a guide and reminder but will also feel free to deviate from them at will.

You should have some definite ideas, at least in general terms, about poses, settings, props, accessories and lighting setups before the subject appears before your camera. During the photo session, you don't want to indicate to the subject—either overtly or indirectly through your obvious indecisiveness—that you are not sure exactly what it is that you want to do. This impression could seriously affect your credibility and the outcome of the session.

Prepare a Pose List—When using an elaborate and versatile setting, such as we often use in our boudoir photography, if a pose doesn't look right in one location of the set, it's a simple matter to move the subject to another area and try the same pose there. In figure photography, such elaborate sets are less common and the luxury of relocation is generally not as readily available.

Let us assume that you intend to have your subject adopt a pose with only a plain chair and table for props. Or, you might want to photograph the subject on location, lying on a bare, sandy beach. If one pose that you had mentally preconceived for the subject doesn't work, either because the subject cannot assume the pose or it just does not look correct, you had better have other poses to draw upon, or you're stuck and the session is over.

To avoid this situation, you should have at least six alternative poses, suitable for the setting or location, at your fingertips. Not all of your poses will work well for any one given subject; some poses will be better than others; some will be excellent and others useless.

The pose should determine the lighting and not vice versa. Also, unless you're deliberately trying to create a photographic paradox, the pose should be appropriate for the mood you had intended and be consistent with the setting or scene. For example, if you created an elaborate 19th-century setting indoors, it would often be inappropriate to have the subject illuminated by complex contemporary standards. Lighting that would simulate a simple and soft "north" light might be most fitting.

In the portfolio section of this book, you'll see lots of different poses. Study them carefully and then think of other poses, ones that you don't see there but that you would like to record on film. Make a list, or a series of sketches, of your repertoire of potential poses for figure photography.

ESTHETIC CONSIDERATIONS

Have you ever happened upon a beautiful spot which you thought would lend itself well for scenic photography and, in a matter of moments, grabbed a camera and taken a dozen or more quick shots? If you have, you might have been disappointed when you viewed the results. Why? Probably because you had not prepared adequately for a really successful shoot. Of course, we have all seen photos that were taken "on the run," involving little or no preparation, that were, nonetheless, outstanding. However, luck plays a very small part in the consistent creation of excellent images. It's good, solid preparation that leads to consistently good images. And preparation does not only involve equipment, props and location. As the previous section indicated, it involves poses. It also involves other esthetic considerations.

Some time ago, we studied with a successful New York still-life and product photographer. While we were with him, he had an assignment to photograph three rather bland and innocuous looking cans for a national company. He spent almost two full days preparing for the shot. During this time, he changed cameras, lenses, angles, lighting setups, exposure, and so on, until he had the combination that produced the image he had preconceived in his mind's eye.

We know that you won't be spending two or three days preparing a model for a nude shot. But you can easily spend many profitable hours thinking about how you are going to photograph a subject, well before she ever arrives for the session, or in preparing a setting for a model to be photographed in.

The Best Time for a Location Shoot

When doing location photography, the time you select to take photos is often critical. Don't assume that you know what the best time of day will be—it can vary from location to location. Visit the area well in advance of the planned photo session and view for yourself the conditions of the light at the time of day you have in mind.

One of our early mentors—an excellent scenic photographer—told us that he often spent several days scouting an area and studying the light. He would watch the light as it changed and played upon the various elements in the scene before he would take a single photo. Even then, of the dozen or more shots that he took, only a handful would actually represent the scene as he had pre-visualized it. To him, spending many hours per day, for several days, just to study the light, was normal and necessary.

In this respect, doing nude studies on location is no different. You must select the time of day that will best serve the types of photographs you are planning to shoot. You may need a hard, contrasty overhead light, found on a cloudless afternoon, or the soft, gentle light that is more typical of evening. Often the best time is when the sun is low in the sky, early in the morning or late in the afternoon. But be careful: the sun's movement changes with the seasons, so that the time of year may be a factor, too.

Recently, we did a location shoot at sunrise at a nearby beach. It had been about seven weeks since we were last at that location. The last time we photographed there, we used some large boulders located near the water's edge as props. At that time, the sun rose directly behind the rocks and this effect helped to produce stunning photos. However, this time the sun was rising substantially to the north of the rocks, almost out of our intended photo scene. This gave us images that were very different from

the ones we had taken previously. It was not an accident; we were aware of the light changes and had planned to shoot accordingly.

Outdoors, you cannot move the natural light source about; you must adapt to it. To adapt, you must be familiar with the nature of the movement of the sun through the sky. It's one thing to read about lighting conditions in a book and quite another to experience them. You must know for yourself what the conditions will be in your chosen area, how long the type of lighting you seek will last, and what affect it will have on your subject, the concept and the results.

We should note that we have only considered the direction of the light here. An equally important consideration involves the quality of the light, as affected by weather conditions.

The Value of Experimentation

Just as a dress rehearsal is essential to ensure the best esthetic and artistic quality of a stage production, so are practice and experimentation sessions vital to ensure good esthetic figure photography. When the time for a real shoot arrives, knowing what to do, how to do it, and with which tools, should be second nature for you.

If a session is to be an experimental one, the subject should be informed of it. Don't conduct experiments during the course of a serious photography session. This could cause delays and problems. A subject may have worked very hard for you, only to discover, to her disappointment, that you were merely practicing and that the photo results are less than good. She may never pose for you again!

We are not suggesting that you should avoid trying new and different things during the course of serious photography. You should! Just don't do it excessively or without warning the subject.

There is another way to practice, besides going through the mechanical steps of actually taking photographs, and it's one that we favor as being very helpful. It involves mental practice. An example should help point out its value. If people actually practice a specific physical task, their proficiency improves. If they don't practice, their proficiency level decreases. It's logical. A university conducted a test in which a control group was directed, not to perform a task, but simply to think about performing all the steps in the same task that was being actually performed by another group. The results were very revealing.

After several practice "thinking" sessions, the control group actually performed the physical task. The results showed that this group closely approached the level of proficiency of the first group, who had actually practiced the real task.

With all of the practical and mechanical aspects of photography prepared for, you can spend many useful hours thinking about how and where you are going to photograph the subject, the tools you are going to use, how you are going to use them, the poses, the lighting to be used, and so on. This mental exercise is good for making a session go faster and more smoothly, and to ensure dynamic images.

DIRECTING THE SUBJECT

It is essential to establish and maintain a good rapport between the photographer and the model and to ensure the model's total trust in the ability, motivation and intentions of the photographer. The model-photographer relationship is, quite naturally, generally at its most delicate and fragile at the beginning of the partnership. The methods that follow are intended to ensure a good rapport from the start.

If we have not worked with a subject before, we try to start with a scenario that allows the use of a long lens, enabling us to keep the camera at a relatively long distance from the subject. Neither the camera nor I will then be intimidating to the subject. This keeps the subject from feeling that her space is being invaded.

Avoid Physical Contact

I almost never have any physical contact with a subject during the course of a shooting session. If Sheila and I think that a pose should be changed, a prop or drape moved, or a light that is located close to the subject altered, Sheila or a female assistant will do the job, not I.

When I need to come close to a subject, I make certain that the subject is informed of what I am going to do before I ever make a motion toward her. Such conduct makes the subject feel comfortable and secure, as well as appreciative of your consideration.

On the rare occasion when I need to personally make a fine adjustment in a pose, to slightly move a hand or arm, a foot or leg, or to adjust the tilt of the head, I not only announce my intentions beforehand, but also make certain to use only just a fingertip to make the correction. I make a habit of using the little finger of one hand to make such fine adjustments. I have found that this is generally totally acceptable to the subject and not in the least intimidating.

Duration of Photo Session

Just how much time it will take to complete a figure-study session will depend on several factors, including your experience, the nature and complexity of the images you're trying to create, and the ability of the subject to follow directions. Sometimes you may spend just an hour or so photographing a subject; at other times you may be at it for a full day. If you are well prepared, you should have some basic idea how long the subject will need to be involved. However, whatever amount of time it takes, don't rush it, or your results are bound to suffer.

Try to inform each subject in advance regarding the amount of time the shoot is likely to take. She will then set that time aside for you and you'll avoid the possibility of her pressing you to rush or even abandon the session at some point.

Some months ago, we decided to do a nude study in which a subject's body was to be entirely covered with a material that made her resemble a statue. We knew that it was going to be an involved shoot which would last about five or six hours—two to three hours to apply the body paint and another two or three hours to conduct the photo session.

We made all of the necessary preparations in advance, got all of the makeup ingredients we needed, had the concept all planned out, chose our subject carefully, but forgot one small detail: we didn't inform the subject exactly for how long we would need her.

On the day of the photo session, while the subject was having the makeup applied, she casually asked whether we had any idea how long all of this was going to take. She had to be somewhere else in about two hours! As a result, the entire session had to be abandoned and rescheduled.

If you notice that a subject is getting tired, or if she informs you so, don't continue shooting. It would be unfair and inconsiderate. It would also be inexpedient because you would be unlikely to achieve good results under such conditions. Fatigue may set in sooner or later, depending on the difficulty of the poses, the natural comfort level at the shooting location—heat, cold, wind, dampness, presence of insects, and so on—or merely on how the subject happens to be feeling on that particular day.

Discuss Creative Goals

Before any photo session begins, it is important to sit with your intended subject and explain the results you are seeking and how you intend to achieve them. After all, the model is going to be the vital, central part of the final image. She should be informed fully of what is expected of her and the role she is to play.

Even though your subject may know nothing about photography, she may well offer a suggestion or two that might spark an idea that turns a satisfactory shoot into an outstanding one. Before you actually photograph a subject, discuss the poses you have in mind, at least in a general way. Inform her why you are choosing certain poses and what result you hope that each pose will yield.

Once the session starts, demonstrate each pose to your subject. If you have illustrations available that show similar poses, show them to the subject. Such visual aids can often be very helpful. Advance discussions and demonstrations of this kind can go far in expediting a session and helping you to achieve your intended end result—artistic figure images.

Work as a Team

We strongly believe that consistently excellent photographic results cannot come about unless you can truly relate to and communicate with your subjects. This is true whether your particular interest lies in portraiture, glamour, boudoir or figure photography. Establishing a genuine rapport is an essential part of your preparatory work.

Before you even get near your camera, spend some quality time with each of your subjects and attempt to learn why they want to engage in this form of photography, which features they think are their best ones, whether they have specific poses or shots in mind, if there are certain body parts that they want concealed, and so on. Generally, this need take no longer than about 30 minutes—just long enough for you to get to know each subject as a person. Your objective should be to gain some insight into each subject's personality before an actual shoot ever comes about.

This is also an excellent opportunity to have your subjects learn a little more about you, your work, and who will be helping you during the shoot. You can provide an idea about the types of photos you wish to create, a little information on how you intend to take the shots, what, in general, is going to be involved, how much time will be spent on the actual session, and how you plan to solve certain specific problems that either you or your subject might think exist.

During these introductory sessions, try to avoid mere chitchat. You should both learn as much about each other as you can, so that when the ses-

sion begins, you won't still be strangers who have to waste valuable shooting time just getting to know each other.

No matter how many people you may have assisting you during a photo session, in the final analysis there are just two key people: you, the photographer, and your subject. The best photographic results will come about only when you and the subject relate to each other, have a common understanding and share a common goal. You must work as a team!

To varying degrees, we are all apprehensive of the unknown. The inexperienced, non-professional subject for nude photography will certainly be no exception. To minimize any fear or uncertainty, keep your subject informed as to what you are doing and going to do throughout the entire photo session. Let her "in" on the entire chain of events.

Be Courteous and Tactful

Courtesy, respect, consideration and tact are perhaps more important in the sensitive area of figure photography than in any other photographic endeavor.

At no time, from the moment of your initial contact with the subject to the conclusion of the actual photo session, should you or your assistants make any remarks or gestures regarding a subject's body or physical attributes that could in any way be misconstrued or taken as a slur, an off-color remark or a "come-on." Figure photography is a sensitive field, demanding the utmost in respect for the people who make it possible—the beautiful women who are prepared to appear before your camera. All "cute" remarks should be avoided.

Even if a subject herself is somewhat liberal in remarks about her own body, you should avoid following suit. Otherwise, your verbal conduct will come back to haunt you, causing damage, not only to your relationship with one subject, but even your reputation.

Work Quickly

Once you're on the set, endeavor to work fast and efficiently. Professional models may be accustomed to working for many hours in front of a camera, but their time is expensive. Non-professional models are likely to get tired after one or two hours of posing. They may not openly express it, but the rigors of posing will begin to show in their faces and in their inability to assume the more demanding poses easily or quickly.

Once a well planned photo session gets under way, the pace will usually build quite automatical-

ly. With each ensuing pose and shot, a subject will relax more and more. She'll begin to respond better to your direction and the session will begin to flow at a nice, steady pace. Try to maintain a good, flowing pace throughout the entire shoot. Keep moments of inactivity and of indecision to a minimum.

For a nude subject, even short periods of lag time—the time it takes to change such things as lighting, camera viewpoint, props or scenarios—can seem like eternities. Such waiting periods could cause a subject to lose the feel of the momentum that you both have worked so hard to obtain. To keep lag time to a minimum, it is helpful to use one or more assistants, at least one of whom should be female.

THE PSYCHOLOGY OF NUDE MODELING

Even when a subject has agreed to be photographed in the nude, she will not necessarily be emotionally and psychologically prepared for an actual figure-photography session. Even the most willing non-professional model will not find it easy to be photographed without clothing, especially in front of total strangers. A model might even begin to have doubts about her decision to do this.

Unlike a boudoir sitting, where it is relatively easy to build gradually from less revealing to more revealing shots, a nude photo session is more demanding on the subject from the very outset.

How can we overcome this problem? It helps to assure the subject anew that what she is about to do will be fun and a pleasant, rewarding, as well as challenging experience.

Handling such last-minute pangs of indecision "comes with the territory." You must be sensitive and observant because a subject may not voice her fears and doubts but show them more subtly in her general attitude. If you can spot these anxieties the moment they surface, you can deal with them quickly, before the indecisiveness gets out of hand. This will save you time if not, in fact, the entire photo session.

Subject's Attitude

Unless you can get a subject to be totally at ease with you, your camera and the surroundings where the shoot is taking place, and display a very positive attitude toward it all, the resulting images are bound to suffer.

Many of the non-professional models we have worked with perceive their figures as looking great in an evening gown, sports clothes, nightwear, and even a bathing suit, but few consider

themselves perfect in the nude. Many are sensitive about revealing what they conceive as "problem" areas of their bodies—thighs that are too heavy, buttocks that are less than firm, a saggy bust line, and so on.

In boudoir photography, problem areas can often be concealed by the selection of an appropriate costume or careful placement of material over the area. With the totally nude figure, you don't have this type of control. Nonetheless, you must still reassure the subject that you will not make obvious body imperfections visible but, on the contrary, that you will conceal and minimize them to the best of your ability.

From the time a subject first agrees to pose for you, up to the conclusion of the shooting session, you must constantly but honestly flatter her and bolster her ego. You should frequently reassure her that she is an excellent candidate for this form of photography, that she has an ideal figure for the type of shots that you wish to execute, that she is following instructions well, that she is quick to pick up and execute the poses you have directed her into, and that she looks quite beautiful.

If you have selected her well and wisely, this will all be true. Never flatter dishonestly. The truth will ultimately be revealed, in the final images, and your credibility and reputation could suffer.

Once the first shoot has been successfully concluded, the best possible way to enhance your model's confidence in her appearance and ability is to show her the photographic results. If you are both pleased, there will be no harm in making minor criticisms, to ensure that the next shoot is even more successful. Be sure to make any critique session a two-way affair; allow her to present her views, suggestions and feelings, too, and listen to them.

Further Useful Tips

The following tips, although minor, should go a long way in helping you toward getting the best from your subjects.

Be sure the subject has a robe to wear between shots. Before the shoot, introduce her to the assistants you intend to use during the session. Inform her of your rule barring anyone from entering the shooting area once you start photographing.

Have refreshments and beverages available, and background music playing, during the session. Start out with simple, more guarded poses and work up to more difficult and revealing ones. Make all your photo sessions fun; let the atmosphere be light and pleasant.

As indicated earlier, whatever you do, never lie to a subject. You will gain nothing by telling her she is great and that things are going well, when in fact she isn't and things aren't. When she sees inferior photographic results, she will feel cheated and have good reason to question your credibility, if not even your ability.

MAKEUP, HAIRSTYLE, PROPS AND ACCESSORIES 6

Obviously, the primary ingredients for good figure photography are a well chosen subject, appropriate poses, good and effective lighting, and competently executed photography. However, there are secondary ingredients, which are also important for achieving excellent end results.

These secondary ingredients usually serve to enhance or modify a subject's appearance, a mood, the composition, the interpretation or the theme. They include makeup, hairstyling, props and accessories.

While the primary ingredients are absolutely essential, the secondary ones need not all be used all of the time. You can use any or all of them, in any combination, all depending on the end result you're trying to achieve.

Facial Makeup and Hairstyling

There will be times when you'll intentionally conceal all or part of a subject's face from the camera's view by placing it in deep shadow, by careful posing, or even by selective cropping.

Even if a subject's face is not going to be visible in the photographs, it is usually good for the subject's morale and self-confidence to have her makeup done and her hair properly styled prior to beginning any serious photo session. Women tend to wear makeup and hairstyles as badges of courage, moving and acting more confidently as a result. If, in their own opinion, they don't look good, they will not feel pretty, much less sensuous and erotic. Their movements—their body language—will often mirror this negative feeling and this can have an adverse affect on your photography.

We feel very strongly on this topic. If a subject arrived with inappropriate or poor makeup or hairstyling which could not be corrected at the shooting location, we would suggest canceling the session and rescheduling it for another time. Continuing under such adverse circumstances would usually result in wasted time, effort, materials and a disenchanted subject and would necessitate a reshoot anyway.

Involve a Professional—Most women can do their own makeup and style their own hair for normal, everyday life. However, few know how either one should be properly done for best photographic results. This is why we encourage all of our subjects to have their makeup and hairstyling done by professionals, immediately before the photo session.

A word of caution is in order here. Simply because a person is a professional is no guarantee that he or she is competent at makeup or hairstyling specifically for photographic purposes. Be sure to see some examples of the chosen experts' work to determine their suitability for working in the context of your photography and its special requirements.

If you do not have advance knowledge of how the subject's makeup or hairstyling is going to look photographically and your photo results are deficient as a result, the subject may fault you and hold you responsible. At the very least, this will result in a dissatisfied subject. You may even be asked to reimburse the subject for the charges of the makeup artist or hairstylist.

Working in the Studio—We prefer to have a makeup artist and hairstylist come to our studio to do their jobs. That way we can monitor the results. If necessary, we can ask for on-the-spot changes, to suit our taste and in keeping with our photographic concept.

In our studio, we also have some control over the pace at which the artist works. He or she is informed in advance that we need to have our subject readied within a certain allotted time. We usually allow 30 to 60 minutes for makeup and hairstyling. If the subject has her hair styled and makeup done elsewhere, we have no control over the time factor. This could lead to a subject arriving very late for a photo session or to a less than acceptable makeup application and hairstyle.

When a subject is having her makeup and hairstyle done elsewhere, we schedule about 20 extra minutes for the photo session, to enable someone on

hand to make any necessary minor makeup and hairstyle corrections when the subject arrives.

Makeup & Hairstyle Should Be Appropriate—
An otherwise stunning nude study could be ruined if the subject were depicted with inappropriate makeup or hairstyle.

For example, if you wanted a look suggestive of Cleopatra or even of the 1920s, it would be inappropriate for the subject to be styled in a contemporary manner. In your communications with the makeup artist and hair stylist, be as explicit as possible about exactly what you are trying to achieve photographically. Draw a picture or cut out photos from magazines to illustrate your needs.

Make Some Tests—Prior to engaging in any serious photographic session, especially if you have to hire a subject for a substantial fee, be sure to shoot some test rolls of film. Test a subject wearing different brands, types and amounts of makeup. It's important to realize that not all makeup types and brands are suitable for photography and that color film does not respond to all of them in the way the human eye sees them.

We have learned that there can be a big difference in the types of makeup typically sold in drug or department stores and the types that are available from special beauty supply houses. The supply houses often carry the special types of makeup that are primarily designed for television, stage and photographic purposes. These are the ones we prefer to use. A good makeup artist should be conversant with the different makeup types and should be experienced in properly applying makeup for photography.

Even though you may be using the correct type of makeup, it may well respond differently with different film types as well as different illumination. One makeup will look better under tungsten lighting; another will respond better with electronic flash. Some makeup will look best on black-and-white film, and so on.

The purpose of the photograph must also be taken into consideration. For example, if you want a figure study to portray the essence of innocence, it would generally be totally inappropriate to have the makeup overstated. It could confuse a viewer, causing him to question the meaning of the image. To portray innocence, it is usually best to keep the makeup very subtle; to have just enough to add some color to the subject's face and make sure that any facial flaws are concealed.

Only through experimentation will you learn what types and quantities of makeup will work best in a given situation.

Obviously, whenever experimentation is involved, it pays to be consistent once success has been achieved. When you know precisely what makeup works best, on which film type, in what amount, and applied in which manner, make a note of these facts and data and stick with the tested and proven combination unless there is a good creative reason to do otherwise.

BODY MAKEUP

In normal portraiture, makeup is only necessary for the face, and perhaps the neck, arms and hands. In figure photography, where the entire body is exposed, makeup may be necessary or desirable over a much larger area.

Body makeup can be either cosmetic, to cover blemishes, enhance the skin tone, and the like, or it can be creative, to produce designs and patterns and other painterly effects.

A word of caution: Never apply body makeup or body paint to a subject's entire body, or to a large area of the skin, without seeking the advice of a professional who is trained and experienced in this form of makeup. Some makeup substances may not allow the skin to "breathe" sufficiently and, if an entire body is covered, this could cause serious illness or even suffocation.

Before you use any body makeup, we suggest that you consult various theatrical supply houses for their advice and also contact the manufacturer of each brand you intend to use.

On a practical note, try to use makeup or paint brands that are water soluble. This will expedite cleaning up when the photography has been completed. It also makes it easier to do on-the-spot corrections as the makeup is being applied or if the makeup starts to look less than fresh during a long photo session.

In our experience, it usually takes approximately 60 minutes to do one side of a subject's entire body with simple body makeup; longer, if some sort of elaborate design is to be fashioned. Allow yourself plenty of time, so the body-makeup application need not be rushed.

If only small sections of a subject's body are to be covered with makeup, or only small designs are to be applied, having an artist perform the task by hand is usually acceptable. For more extensive body coverings and body design work, airbrushing water-soluble makeup onto the subject is faster and usually leads to a better, smoother looking result.

Other Body Treatments—In addition to regular body makeup and paint, the application of baby oil and water can be very effective and attractive.

Apply regular baby oil to the subject's skin and then use a spray bottle to spray warm water on the subject. This creates a wet look that can lead to very dynamic figure photographs.

Another body treatment that can be effective—although we don't particularly favor it—is the application of non-toxic, water soluble, ceramic clay. Once the clay has been applied to the subject, the body will take on the semblance of a statue. The initial effect can be great. However, it is not an easy substance to work with. It takes about two to three hours to apply, is very messy and leaves a residue—a very fine powder—on everything within the immediate area.

Applying body enhancements is not a do-it-yourself job. It is generally impossible for a subject to apply body makeup or paint to her own body with any measure of success. Ideally, a female subject should have the job done by a professional of her own sex. If your own female assistant can do a competent job, that's fine, too.

Body makeup can change a subject's whole attitude. Once a subject has had body makeup applied to her entire body, you'll often notice an interesting change in her. She seems to feel much more "dressed," even though she is still totally nude. The body covering seems to provide some feeling of security. For this reason, many initially timid subjects will feel quite at ease in a nude session from its very beginning when some kind of covering has been applied to the skin. Take advantage of this condition. It can often lead to some dynamic photographic results very early in a photo session.

Props

If you intend to use props or accessories for a nude photo concept, it is important to choose and use them prudently. Don't use props that are likely to overpower the major point of interest—the subject's body. However, as in all artistic endeavors, this is a rule that may sometimes need to be broken. There may be times when you'll intentionally use a prop that is very prominent.

For example, take the popular photo theme of the nude who is posed lying on a barren floor with a large boa coiled about her body. Which of these two would be the subject matter and which the prop? For the image to really work, these two would generally need to have pretty equal weighting or emphasis.

A prop might also be so closely involved with the subject that one would not even think of it as being a prop. For example, if you photograph a nude under a cascading fountain, you're very legitimately using the fountain as a prop, but a viewer of the image would hardly regard the cascading water as anything but a major part of the setting.

Don't be tempted to use props just for the sake of using them. A low-key or high-key setting, in front of plain background paper, with just the nude figure displayed, would often be quite sufficient. A prop might easily distract from the directness and simplicity of such a scene.

As indicated earlier, props can sometimes represent the actual setting itself. For example, a vase of flowers would be a prop but having a subject reclining on a bed of flowers would change the whole concept. The flowers would, in fact, become the setting.

Propping is an Art—Selecting appropriate props and knowing where and how to use them is an art in itself. Effective propping can give a setting or subject a complete or finished look while poorly handled propping can ruin an entire photo concept.

Propping is so important, in fact, that many professional photographers turn this responsibility over to an expert stylist, who will choose, locate and apply appropriate props to the setting. In consultation with the photographer and any other creative person involved in the project, the stylist will stage the entire scene. If you can't afford or don't really need this professional help, you must become proficient in selecting props and styling a setting.

Use props with respect and restraint; they can be a very powerful influence, for better as well as for worse. Make your visual statement decisively. Avoid overstatement, understatement and misstatement.

You can often gain valuable insight into the propping and styling of settings by looking at advertising photos in national magazines. Learn to see, especially, how props are used effectively with people in photographs.

Other valuable sources of inspiration are window displays, which can give you a good insight on how effective propping can enhance a setting.

Where to Find Props—Some of the best sources for props that we have found are flea markets, "junk" stores and second-hand furniture shops. Whether you are looking for pieces of material, certain types of clothing, decorative household items or furniture, rummaging through stores of this type can serve two purposes. As well as giving you ready access to the various and sundry props that you might need, usually at very reasonable prices, it can also give you some great, creative ideas.

Accessories

Here we're not talking about photographic and camera accessories, such as filters, tripods, lens shields, and so on, but accessories that can be used and worn by a subject for a photo shoot. These "personal" accessories should generally enhance the subject's femininity. They could take the form of a strand of pearls, earrings, gloves, a hat or a scarf. Accessories are frequently used to add a touch of color, balance, class and femininity to the subject.

Like props, accessories should be consistent with the theme, setting or mood you are intending to create. And they shouldn't be so large or prominent as to dominate the subject and distract viewer attention from the main point of interest—the subject's body.

Once the basic theme and setting have been established, step back and "see" the scene in your mind's eye. If it seems to be lacking something, think of props or accessories that might be able to fill the void. However, nothing should be added without a specific purpose and design in mind, and then only with the intention of making the primary subject matter—the subject herself—stronger in representation. If a prop or accessory doesn't add something very specific to an image, don't use it. If it doesn't do any good, it will almost certainly do some harm to the basic visual concept you're trying to convey.

EQUIPMENT 7

Simply having a large quantity of sophisticated photo equipment is no guarantee that great photographs will result. Good photos are made by people, not by camera equipment alone. If you're just entering the field of figure photography, don't rush out and buy a lot of equipment. Begin with limited, good and reliable equipment that is easy to work with. As your knowledge, proficiency and needs increase, you can purchase the appropriate equipment necessary to meet that growth.

As a matter of fact, early on during your venture into figure photography, getting involved with too much photographic equipment could hinder your creativity. You could be so occupied with thoughts of lens changes, filters, flash units or trying to figure out how various pieces of equipment work, that you would fail to devote the needed time and thought to your subject and to the creation of artful photos. If you're a beginner, learn to work effectively and efficiently with a few basic items first. Then add new items as you realize their need.

If you're already an experienced, fully equipped photographer in some other field, you probably know all you need to know about equipment and we won't be able to help you very much. So we invite you to read, skim or skip this chapter, as you see fit.

Any photographer—beginner or expert—can produce stunning nude images with nothing more than a 35mm cameras with a 50mm lens, natural window light and one white cardboard reflector. However, we don't suggest that you start with such very basic "basics."

At the least, we think that you should have a good camera, at least two high-quality lenses of different focal lengths, a sturdy tripod, a soft-focus filter, a warming filter, a reflector and a good handheld exposure meter for making reflected-light and incident-light readings. Such equipment will allow you to create good natural-light images.

We shall discuss lighting equipment and its use in the next chapter.

General Guidelines

Here are some general guidelines that we have followed and which may be of help to you.

Buy the Best—You get what you pay for, so buy the best you can afford. Cheap equipment is often unreliable and will not withstand the rigors of constant use. It is also often difficult and surprisingly expensive to have it repaired or serviced.

Buy Easy-to-Use Equipment—Avoid equipment that is unnecessarily heavy, bulky and awkward, and that is hard to work with.

Growth Potential—Seek out equipment that will afford the possibility of growth; that will allow you to expand the use of the item bought rather than eventually making the initial purchase obsolete.

Don't Copy Others—Don't buy equipment just because another photographer, whose work and style you admire, owns the same type. His success is due to his skill and artistry, not his hardware. Equipment selection is a very personal matter. What suits others—even experts and celebrities—won't necessarily suit you!

Camera Format

Figure photography is possible with most camera formats, from 35mm to the large view-camera sizes. Each format offers certain advantages and limitations. The majority of our nude studies are shot with the 2-1/4-inch-square format. Some are done with 35mm camera equipment. Rarely do we shoot such images with a view camera.

Advantages of 35mm—With the advancements made in recent years in the resolution capabilities of both lenses and films, 35mm single-lens-reflex cameras (SLRs) can produce high-quality images, capable of considerable enlargement. These cameras are lightweight, portable and fast and easy to work with. Most incorporate excellent

viewing and focusing features as well as lens interchangeability.

Because of their small size, 35mm SLRs are unobtrusive and present little or no intimidation to non-professional models. A view camera on a tripod, by comparison, can inhibit the inexperienced figure model. The 35mm camera can be used handheld, enabling you to work quickly from many angles, and often in tight quarters, such as you may encounter when working in a subject's home.

The 35mm format is also economical where film cost is concerned. This gives you the freedom to shoot more liberally.

Disadvantages of 35mm—Notwithstanding all of the positive features of the 35mm format, there are some disadvantages that cause us to favor the 2-1/4-inch-square format most of the time.

Because the 35mm film frame is small, evaluation of negatives, contact sheets and slides is relatively difficult, generally necessitating the use of some kind of magnifying device. Also because of the small film size, retouching of an image is impractical.

With really high image magnification, such as in 20x24-inch or 30x40-inch enlargements, overall sharpness and quality are usually noticeably better from 2-1/4-inch-square original images.

Lastly, 35mm SLR cameras, typically, will not synchronize with flash at all shutter speeds. This somewhat hampers creative lighting control.

The 2-1/4-Inch-Square Format—Cameras of this format, as well as their lenses and accessories, cost more and are heavier and less maneuverable than their 35mm counterparts. They also tend to be slightly more intimidating to some subjects. However, the larger film size makes it all worthwhile for us. It makes evaluation of positive and negative film much easier and frequently yields print enlargements of a better quality. The larger size also makes film retouching less problematical. Like the 35mm SLRs, these cameras also offer lens interchangeability.

Because most 2-1/4-inch-square cameras have leaf shutters rather than focal-plane shutters, most will sync with flash at all shutter speeds. This feature gives us much greater control when shooting outdoors and trying to balance flash with ambient light.

The View Camera—Although we have used a view camera for some of our figure studies, it is not a format that we frequently favor. The main advantages are the larger image and the perspective-

and sharpness-controlling camera movements. However, the high film costs, the bulkiness and weight of such cameras, and the potential intimidation of non-professional subjects outweigh the desirable features of this format, at least as far as we are concerned.

No single camera format will be ideal for all of your needs, all of the time. This is true not only in the context of figure photography but in other areas of photography also.

Lenses

Lens interchangeability makes a camera into a truly creative tool. Wise lens selection—affecting camera viewpoint, image size and perspective, creative distortion, and so on—is essential for successful figure photography.

Focal Length—When we shoot figure studies with a 35mm camera, we usually work with three lenses—a 35mm, a 50mm, and mainly a 100mm macro. When using the 2-1/4-inch-square format, we favor using a 60mm lens, a standard 80mm lens and a 150mm lens.

One of the reasons that we interchange lenses during the course of a photo session is to increase pictorial variety; to give us and our subjects more choices. However, this is not the only reason.

We generally base our focal-length selection on four main criteria:

1. How much space do we have to work in?
2. Do we want a normal or exaggerated perspective?
3. How much of the scene do we actually want to record on film?
4. How much depth of field do we want?

Working Space—The smaller the area that we have to work in, the more restriction there will be in choosing lenses. In tight quarters, we'll often be forced to select a fairly wide-angled lens. This may cause some image distortion that we would rather avoid by moving farther from the subject and using a longer lens.

If we need to work at close quarters with a wide lens, we try to minimize distortion by using an appropriate body pose. We avoid having some parts of the subject much closer to the camera lens than others.

Normal or Exaggerated Perspective—A creative photographer does not simply choose a viewpoint quite arbitrarily and then select a lens that will give him a frame-filling image. There is more to selective lens choice than that.

First, the camera viewpoint should be chosen to create the desired feel of perspective in the image. Perspective is simply the relationship between things that are at different distances from the camera.

Camera viewpoint can affect the size relationship between your human subject and the background, or between different parts of the subject, such as her legs and her upper body. By coming very close to the subject, the perspective will be exaggerated; by moving farther away, it will be more flattened out and geometrically "correct."

Once you have chosen the appropriate camera viewpoint and camera-to-subject distance, you then select the lens focal length that will frame the image the way you want it on film.

Angle of View—Whether you're deliberately trying to control perspective or not, the choice of lens focal length enables you to control the image framing from the specific camera position you have adopted. The longer the focal length of the lens, the narrower the angle of view will be and the less information, both horizontally and vertically, will be included in the film frame. Conversely, the shorter the lens focal length, the greater the angle of view will be and the more information will be seen by the film.

Most of the nude studies that we photograph in our studio—whether head-and-shoulders, three-quarter length, full body or selected body parts—are taken with a 100m macro lens when we're shooting 35mm. In the 2-1/4-inch-square format, we normally use a 150mm lens.

We chose the 150mm lens because we generally prefer to have a subject appear both prominently and with minimal distortion in the final image. We also like a fairly tight crop that eliminates distracting elements. Furthermore, we enjoy the ability to work at a comfortable distance from our subjects.

Depth of Field—This is another factor to consider when deciding upon which lens focal length to use. If you had three 35mm cameras set up next to each other, each with a lens of different focal length—such as 28mm, 50mm and 100mm—and each focused on a subject nine feet away and set at the same *f*-stop, each camera would yield an apparently different depth of field.

Basically, and all other things being equal, the shorter the focal length of the lens, the greater the apparent depth of field. The longer the focal length of the lens, the shallower the apparent depth of field. For example, at a lens aperture setting of *f*-11 the apparent depth of field will be greater with a 28mm lens than with a 100mm lens at the same *f*-stop setting.

If you wanted greater depth of field than is possible with the smallest lens aperture you can use, change to a shorter lens while shooting from the same distance. If you want to limit depth of field to a very narrow zone, narrower than the widest lens aperture will provide, shoot from the same distance with a longer lens. Of course, these changes will also affect your image framing and overall composition.

Don't be tempted to change lens focal length and then also change your shooting distance to maintain the same image framing. By maintaining basically the same image size in this manner, you would cancel out the effect the lens focal length has on the depth of field.

Film Selection

Film represents a key ingredient in your photographic equipment. Choosing the best film brand or type for any given purpose will often be a very subjective matter.

Film Type—If you want to end up with prints of your images, use color-negative film. If you want transparencies or slides, use color-reversal film.

Color Balance—If you're using color-transparency or reversal film and tungsten lighting is the sole source of illumination, use a film designed for tungsten lighting rather than using a daylight-balanced film and attempting to correct the color shift with filtration. In daylight, use a daylight-balanced film.

Film Speed—If you are going to be working in a low-light situation, use a fast film, with a high ISO rating. If there is ample illumination and you want optimum image resolution and quality, select a slow film.

If you want to deliberately create a grainy look in a final image, select a fast film, such as one having a speed of ISO 400 or ISO 800, or even higher.

Don't Be Afraid to Experiment—It's okay to deviate from the norm in order to achieve specific, unusual effects. For example, you can use tungsten lighting with daylight-balanced film if you want photos having a very warm, orange-red appearance. On the other hand, if you use tungsten-balanced film in daylight or with electronic flash, your images will look very bluish and cool. Such results are okay, if they give the effect you had intended.

Using different film brands, types and speeds in a variety of situations will yield a great variety of

photo results. By testing different films under widely varied conditions, you can become proficient in producing consistent and predictable results.

The ideal situation is to test a wide variety of films and then settle with the few that specifically fill your needs and satisfy your tastes.

Before you experiment widely, we suggest that you start with one film brand and type and shoot only with this for a while. Learn all you can about this film and how it reacts to different lighting and filtration situations. When you have established this base to work from, move on to other types. Continue testing until you have found the films you like to work with.

Films We Use—At present, we most commonly use Kodak Professional Vericolor III (ISO 160), Vericolor VPH 400 and Fujicolor Professional (ISO 100) color-negative films for our figure photography. The Kodak films give excellent, warm skin tones while the Fuji film yields a somewhat "cooler" look.

In the color-transparency films, we prefer Professional Ektachrome 64 and Professional Fujichrome 50, plus the new ISO 50 Fujichrome film called Velvia. The Kodak film, again, gives excellent, warm skin tones while the Fuji film gives a somewhat "cooler" and more bluish look.

We suggest that you test the films we have mentioned on one subject, under a variety of conditions, and then compare the results. You'll see that each film will give you a slightly different result. It's not that one will be better than the others; just different. By being aware of these differences, you can choose more wisely the correct film for each photographic task you embark upon.

Filters

The filters we use most frequently in our figure photography are soft-focus filters and color-warming filters. Occasionally we'll also use "special effect" filters, such as a four-pointed star filter. However, it's important to restrict the use of such filters to really appropriate situations. Otherwise, their effect can detract from the esthetics of an image, rather than adding to it.

With some occasional exceptions, we also usually avoid special-effect color filters such as deep blue, red and green and such devices as multi-image filters. We want our images to impress because of the pose, the setting, the lighting and the mood, rather than because of the effect of a filter.

Soft-Focus Filter—Most modern camera lenses produce images of incredibly high resolution, capable of recording the most minute detail. When you shoot glamorous, romantic images of women, you generally don't want such totally unforgiving detail. The images would look too literal, too sharp and too harsh. This is why we frequently use some sort of soft-focus or diffusion filtration.

Depending on the degree of soft-focus effect used, you can simply flatter and glamorize the female face and form or go to the extent of giving an image a distinctly dreamlike, ethereal look.

Some photographers like to make their own soft-focus filters by smearing vaseline on a clear-glass filter. This has the advantage of giving you a wide range of possible effects. However, any one effect produced is not easily repeated in exactly the same way on a later occasion. For this reason, we prefer commercially available soft-focus filters.

There are numerous types and grades of soft-focus filters on the market. There is no "correct" one for figure photography. You must experiment until you find the type or grade you prefer, for the results you have in mind.

Some soft-focus filters cause a distinct glow or halo to appear around the brightest image parts. This effect is sometimes inappropriate, especially in images that are deliberately intended to be in low key.

In a low-key situation, a filter or diffuser made of black netting would be more appropriate. You can purchase black netting from a fabric store and make your own filters. The degree of softness achieved will vary with the thickness or density of the netting used. You can also purchase ready-made filters of the same type, such as the "Softnets" made by Tiffen. However, with such filters you often need to make an exposure compensation because of light loss.

We use "Softar" filters by Hasselblad, the "Softnets" by Tiffen, black net filters which we make ourselves from material purchased from a local fabric store, as well as filters by Harrison and Harrison. We even make soft-focus filters from special plastic bags that we purchase from a local paper company!

Some filters, such as the Softars, require no exposure compensation while others, such as the black-net filters we make ourselves, can require anything from 1/2 to 2 f-stops of added exposure to compensate for light loss.

Commercially available filters usually come with full directions, including exposure-compensation

information. However, we recommend that you don't blindly accept what the manufacturers tell you. Test each filter—whether purchased or home-made—to find out how to get the precise effects you want.

Here's a simple way to establish the approximate light loss through a filter. Take an incident-light meter reading of a light source. Let's assume the reading is f-16. Now, pointing the meter in exactly the same direction, cover the meter's diffuser dome with the soft-focus filter and take another reading. If the meter now reads f-11, you know that the light loss is one f-stop and that you will normally have to give double the original exposure when using this filter.

Many manufacturers of soft-focus filters make their filters in varying degrees or grades of softness. Unfortunately, we have found that there is little standardization in these grades from one manufacturer to another. For example, one company's No.1 soft-focus filter may give an effect that is quite different than another company's No.1 filter. Only through testing of the filters can you have accurate knowledge as to the degree of softness you can expect from each one.

Commercially available soft-focus filters, such as those from Softar or Harrison and Harrison, can also be used in combination. For example, using a No.1 and No.2 filter together will give a softer effect than either the No.1 or the No.2 alone.

Soft-focus filters generally reduce image contrast and color saturation to some extent. This is not necessarily a bad thing. You can often use this to your advantage and create some very subtle, lovely figure studies, less harsh and blatant than those made without such filtration.

If the contrast level of your images appears too low or the colors are too muted when you use a soft-focus filter, you may consider changing the light quality. Often you'll find that by using a harsher, more specular light source you'll achieve a better result. You may have to change from a soft to a hard light source in order to achieve more contrast and saturation. The reverse is also true: the harder the light source, the more soft-focus filtration you may need to use in order to have the subject presented in the most favorable way. We discuss lighting in more depth in the next chapter.

Whether soft-focus filtration is appropriate depends very much on the type of image you're aiming to create. For example, if we are shooting a strong graphic image, such as a silhouette, with bold, sharp lines, we would normally use a hard light source and no filtration at all. On the other hand, using a similar hard light source, if we wanted to soften the harsh lines of an image just a bit without changing the overall look or mood too drastically, we might use a No.1 Softar. If we wanted an extremely soft look, we might use a No.2 and No.3 Softar combination, together with a very soft light source, such as a 4 x 7-foot light panel.

Warming Filters—Before closing our discussion of filters, let us briefly mention the one other filter type we commonly use. The warming filter is an amber or yellowish filter that "warms" the image. It is excellent for giving a healthy glow to skin tones, especially in outdoor conditions that may be somewhat excessively bluish—such as in open shade or under an overcast sky.

We prefer to use a warming filter for most of our outdoor figure studies, especially during the middle of the day. However, even when we photograph early in the morning or late in the day, when the sun is at its "warmest" color, the presence of blue light in the shadows sometimes bothers us. To reduce or eliminate this blue condition and add warmth to a subject's skin tone, we use an amber warming filter. We generally use one of the following: a Cr.No.1.5 or No.3.0 by Hasselblad, a Wratten 81A, a Tiffen No. 812 or a Singh-Ray warming filter.

Warming filters come in many strengths. We suggest you familiarize yourself with the Kodak light-balancing filters in the series 81 and color-conversion filters in the series 85. They can take care of virtually all of your color-warming needs.

Reflectors

Both outdoors and in the studio, we often use reflectors instead of electronic flash as a secondary light source.

Reflectors can be used to help fill in shadows. A well placed reflector can raise the illumination on the shadow side of a subject by one or more f-stops, depending on the type and size of the reflector, the amount of light striking it, and its distance from the subject. A reflector can also be used to back-light or accent a part of a subject or scene. Reflectors are a wonderful compromise when flash is not available or practical.

Reflectors are available commercially in many sizes and shapes—square, round and rectangular. They are made from a number of different materials and in varying colors. They can be matte, super

matte or highly reflective; they can be silvered, golden, white or mirrored.

Even though all of these are readily available on the market, many of our reflectors are home made, to suit our specific purposes.

Foamcore Boards—These boards come in white and usually in one standard, 4x8-foot size. They are readily available from most art or hardware stores and make excellent reflectors.

You can cut them into any size or shape with ease; they are only about 1/8-inch thick and can be cut with an X-acto or carpet knife. They can be used with their natural white surface or modified by covering all or part of the surface with pieces of material, such as silver or gold mylar or even colored gels. The boards are inexpensive—about $10 per 4x8-foot board—very lightweight and easily transportable and movable.

From a structural standpoint, a foamcore board makes a great "gobo"—an item used to hold back unwanted light. However, for this purpose it should be black. Your first inclination might be to paint it black. Don't do it! The boards are highly absorbent and paint will soak in, causing them to buckle. A better way is to cover the board with some black material.

Mirrored Reflectors—A regular mirror can make a very efficient reflector. In fact, sometimes a mirror can be too efficient. A highly polished mirror will sometimes reflect almost as much light as is coming from the actual source. This is okay if the reflector is being used as an accent or back light but totally inappropriate for a fill light.

Plastic mirrors are easier to use than those made of glass. They are lighter in weight and therefore easier to transport and maneuver. They can usually be purchased from companies that sell formica. One of the standard size of 4x8 feet costs about $100. Although this size is often too large to work with, the plastic mirror can easily be cut by the supplier into any size or shape you might want.

Although plastic mirror reflectors are heavier and cost considerably more than foamcore reflectors, their efficiency in reflecting light is far greater. However, they are slightly less light-efficient than top-quality glass mirrors. A section of plastic mirror will generally reflect about one-half of the light falling on it.

Reflector Efficiency—The more dull or matte the surface of any reflector, the less light-efficient it will be; the less light will be reflected back onto a subject. A white reflector is less efficient than a

mirrored one and will produce a softer reflected light. A mirrored reflector will give a harsh, specular light.

Compromises are involved when you select reflectors. They should be chosen or made to suit your personal preferences and the results you're trying to achieve.

You can create reflectors of various kinds by using a wide variety of materials. For example, aluminum foil, adhered to a board, can yield an excellent reflector. You can leave the foil in its original, flat form, or you can crumple it to a greater or lesser degree and then straighten it again sufficiently to enable you to adhere it to a board. Each different treatment will give you a slightly different reflector effect.

When To Use Reflectors—A reflector, like a light source, should be used to deliberately accomplish a specific end result, such as backlighting a subject, accenting a portion of her body, or filling in shadows.

If you want the light to be soft and subtle, a white reflector is a good choice. If you want bold and prominent reflected light, you might use a section of plastic mirror or a white foamcore board covered with silver mylar.

Reflector Size—As a general rule, a reflector should be at least the same size or slightly larger than the area to be illuminated. For example, if we want to rim light a standing subject with a strip of light from her head to her feet, we would use a 6-foot-tall reflector. For such rim lighting, the width of the reflector would not need to be very great—no more than six to nine inches.

If a reflector is too big, it may put light in areas other than the place intended. If it is too small, it usually will not adequately illuminate the desired area. That's why we like to tailor-make our own reflectors.

Exposure Meters

Accurate and consistent exposures are essential for top-quality photography. It does not matter what lighting situation you might be faced with—tungsten light, daylight or electronic flash; high-key or low-key—your film should always be receiving the correct amount of light to achieve the desired end effect. In order to ensure exposure accuracy, you should use a good exposure meter.

For most of our figure photography we use a handheld light meter in the incident-light mode. The meters we use at the present time are the Minolta Auto Meter III-F, the Minolta Flash Meter III and IV and the Ultra-Pro by Gossen.

Many photographers "bracket" their exposures. They take a meter reading, set their camera accordingly and then take a photo. They will then back this photo up by taking the same shot at several other exposure settings, such as 1/2 and 1 f-stop over and under the metered exposure, to ensure the best possible result.

Although we have used this exposure method on some occasions, we generally find it wasteful and time-consuming. It's a matter of personal taste and style, and each photographer must work in the manner with which he feels most comfortable.

A brief anecdote may show you why we prefer not to get into the "bracketing" habit. Many years ago, Sheila and I studied with a well known fashion photographer. We were with him when he shot an ad campaign for a national company. He had to take five different shots, involving five different settings. The cost of the shoot, including a professional model, was high and it was important to avoid the need for a re-shoot. The photographer's technical "safety net" was to use exposure bracketing. To get his five images, he exposed a total of 2700 sheets of film. Ever since that experience, we have resolved to rely on exposure accuracy rather than on multiple exposures. We normally work in a sufficiently controllable environment to make this quite possible.

Don't just meter the subject and setting at the beginning of a photo session and leave it at that. You should meter during the course of your photo session, every time there is a major move of your subject in relationship to the lighting setup, and so on.

We start all of our shots by metering the main-light source at the subject's position, with the incident-light dome of the meter directed toward the main source of illumination.

All other lights—back lights, background lights, accent lights and fill lights—whether from direct electronic flash, reflectors or ambient light, are then metered separately and adjusted to emit slightly more or less light than the main light, depending on the effect or mood we are trying to create. In other words, the main-light meter reading is used as the "standard" and all other lights are adjusted accordingly.

If the main-light value on the subject shifts up or down—as it often does during a studio sitting when a subject's distance from the main light changes—it's a simple matter to re-meter the main-light source and then move it closer to or farther from the subject, or adjust its power, so that we can remain with the initial f-stop setting that had been used.

Whether indoors or outdoors, with ambient light, electronic flash or reflected light, this constant monitoring by metering helps us maintain consistently good exposures for each frame of film shot during an entire photo session and eliminates the necessity for bracketing.

Camera Support

In our work, a tripod is an essential item of basic equipment. Since most of our figure photos take time to set up and involve little movement, we use a tripod most of the time, even when working with 35mm cameras.

A tripod is essential when a heavy camera, such as a view camera, is used and whenever a shutter speed that is too slow for handholding the camera is employed.

Obviously, in most action photography, involving such activities as sports, a tripod would be more of a hindrance than a help. If your figure photography involves action and motion, use your camera handheld. However, nude studies are usually of a static nature and a tripod should be a standard piece of equipment.

The camera support we use in our studio is a relatively expensive 7-foot stand on a very sturdy, three-wheeled dolly. For our location photography, we use a much more readily portable tripod, without wheels. Our camera supports are by Tiltall and Bogen. When you have a choice, always go for the heavier, sturdier tripod. Stability is the main purpose, and this is best achieved with a sturdy tripod or stand.

Even for our 35mm cameras, we use tripods that can support more weight, such as a 2-1/4-inch-square camera. For our medium-format cameras, we use tripods that would support a 4 x 5 view camera. This helps us to always get the stability we need.

Most of the more elaborate tripods that we have seen come with separate, individual controls for camera height, horizontal swing and vertical tilt. We don't like these separate controls and therefore modify our tripods with a Leitz ball-and-socket head. This head has only one knob, allowing us the ability to control camera height, swing and tilt all at the same time. We find this much easier and faster than using a tripod that is not so equipped. However, the Leitz head is not cheap, costing about $150.

Most of the better and sturdier camera tripods stand about 30- to 36 inches tall when their legs are not fully extended. Most have telescopic legs that enable the height to be extended to six feet or more. However, there will be times when having a camera even only 30 or 36 inches above the ground will be too high. If you want to shoot from a lower camera angle, such as 12 or 16 inches above the ground, it's important to have a tripod that will allow the legs to be opened more fully. We have found that the Bogen model 3068 works great for such purposes.

Although a tripod may not always be necessary in figure photography, there really is little reason *not* to use one. A good, sturdy tripod is a bit of extra insurance that can only increase the sharpness of the final image.

LIGHTS AND LIGHTING TECHNIQUE **8**

Serious figure photography demands the mastery of the basics of lighting. A photographer must have the ability to consistently control the illumination, whether it be artificial or natural. He should know how to promote or subdue a mood, reduce or accentuate texture, emphasize or understate contours of a subject's body.

The purpose of this chapter is to impart enough general information about lighting to the newcomer and also to remind the more experienced photographer of the essential basics.

The sources of illumination for photography can be of numerous distinct types. The number of lights used and the quality of the light must be chosen carefully and light placement must be well structured. You should always think in terms of "building" your lighting around the subject and setting, one light at a time.

The two most basic lights are the main and fill lights, discussed next.

Main Light

The first light to consider is the main light. If you were to shoot with only one light, it would usually—although not always—be the main light. It may be natural daylight, electronic flash, tungsten bulbs or some other form of illumination. Depending on the specific needs and aims of the photographer, a main light can vary in power output, size and shape. This main light is also commonly referred to as the "key" light.

Fill Light

The fill light serves to lighten the shadow areas created by the main light. In controlling the overall contrast of the scene, the fill light helps to establish an overall mood for the photographic image. Sometimes, depending on the quality—the hardness or softness—of the main light and on the overall effect desired, a fill light may not be needed at all.

Like the main light, the fill light can come from one of several sources, including natural light, electronic flash and tungsten light. It could also come from light reflected from a portable reflector, a nearby wall, a sheet, or a sandy beach on which the subject is posed.

Fill light should never totally overpower the shadows created by the main light. It should also not create its own shadows, which would then conflict with the main-light shadows. For this reason, the fill light should generally be soft, close to the camera position and of lower brightness than the main light.

Other Lights

In addition to the main and fill lights, there are rim lights, back lights and special spotlights for accentuating or highlighting parts of a subject's face, body or hair, a prop, or part of a setting. Finally, there is the background light, used to illuminate the scene or backdrop behind the subject.

Before we discuss these other lights in greater detail, let us look at some of the possibilities that are available to a photographer when lighting a subject with only two lights—the main and fill light.

Basic Lighting

The possible lighting combinations and potential available with just a main and a fill light are enormous. For example, by just changing the size of the main-light source, the light quality can be varied greatly. A small light source will emit a "harder" light than a large source. A large light bank, umbrella light or soft box produces light of a "softer" quality. Hard light produces distinct, abrupt shadow outlines while soft light yields a gentle gradation of shadows into highlight areas.

The main light does more than simply provide the illumination needed to record an image on film. It is responsible for providing the modeling and texture in a subject and setting the mood for a photo scene. For example, using only a main-light source at about 45 degrees to the right or left of the camera-subject axis will cause an appreciable

portion of the subject's body to go into deep shadow. This single-light concept can be very effective for certain types of shots; it can create an air of somberness or mystery.

A main light can be used to "model" or sculpt a subject's body and face with light in a number of different ways.

Two Main Lights—By using two lights as main-light sources—one for the subject's face and the other, set to the same power output as the first, for lighting the subject's body—the lighting variations possible for any given subject increase even more. With each variation, a totally different photographic "look" can result.

The two main lights might differ in size, shape and type, but their power outputs—the quantity of light falling onto the subject from each source—should be equal. Also, when you "double-light" a subject in this fashion, you must still think of the subject as being illuminated by only one primary source. This means that the shadows must not provide conflicting, confusing information. If the body light casts shadows toward the right side, the face light should do the same.

If the two light sources are not equal in power output—for example, if the lighting on the subject's face is more powerful than that falling on her body—the two sources cannot both be considered as main lights; one of them then becomes an "effects" light.

Main and Fill Illumination—The function and effect of a fill light is greatly dependent on the character of the main light. Depending on its power setting or distance from the subject, compared to the main light and its power setting and size, the fill light will play a greater or lesser part in determining the ultimate atmosphere and drama in an image. This control further increases your creative lighting potential.

Notwithstanding all of these lighting possibilities, we like to keep our lighting as simple as possible, while consistent with our preconceived concept. In very basic terms, if you want to record something with detail, light it adequately. If you want to record no detail in a specific area, don't light it. If you want subdued detail, use an appropriate amount of light. To do this well, you need to be very familiar with the exposure-latitude characteristics of your film and well versed in your lighting and exposure techniques.

In the portfolio section that follows this chapter, you will see many lighting variations illustrated and described. They should be helpful in giving you some understanding of the basics of practical lighting as well as provide you with some ideas for your own shooting.

Light Quality

When a subject is lit only by a main light, shadows will be created. Where the illuminated area stops and the shadows start, a line of demarcation appears. When this line is very sharply defined, the light that is causing this condition is said to be "hard." When this line is very subtle and not easily discernible, the light is considered to be "soft." This light "quality" has nothing to do with the "quantity" or total output of the illumination.

The power output of a light source has other effects on your photography, such as on the potential depth of field that is possible, but has no bearing on a light's quality. If you had two identical lights, connected to identical power packs, each placed at 10 feet from a subject and at the same angle, with the power of one at 200 watt-seconds and that of the other at 800 watt-seconds, the quality of light falling on the two subjects would be identical. Using the 800-watt-second light would merely give you the luxury of working at a two *f*-stop smaller lens aperture, giving you considerably greater depth of field.

A number of factors affect the quality of a source's light: the size of the light source and its distance from the subject; the angle of the light in relationship to the subject; the type of material the light passes through; and the type of housing a light source is contained in.

Size of Light Source—As a general rule, the smaller the light source, the harder the light produced. Conversely, the larger the light source, the softer the light. For example, a light which is housed in a four-inch bowl reflector will produce harder light than the same light housed in a 24-inch bowl reflector.

This "rule" is not quite as hard-and-fast as it may appear. That's because what really matters is not the absolute size of the source, but its size in relationship to the size of the subject—and that varies with the light-to-subject distance.

The closer a light is placed to a subject, the larger it will appear from the subject's viewpoint and, as a result, the softer the quality of the light falling on the subject will be. Conversely, the farther a light is from a subject, the smaller the apparent size of the source and the harder the resulting light quality. As a source is brought closer to a subject, it becomes apparently larger, and vice versa.

Lighting Angle—The closer any specific light source is to the camera-to-subject axis, the softer

the lighting will appear. That's because shadows visible at the camera position will be minimal. The farther the source is from the camera-to-subject axis, the larger and more pronounced the shadows will be, so that the light will appear harder in quality.

Diffusing Materials—Passing light through translucent materials of plastic, nylon, linen and the like can soften the illumination falling on a subject. The softening effect is largely due to the fact that the source is usually made effectively larger by the diffusing material. For example, if you place a 20x20-inch diffusion screen in front of a bare bulb, the effective size of the source is increased to about 20x20 inches. To some extent, the light is also softened because the diffusing material renders it less directional.

When you place a diffuser in front of a light source, you always reduce the effective brightness of the illumination. The denser the material used, the more power will be needed to pass a given amount of light through it. For example, if you placed one thickness of nylon or white linen in front of a light source, you might need to open your lens by one *f*-stop, or double the light output of the source, to compensate. You could also move the light source closer to the subject. Moving the light closer to the subject will give you an added softness because you have now effectively made the light source larger from the subject's viewpoint.

It will only be through experimentation that you will discover the most effective and expedient ways and materials for softening illumination to a degree that suits your specific purposes.

Light Housings—Examples of typical light housings are a bowl reflector, an umbrella and a soft box. A housing is something a light or lights fit into and that serves to reflect the light out to the subject.

Most bowl reflectors produce harder light than umbrellas, because they are smaller. Umbrellas produce harder light than soft boxes, if they are smaller. A soft box will produce harder light than a much larger light panel, and so on.

If you want body contours or the texture of a subject's skin to be sharply defined, a light in a relatively small reflector, yielding a hard light, may be the answer. If you want the contours or skin texture of the subject displayed more subtly, an umbrella light or soft box may be an appropriate choice. No single housing will be the "right" choice for all of your photographic situations; it all depends on the results you are after.

After experimenting with a number of different light housings, you will eventually find certain housings and combinations that you favor, just as Sheila and I have.

Housing Color and Texture—The color and texture of a housing's interior surface will also have an effect on light quality. For example, a housing with a matte, white interior will yield a slightly softer, more "gentle" light than one with a shiny, silvered or golden interior surface. A light in a 24-inch bowl reflector that has a matte, white interior will produce a somewhat softer light than the same light housed in a 24-inch silvered bowl reflector.

A golden reflector is useful outdoors under a blue sky or in open shade. In such conditions, it makes a very suitable fill reflector, enabling you to warm up shadows that might otherwise be unacceptably blue.

Lighting Technique

Now that we have had some discussion about light quality, we will briefly discuss how basic lighting setups are obtained and how you can use them to create various lighting effects for your figure photography.

Lighting the Nose Axis—Lighting of a subject's face should be constructed based on the subject's nose axis.

In Diagram 8-1, the subject's nose is pointed toward 0 degrees, in this case the camera-to-subject axis. The main light, and even the fill light, could be placed to the right or left of this position,

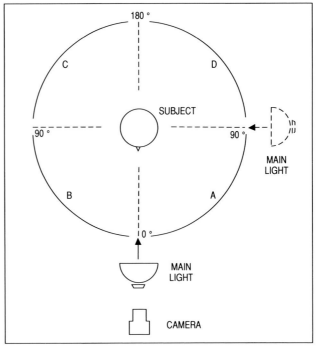

Diagram 8-1

along arc A or arc B. Arcs C and D, as will be indicated in a moment, are most commonly the areas for placement of back lights, top lights and kicker lights.

If we were to light a subject's face by placing a main light at the 0-degree position, square to the nose and face, the front of the face would be illuminated evenly. This type of lighting is often referred to as "glamour" or "flat" lighting; virtually no shadows are seen at the camera position.

If we were now to move the main light to the 90-degree position, to the right or left, the subject's face would be in "split" lighting; one-half of the face would be in light and the other in deep shadow.

Between the 0-degree and 90-degree positions, along arc A or B, lie the positions for creating other standard main-lighting patterns. Each pattern used will give a subject's face a different look. Not all patterns will be flattering to all subjects, nor appropriate for all pictorial moods or themes.

For example, frontal glamour lighting reduces contrast, minimizes lines and wrinkles, flattens the facial "modeling" and minimizes skin texture. However, this is not appropriate illumination if your aim is to produce a dramatic mood. It creates no appreciable shadows, generating no drama or mystery; little is left to the viewer's imagination.

On the other hand, split lighting dramatically increases contrast, significantly accentuates lines and wrinkles, and helps to accentuate contours and texture. It is a great lighting pattern to use for creating a mood of drama and mystery, since a portion of the face is left in deep shadow.

Although sharp side lighting is frequently flattering to a subject's figure, it is often not as flattering to the female face as is glamour lighting. As a result, a compromise often has to be made, such as placing the light around 45 to 70 degrees from the 0-degree axis rather than at 90 degrees.

Another way to solve this problem is to "double light" the subject, using two main lights. The face light could be set at the 0-degree position and the body light could be positioned obliquely—to the right or left of the 0-degree axis—for a flattering rendition of the body contours.

As indicated earlier, when you use two main lights, be careful not to generate distinct, sharp shadows that contradict each other—one running to the left and the other to the right. So long as the face light is frontal and soft, this is not likely to be a major problem.

Our lighting angles are based on the subject's nose axis, not on the location of the camera. For example, if we had the subject turn her head to her left, facing the 90-degree mark in Diagram 8-1, and then we placed the main light in line with her new nose-axis position, even though her face would now be 90 degrees to the camera axis, it would still be 0 degrees to the light axis. Of course, the frontal light on the subject would not appear as flat and shadowless now, since the light is coming from a side location rather than from the camera viewpoint. Thus, the end effect of a light is caused by a combination of subject angle, light angle and camera position.

Lighting the Body—In Diagram 8-2, the subject's body has been added. To establish lighting for the body, you should follow the same rule as for lighting the face: the lighting should be based on the "nose" axis. When thinking of the position of a subject's body—which, of course, doesn't have a nose—assume that her head is pointing in a frontal direction. In such a pose, a frontal nose position indicates a frontal body position.

Since both the body and face are shown square to their main lights in Diagram 8-2, both are receiving glamour lighting. As we have already noted, such lighting can often be very flattering to the female face but less flattering and dull for the body, primarily the bust and waistline. Flat lighting of this type often tends to make the bust appear flatter while emphasizing or exaggerating the width of the waistline and hips.

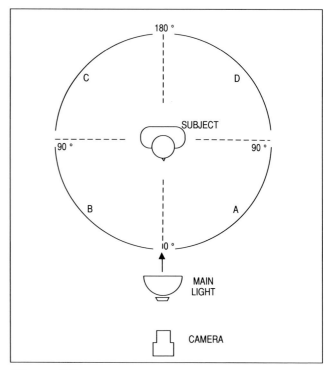

Diagram 8-2

48

In Diagram 8-3, the nose axis and the camera are at the 0-degree position and the body is turned at 45 degrees to the camera position. You will note, however, that both the subject's head and her body are in the 0-degree position for lighting purposes. You have the option of lighting the face and body separately with two lights, one at each 0-degree position as indicated in Diagram 8-3, or using just one light source placed on either 0-degree line.

For example, referring to Diagram 8-3, if you used one main light only, at the 0-degree camera position, you would be glamour lighting the face but lighting the body obliquely, since the body has been turned at an angle in relationship to the light. This type of lighting is glamorous for the female face as well as for the body. Since the lighting is crossing the subject's body at an oblique angle, it helps to bring forth body contours and skin texture; it flatters the bust and waistline by creating shadows.

If you leave the body in the same position but turn the subject's head to her left, as shown in Diagram 8-4, the body and head can still receive 0-degree frontal lighting from their respective main lights, as shown by the lines.

As before, you have the option of lighting the body and face separately or with just one light at either 0-degree position, depending on the result you want. Again, by varying the body and face positions, the camera angle and the light positions, you have an almost infinite variety of lighting options available to you.

Other Lights

As noted earlier, in addition to the main and fill lights there are kicker lights, accent lights, top and back lights, as well as background lights, all of which can be used in figure photography. Each has its own function and serves its own purpose. These lights can be used in any combination, depending on the results and effects sought. Our previous discussion regarding light quality applies equally to these lights.

As a general guide, a top, back, accent or kicker light can be placed anywhere along the arcs C and D in Diagram 8-1. They can be placed above or below the subject, depending on the effect you want to create.

Accent or Kicker Light—The function of the accent or kicker light is to highlight or accent one or more portions of a subject's body or head, or props or objects that are to appear in a photo scene. These lights are usually of the spotlight type, housed in small, four- or five-inch silvered and snooted reflectors. Such housings make the lighting very directional and easily controllable, producing a hard, precisely limited light. A kicker light does not even have to be a true light source; it can be in the form of an appropriately sized, shaped and placed reflector.

Where and how to use an accent light will often not be decided until your subject is posed on the set or at the location. It's generally at this time that you'll make the decision as to which portions of the subject's body, set or props should be accented, and how this should be achieved.

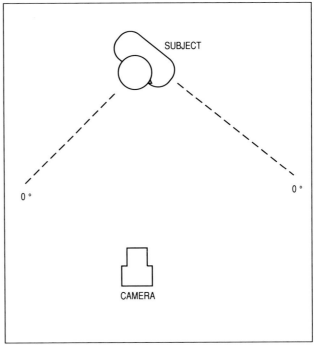

Diagram 8-3

Diagram 8-4

You can vary the intensity of an accent light to provide a brightness on the subject greater than that of the main light or somewhat lower, depending on exactly what effect you want to achieve.

Keep your lighting as simple as possible and use accent lights with restraint, especially until you are really confident of your basic lighting technique.

Back Light—This light can be similar to an accent light in type but its placement generally differs. It is often positioned directly and squarely behind a subject. Its height can be set as low as the floor, up at the level of the subject's head, or anywhere between these extremes, depending on which part of the subject's body you wish delineated with light. Its purpose is usually to provide graphic separation between subject and background, to outline the body, or to highlight the subject's hair.

Top Light—This light, which can be of any size or shape and in any form of housing, is most conveniently used on a boom stand, suspended above and slightly behind a subject. It, too, has the purpose of visually separating a subject from the background as well as providing ideal illumination for the back and top of a subject's head and sometimes additional illumination for the back of the body as well.

When we want a rather hard edge to the light, we will use a top light housed in a six-inch silvered bowl reflector. For a softer top light, a light housed in an 18x24-inch soft box is ideal.

Background Lights—The background lighting serves to illuminate a background so that it can be seen and recorded on film, and to graphically separate a subject from the background.

Depending on the size and reflective quality of the background and the emphasis you wish to place on it, you may use a single source or several lights. Again, depending on the area that needs to be covered, you can use lights in small bowl reflectors, in umbrellas or in large light banks. To obtain uniform illumination on a large background, you should use lights from both sides.

When you're using large and bright background lights, watch out for unwanted flare. This is caused by spill light that reflects from the background onto the subject. Such flare is accentuated by having the subject placed too close to the background and by having the background lights too powerful. Flare causes a subject's outline to "glow" and be less than sharply defined in your final images.

Flare, like most other conditions, can sometimes be used creatively for a special effect. Generally, however, you should avoid it.

Studio Lighting

There are many lights and lighting potentials to choose from. Until you gain proficiency and confidence, it's best to work with relatively simple lighting setups. This will lead you to consistently good results more quickly and keep you from becoming discouraged.

Our Main Lights—We generally favor using one of the following four light sources as main light, depending on the light quality we want: a hard light in a four-inch snooted housing; for a softer light, we might use an 18-inch bowl light with a grid spot and plastic diffuser cap; an even softer light can be attained with a four-foot, white umbrella with a plastic diffuser cap; for an extremely soft look, we'll use the "Shero" light, developed by ourselves, which is a silver- or white-lined light-panel unit.

Our Fill Lights—For a fill light source, we frequently use our own, white-lined "Shero" light, a 3x4-foot, white-lined soft box, or a white- or silver-lined three-foot or six-foot umbrella. Occasionally we'll use a smaller fill source, such as one or two four-inch snooted lights. Again, it all depends on the effect we are after.

Basic Studio Equipment—To keep your lighting setup relatively simple as you begin figure photography, we suggest that you use a four-foot or six-foot white-lined umbrella as main light. Buy one that allows its opening to be covered with a diffusion material or screen. Umbrellas made by Balcar and Photogenic offer this facility. This option of diffused or undiffused light makes the single source more versatile.

For a fill source, a white-lined three-foot or four-foot soft box, such as are made by Chimera or Plume, is a good choice.

Add two accent or kicker lights, preferably with four- or five-inch snooted housings, one top light in a six-inch silver-lined bowl reflector, two background lights, one 4x6-foot white foamcore reflector and one 3x6-foot mirrored reflector.

For the background lights, we suggest that you have two six-inch silver-lined bowl reflectors and two three-foot silver-lined umbrellas. These will afford ample versatility for your background illumination. Should the need arise, the bowl reflectors could also act as accent lights.

Power Packs—We have approximately 20 different power packs in our studio, ranging in power output from 100 watt-seconds to 2400 watt-seconds. We favor the units made by Broncolor and especially like their "Pulso 2" model.

Of course, we're not suggesting that you need 20 power packs! We suggest that you start with at least two packs in the 1000-watt-second range. Unlike packs in the lower wattage range, a 1000-watt-second power pack will allow you to use more than one light at a time and also permit the use of a smaller lens aperture, for greater depth of field.

The lighting setup we have just described is not too involved and yet will allow you to create a variety of different effects for your figure photography, including high-key and low-key lighting, described next.

High-Key Lighting

A high-key image is one that is predominantly within the bright end of the tonal scale. It demands a special high-key subject—blonde, light-skinned, in a bright setting and, when clothing is involved, in light garments. It also demands special high-key illumination.

We construct our lighting so that the chosen white background receives more light than the subject, the props and the remainder of the set. We want the background to record on film as pure white, without any detail.

Depending on the type of background material used, this means that it must usually receive between one and two f-stops more light than the subject. Our own white studio background is usually given two f-stops more light than the subject receives from the main light. This assure us that the subject's face and figure will be the darkest reference points in the image. This is the effect we usually want in a high-key image.

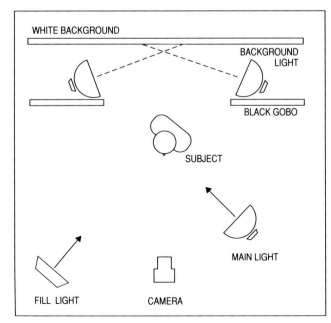

Diagram 8-5

The Setup—For creating a high-key photograph, a four-light setup is usually adequate.

You can begin by setting up a background sweep of white, seamless background paper, supported by two stands. For a full-figure shot, a nine-foot sweep would be appropriate. Place the subject at least seven or eight feet from the background. This distance will help guard against possible unwanted flare around the subject.

Next, set up two background lights of equal power. We normally use two three-foot silver-lined umbrellas. Place one to the left and one to the right of the background, at about a 45-degree angle in relationship to the background. Aim each just beyond the background's center, as shown in Diagram 8-5, so that the entire background is lit evenly.

With both of these lights turned on, take a meter reading at the center of the background, noting the indicated f-stop reading.

Now turn these lights off and position your main light and turn it on. Adjust the power of the main light to emit two f-stops less light. Let us assume the background reading was f-16. The main light should then be adjusted to emit light at the subject's position at a value of f-8. The camera's f-stop setting must be based on the main light's output on the subject.

Next, position your fill light and adjust its power, based on the lighting ratio that you prefer for the results. Using the above example, we would, typically, adjust the fill-light power to emit no more than f-5.6 of light; sometimes even f-4 or slightly less. It would depend on just how dramatic we wanted the final high-key result to appear.

Finally, you must set the f-stop on your camera. Although, in this example, the main light's output was f-8, for a good, bright high-key effect we would set the camera's lens to f-5.6.

This simple four-light setup represents a good starting point from which you can derive some beautiful high-key results. We sometimes use setups that are a bit more elaborate, including kicker lights at floor level, and so on.

Low-Key Lighting

Low-key images are, basically, the opposite of high-key images. Virtually everything, including the background, should be at the dark end of the tonal scale. The background should often be totally black, lacking all detail. The lit parts of the subject's face and body are generally the lightest portions of the image.

The subject should be suitable for low-key record-

ing—black or dark hair, dark drapes and props and, if clothing is involved, it should be dark, too.

Although black background paper could be used, we have found it to be unacceptable most of the time. It will not record as the deep black we generally desire. Spill light, from the main and fill lights, even when protective gobos are used, often illuminates the background to some extent and keeps it from being totally black.

In order for us to accomplish a true low-key setting, we use black carpeting on the floor and black material for our background. A wisely selected black material and carpeting absorbs light like a sponge, reflecting no measurable light and keeping everything black and without detail, including the "horizon" line where the floor and background meet.

The Setup—For low-key photography, there are many possible lighting choices. For main lighting—depending on whether you're going to light the subject's face and body with one or several separate lights—you could use anything from an arsenal including snooted spots, white-lined diffused umbrellas, a large soft box, a large light panel unit, and so on. No matter which main-light setup we start a scenario with, we are likely to change it several times during a session.

No matter how many separate lights you use, remember that the essence of low-key photography is a low key light, and this implies a restraint in lighting rather than an excess of it. Use your lights for achieving specific effects rather than for indiscriminate "bathing" in light.

We will commonly use a white 3x6-foot foam-core reflector, just out of the camera's view, as an additional fill light. It serves to direct some of the main-light illumination back onto the subject, to brighten shadows and reduce the overall contrast. This fill light also helps to add a little sparkle to a subject's face and to brighten the area around the eyes.

Depending on how we want a subject to be represented in the final image, we might add a top light and a kicker light or two behind or to one side of the subject. These lights will accent one or more portions of the body.

Finally, we would usually add a back light. This helps to separate the subject more clearly from the black background and to further outline the body. The illumination coming from behind the subject will also help to increase the overall feeling of depth in the image.

For a typical low-key lighting setup, see Diagram 8-6. You'll see a few examples of typical low-key lighting in the portfolio section following this chapter.

Outdoor Lighting

When you're shooting outdoors, especially with non-professional models, you should be prepared to work fast. This means being mobile and as unburdened as possible by lighting and other equipment. This is the time to keep your lighting simple.

Typical Lighting Setup—Outdoors, we usually prefer to use electronic flash as the main light and the natural daylight as the fill source. Our second choice is to use the natural light as main light and electronic flash as the fill source.

Because outdoor illumination tends to be variable and unpredictable, we usually disfavor working with natural light alone. By augmenting the natural light with flash, we have much more control. Flash also gives us the ability to put some sparkle into our final images, regardless of what the natural-light conditions happen to be.

Ideally, we prefer working with studio electronic-flash heads, housed in one of our own "Shero" light-panel units, and with studio power packs. However, if time is a major factor or if we intend to change locations frequently during the course of a photo session, we'll often resort to the use of portable flash units.

Although there a number of very good portable, battery-operated units on the market, we have found the Multiblitz portable flash units particularly good. The light and its power source are all contained in one unit; it can be used either with a portable battery or with household current; it is very dependable and is easy to set up and dismantle.

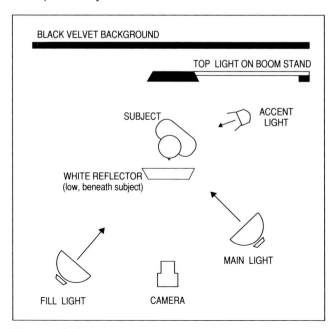

Diagram 8-6

When used behind a 3x6-foot light panel, covered with a bed sheet, or with our "Shero" light housing, flash lamp heads can produce extremely soft lighting. They can produce somewhat harder lighting if used with a white or silver-lined umbrella, and still harder light when used with only their standard six-inch silvered bowl reflectors.

If time is really a factor and we have no other choice, we'll use natural light only and no electronic flash. However, to get some brilliance into such a scene, we'll frequently use two reflectors. Typically, one will be a 3x6-foot plastic mirror, often covered with an amber gel. It will act as main-light source, reflecting the natural light back onto the subject's face and figure.

A second, large plastic mirror would be used behind or to the side of the subject, to act as a back light or accent light. The direct natural light would be used as the fill source.

In the event that you wanted to or had to use the natural daylight only, you would need to use that light as the main-light source and take advantage of what may be immediately around the subject to serve as fill reflector. For example, you could use the natural light bouncing off of a white or bright wall, a light sandy beach or a large rock.

Background—In your home or studio, it's relatively easy to control the background and the lighting on it. Out on location, you have less control over the background and its illumination. Also, doing figure photography outdoors, where intruders are always a possibility, can tend to preoccupy a photographer to the extent that he does not pay as much attention as he should to such details as the background.

Our advice is to keep backgrounds simple and uncluttered, and to pay attention to the background lighting values, so that you can expose your film properly. You must avoid spoiling otherwise good figure studies by having the background drastically under- or overexposed.

Once you have selected your setting and background, meter the background area. Compare this meter reading with the lighting on the subject. If the background measures too bright or too dark in relationship to the subject lighting, the simple solution is to increase or decrease the main and fill lights for the subject, to bring them more in line with the background illumination.

If this is not practical, you'll have little choice but to move into another area or wait for a different time of day, when the lighting is more in keeping with the lighting ratios you want. Adding lights to a dark background or gobos for a "hot" one is usually ineffective and very time-consuming.

There is another way to approach this problem, if you're using a leaf-shutter camera. If you use electronic flash as your main, fill and accent lights, exposure of your subject can be based on the flash, your camera's *f*-stop being set according to the output of the main light. The more distant background will be exposed based on the natural light, and this exposure can be controlled by your camera's shutter-speed setting.

For example, say that we want to photograph a subject positioned in the shade of a tree. We intend to use three electronic flash heads—a main light, a fill light, and an accent light from the back or side. We would position our main light and take a meter reading for that flash illumination. Assume it indicates *f*-8. We would set our camera's lens to *f*-5.6.

We would need more information before we could set the shutter speed on our camera. We would position our other two lights and meter them. Once their power had been adjusted to our taste, in line with the main light's output, we would take an ambient-light meter reading of the background area that is within the camera's angle of view. Let us assume that the area behind the subject, in fairly bright light, gave a meter reading of 1/30 second at *f*-5.6.

Now we are almost ready to set our camera's shutter speed. Since we know that we are going to photograph the subject with flash, the common number that we must work with is our camera's *f*-stop setting—*f*-5.6. The ambient-light value must match this number. The bright background metered at 1/30 second at *f*-5.6. Accordingly, we could set the shutter speed to 1/30 second.

We can actually set the shutter speed to give the background any tonal value we want. Remember, the camera's lens aperture must remain at *f*-5.6. If we want the background to be relatively bright, we could use a shutter speed of 1/8 second, overexposing the background by a couple of stops. Since the lens aperture remained at *f*-5.6, the subject would still be properly exposed by the flash.

By the same token, if we wanted the background very dark, we could set the shutter speed at 1/250 second. This would underexpose the background by three *f*-stops. Again, the flash exposure for the subject, at *f*-5.6, would still be correct. The shutter-speed setting will affect only the naturally lit background.

Taking photos by this variable-exposure method for the background will yield images that differ greatly, even in the one, identical location and with similar subject poses. It's an easy way to add pictorial variety to an outdoor shoot.

IMAGE
1

You do not need a lot of props in a photo scene in order to produce a stunning figure study. A simple mirrored vanity table, a stool, a candle and a few accessories on the table are all that are needed.

We intentionally held the lighting back on the vanity table and stool because we did not want them too prominent and thus distract viewer attention from the subject. However, we did not want the subject to appear to "float" in black space either. To avoid this, we used a white cushion on the stool rather than a black one. A viewer becomes immediately aware that the subject is actually sitting on something. The highlights on the heels of the shoes also help to "separate" the subject from the black background.

The pose is somewhat traditional but very flattering, both as the model is seen directly and as she is seen in the mirror reflection. When using such reflections, always be sure that the mirror image is flattering, is appropriately lit, and complements the prime image of the subject in a visually pleasing manner.

If it were not for two subtle elements in this photo, the scene would be virtually timeless. However, the subject's high-heeled shoes and her brief outfit make it very clearly a contemporary shot.

The candle was placed on the table to "fool" the viewer into thinking that this was the only source of illumination, even though it did not actually contribute to the effective lighting on the subject.

We used a five-light setup. An amber-gelled top light—housed in a five-inch silvered bowl reflector, mounted on a boom stand and placed above and between the vanity table and subject—lit the subject's bust, the top of her hair and the top of the vanity table. Two, amber-gelled, three-inch snooted kicker lights, placed about 90 degrees to the left of the camera-subject axis, gave the illumination for the back of the subject's hair, her back and buttocks, and a portion of the stool.

Two other lights—each housed in a 12-inch bowl reflector with a 20-degree grid spot and plastic diffuser cap—were placed to the right of the camera, almost in line with the subject's nose axis. This afforded the frontal illumination for the subject's face and legs.

To slightly soften the image, we used a Softar 2 soft-focus filter. Exposure was 1/15 second at f-11. The slow shutter speed allowed the glow of the candle to be recorded adequately on the film.

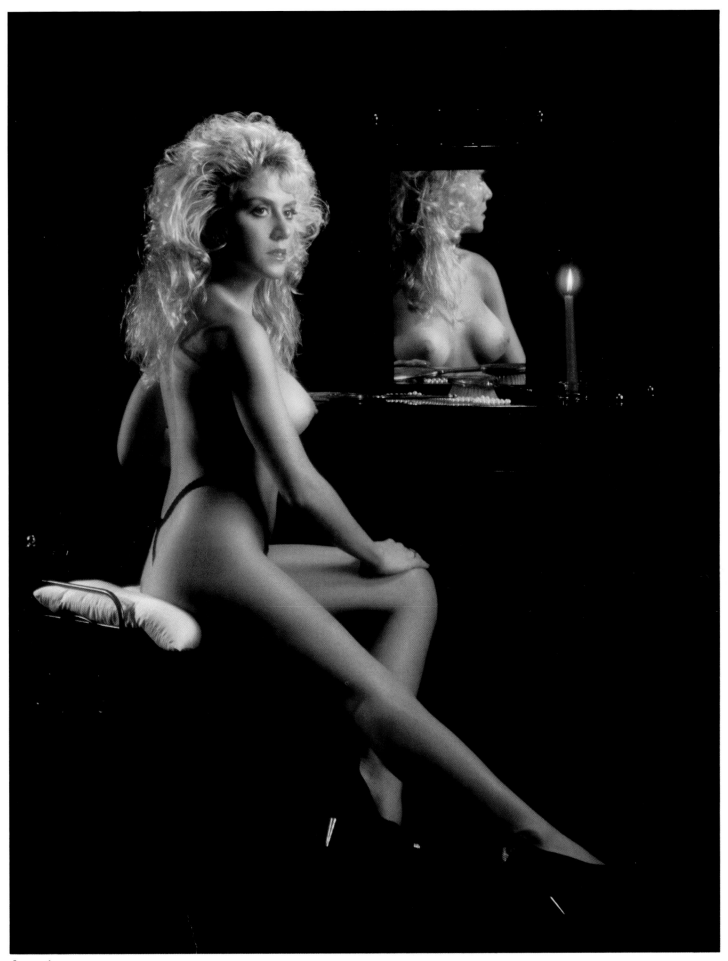

Image 1

The pose in this photograph is less guarded and more daring than the one in the previous image. By making eye contact with the camera, the subject is appealing directly to the viewer. This is a fine example to show that a figure study can be sensuous and yet very delightful and innocent.

We shot in a high-key setting and by high-key lighting to deliberately create an atmosphere of lightness, joy and purity. The brightness, the pastel colors, the frilly quality and sheer airiness of everything surrounding the model and draped about her body further enhance the atmosphere we wanted to convey.

This image was shot with a seven-light setup. Two silver-lined, three-foot umbrellas were used for the background, their power adjusted to emit two full *f*-stops more light than the main light on the subject. A third light, housed in a five-inch bowl reflector, was mounted on a boom stand and placed above and slightly behind the subject, to illuminate the top and back of her hair.

The main light was a six-foot, white-lined umbrella, with a plastic diffuser cap over the light source. It was placed about 30 degrees to the right of the camera-subject axis. A fill light in the form of a 3x4-foot soft box was placed about 20 degrees to the left of the camera-subject axis. Its power was adjusted to give two full *f*-stops less light than the main light.

The final two lights—two snooted kicker lights—were placed approximately 90 degrees to the left of the camera-subject axis and directed onto the subject's back and the back of her head. The power of these accent lights, as well as that of the top light, was set to equal the main light's output.

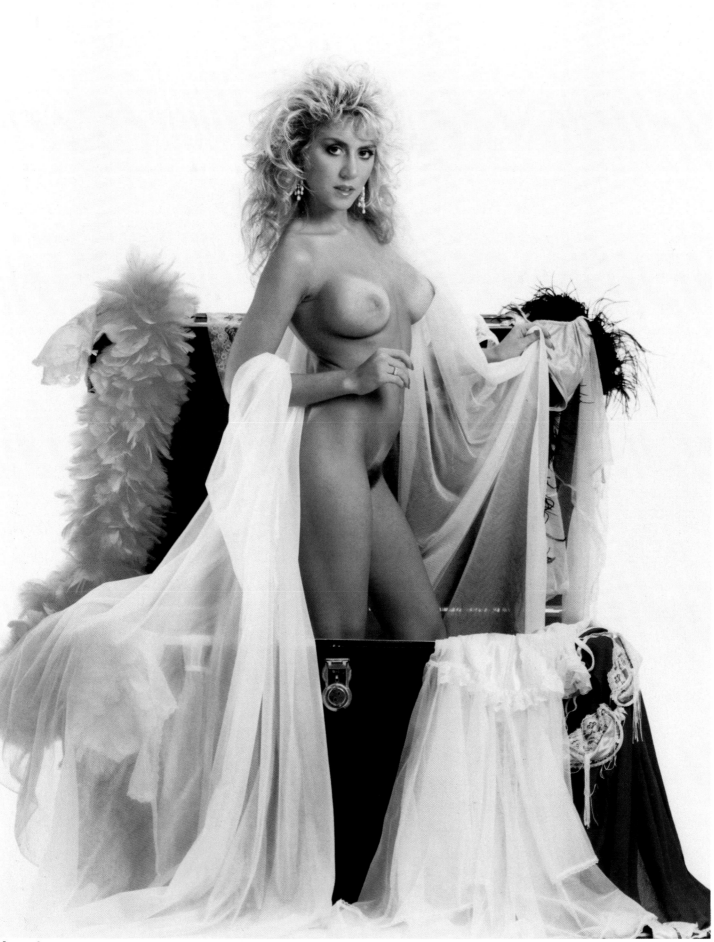

Image 2

Image 3 demonstrates a traditional pose in a simple, low-key setting. Because the subject's face is easily discernible, the image does not have a feel of mystery or the same high impact as Image 4.

In Image 3, the face was intentionally highlighted so that a viewer's eye would immediately go to it, causing the other body elements to become secondary. Notice, incidentally, how light was used to flatter important areas such as the breasts, the line of the back, the buttocks, the upper legs and the hair. Notice also how the subject's heels are clearly highlighted. This was essential; it provides the only clue that she was, in fact, in a kneeling pose.

Image 4 is a good example of a classic figure study. The pose is traditional, the setting timeless and the subject "impersonal" because she is unrecognizable.

Although the model is in a static pose, there is a distinct feeling of motion in the image, almost as though she is waiting to spring into action.

Because of its impersonal nature, the image suggests womanhood in general rather than the specific woman who is posing.

The pose in Image 5 is quite dramatic and even sensuous. The unusual view of an upside-down face adds drama, as does the loosely hanging hair.

This pose called for considerable flexibility on the part of the subject. Don't be surprised if not too many subjects are able to get into this kind of pose.

This image was created with a very simple two-light setup. The main light, in a five-inch silvered bowl reflector, was above the subject on a boom stand. This light illuminated the subject's legs and bust. A second light, in a 12-inch bowl reflector, with a 10-degree grid spot and covered with a plastic diffuser cap, was placed on a low stand about 70 degrees to the right of the camera-subject axis. This light furnished the illumination for the subject's hair and face. Its power was adjusted to equal that of the main light.

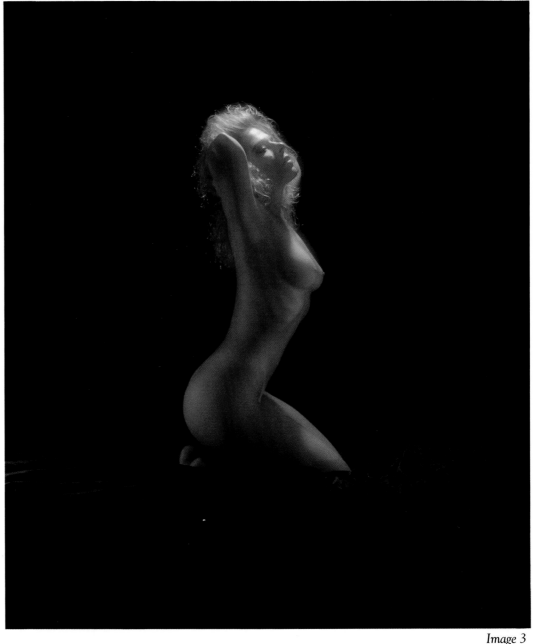

Image 3

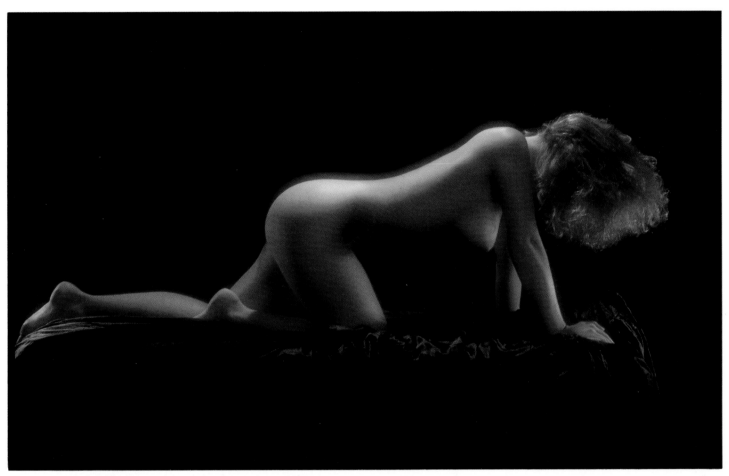

Image 4

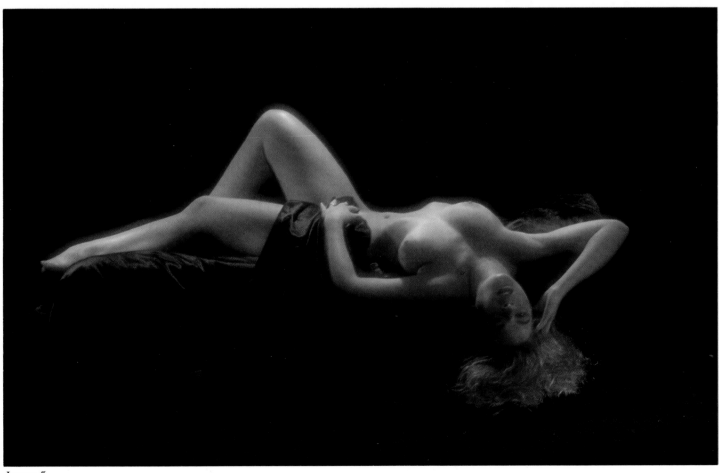

Image 5

Although Images 6 through 10 appear as though they may have been taken at a subject's home, they weren't. They were all shot on one of our permanent studio sets. As you can see, a setting such as this fireplace set can offer a wide variety of moods and images.

Although these five images are of the same subject and in the same setting, each demonstrates a different pose, a different mood and, as a result, has a different impact on the viewer.

All five images were made with a medium telephoto lens and a Softar 2 soft-focus filter.

During this one photo session, with the one subject and setting, we were able to shoot 22 different images. We could have achieved even more variety if we had changed lens focal lengths and varied the degree of diffusion or soft focus during the shoot.

When a fireplace is to be included in a photo scene, we recommend that you actually build a fire. Otherwise, the fireplace will record as no more than a dark pit.

Although our fireplace uses real logs, with the fire being kept alive by a gas burner, we seldom use it in this manner because it calls for relatively long

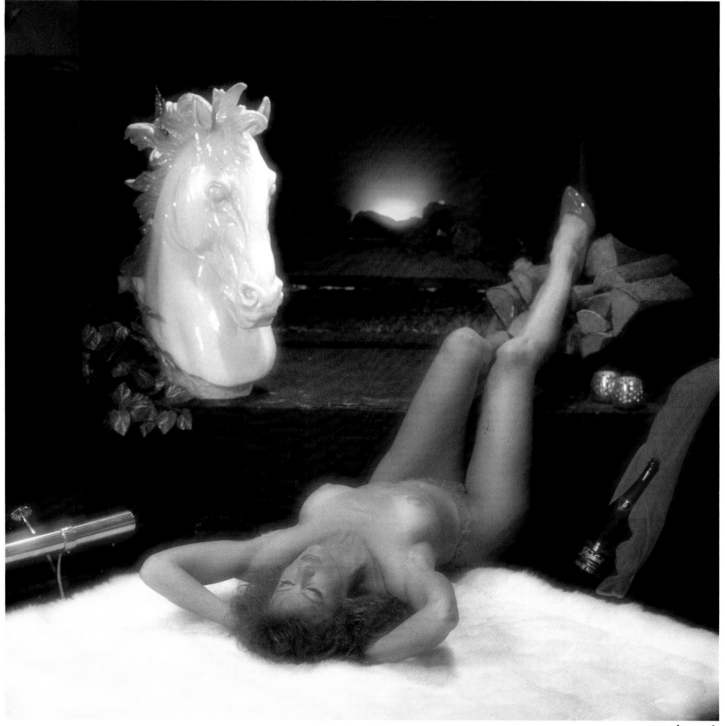

Image 6

exposure times. Our fireplace setting is used not only for nude studies and boudoir photography, but also as a setting for family portraits. We have found that non-professional subjects, and especially young children, have difficulty remaining rock steady during long exposure times.

We have taken a photograph of an actual, beautifully burning log fire and made a fireplace-sized Duratran transparency of the image. We place this larger than 20x24-inch Duratran in the fireplace, put an appropriately powered light behind it to transilluminate it, and use this "prop" as our fire. It works very well.

However, for the photos reproduced here we used a simpler method. We placed a flash head, covered with a deep-amber gel, behind the logs. We set the power output of this flash to give two f-stops less light than the main light.

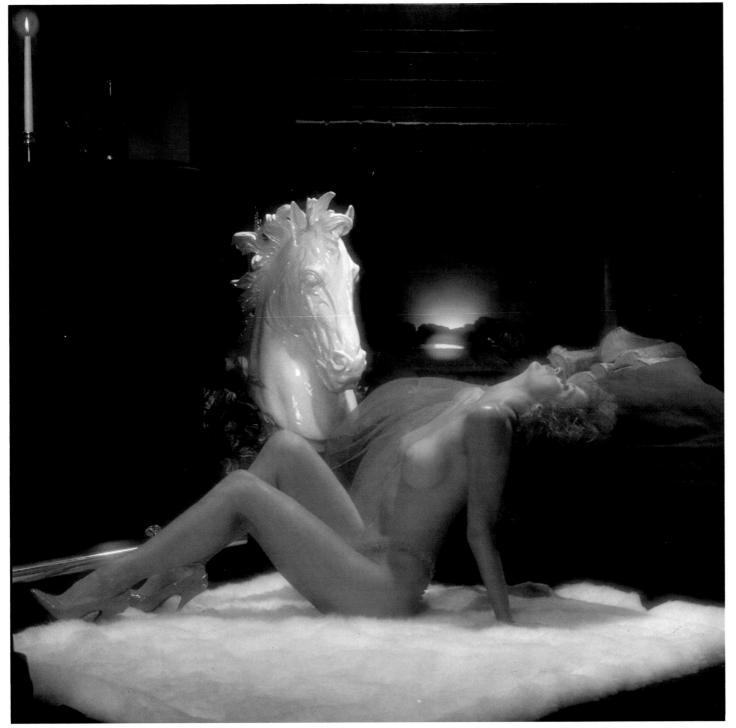

IMAGES
8, 9, 10

Image 8 is a good example of a traditional pose in a contemporary setting. In contrast to the other fireplace photos, this one places most of the emphasis on the subject's figure and less on the setting. However, enough location data—the glow of the fire, the horse's head and the logs—was left in the scene to clearly establish the location to a viewer.

Image 8 depicts a very revealing pose. The arms are raised and the full bust is exposed. Because the distant leg is raised, rather than the near one, more of the lower body area is visible. A pose such as this must be handled carefully if the resulting photo is to have grace, dignity and an innocent beauty rather than a sexually exploitive quality.

The fact that part of the face is covered by one arm, and the presence of the downward-pointing triangle formed by the arms, cause a viewer's attention to be directed downward very effectively to the subject's body which, clearly, is the key feature of this image.

Images 9 and 10 are very personal nude studies. Because of the subject's direct eye contact with the camera—and thus with the viewer—these images could well be intended for the subject's one special person in her life rather than for public display.

Although the pose shown in Image 10 can be very sensual and flattering, it can also create problems. In this case, the subject's right side developed some severe wrinkles around the waist. They were unflattering and had to be concealed. We could have had the subject assume a different pose. However, this would have changed the concept we were aiming for. A second, also undesirable, alternative would have been to ignore the situation and deal with the problem after the shot had been taken. This would have necessitated extensive art work or retouching, which is both costly and time consuming.

A final solution to the problem—and the one we used for this photo—was to have something cover up the problem area without destroying the nude concept we were after. That's the reason for the right arm and the red material across the waist area. You'll notice that the pose and the drape both solve the problem and also look very natural and attractive.

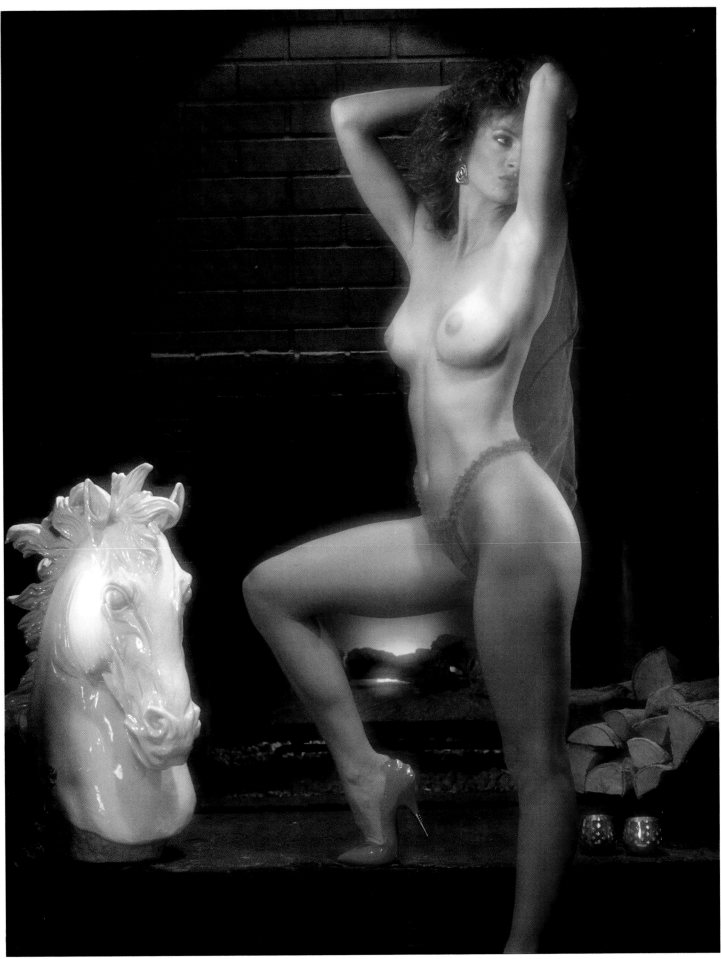

Image 8

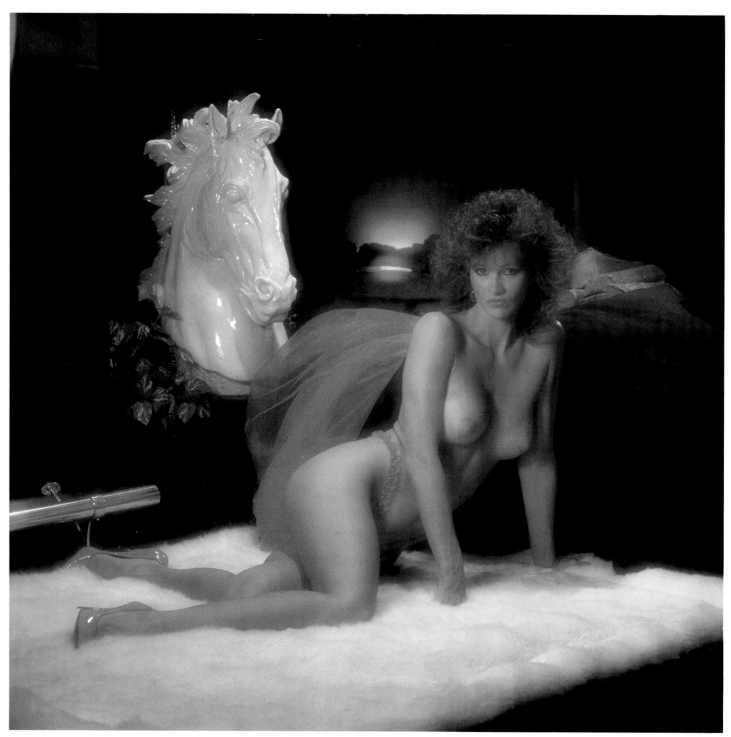

Image 9

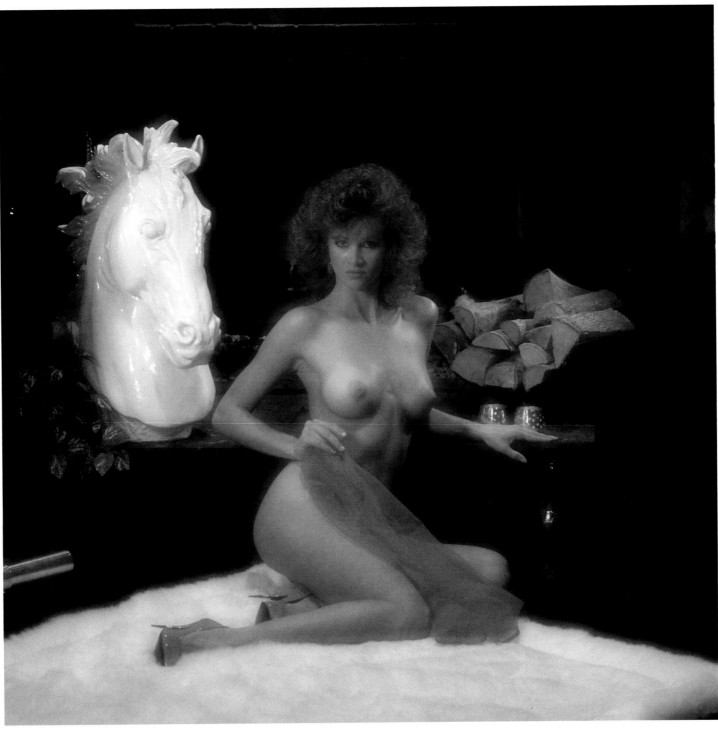

Image 10

Sometimes a prop can lend strong support to an image. Such is the case with the attractive shoji screen we used for Images 11 through 15.

This roll-up screen is readily available, in a number of different colors and sizes, from many import stores, such as *Pier 1 Imports*. It is not expensive. The screen can be set up and moved very easily and quickly, making it a pleasure to use.

This prop also offers great photographic variety. You can place the screen perpendicular to the camera's lens axis and shoot through it, as depicted in Image 11, or you can use it as a side wall, as shown in Images 12 through 15. You can also use such a screen as a backdrop.

When you shoot through a screen of this kind, you should take some special precautions. If you choose too wide a lens aperture, such as *f*-4, and the subject is at a considerable distance from the screen, such as six or seven feet, depending on your precise point of focus, either the screen or the subject may be less than adequately sharp.

Since we wanted both the screen and the subject in sharp focus, we placed the subject very close to the screen—about three or four inches away—placed the point of focus on the near side of the subject, and chose a lens aperture of *f*-11.

The subject's face was intentionally allowed to fall into deep shadow so that full emphasis would be given to her figure.

Image 11

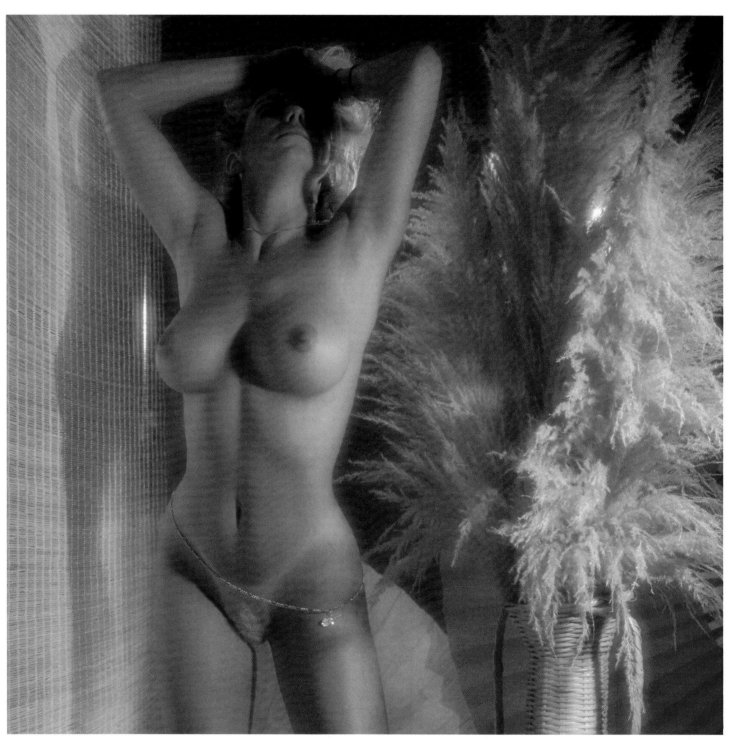

Image 12

In contrast to Image 11, which was very subtle, Image 12 leaves little to the imagination. This is an image of full frontal nudity, with no props or shadows to hide any parts of the subject's body. To keep the image "impersonal" and give it a certain "statue" quality, we avoided direct eye contact of the subject with the camera and kept her face somewhat in shadow.

When shooting through a shoji screen, as in Image 11, you should keep props to a minimum. The main theme of the image is the combination of the slat pattern and the subject's body. The low key of the setting and the small openings between the screen's slats would make it difficult for a viewer to keep his attention on a variety of props as well.

However, when we shot with the screen to the side, as depicted in Images 12 through 15, we could afford to be more generous with our propping. That's why we gave much more prominence to the plumes and basket in those photos. We also thought that the colorful fans behind the subject, and the lines and texture of the screen itself, were good items to either mirror or contrast with the texture, lines and curves of the subject's figure.

Although Image 13 was originally taken as a full-figure shot, the image looks better when it is cropped to include only the torso but not the head, as you see it here.

For the most part, our studio shots are well thought out in advance. Accordingly, we generally crop in the camera rather than after the shoot. This procedure forces us into a discipline to see exactly what we want before we shoot, rather than manipulating our images at a later stage.

Nonetheless, sometimes we will find, after a shot has been taken, that the image will look better and be strengthened if it is printed or presented in a more cropped fashion. Such was the case with this image. By eliminating the subject's face from the image completely, much more emphasis is placed on the body. The dramatic lighting provides beautiful modeling to the subject's body.

You will notice that the props around and behind the subject are fully lit, while the subject herself is in low-key lighting, with only selected body parts accented by light. This gives the image added depth and dimension. If we had chosen to do the opposite—subdue the props and highlight the body—an entirely different photo would have resulted. We believe that such an image would not have been as strong.

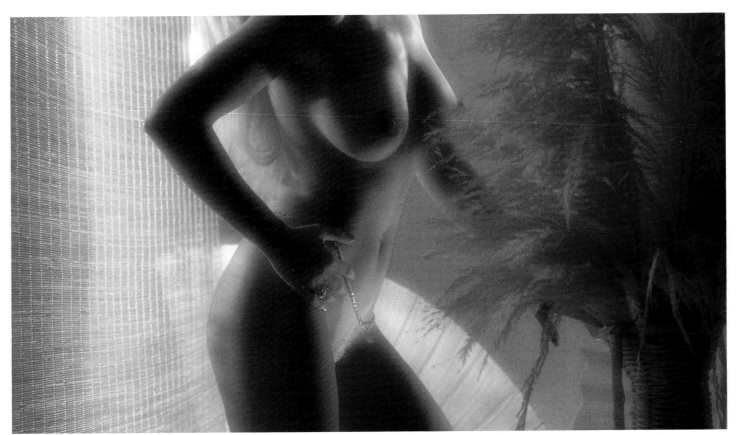

Image 13

Image 14 is a good example of a "graphic" figure study. The subject is in a pose that creates a geometric pattern with the body. Notice how the rim lighting helps to emphasize the lines and the "graphics" of the image.

To give the image a strong three-dimensional look, we chose a three-quarter camera angle rather than a direct side view. Had the body been turned more into a profile position, the image would have lacked depth.

The curves of the fans, the subtle pattern of light coming from the shoji screen, and the highlighted basket on the right side all help to "contain" the subject and draw viewer attention to her.

When you are setting up a figure pose, be very careful and selectively light those areas that you want to reveal prominently, and do so in a flattering manner. Don't over-illuminate areas that should be kept in a low key. Only by such selective lighting can you be sure to get artistic figure studies rather than what might appear more like sexually exploitive, undignified images.

In Image 15, we wanted to get the viewer to concentrate on the upper part of the subject's body. To

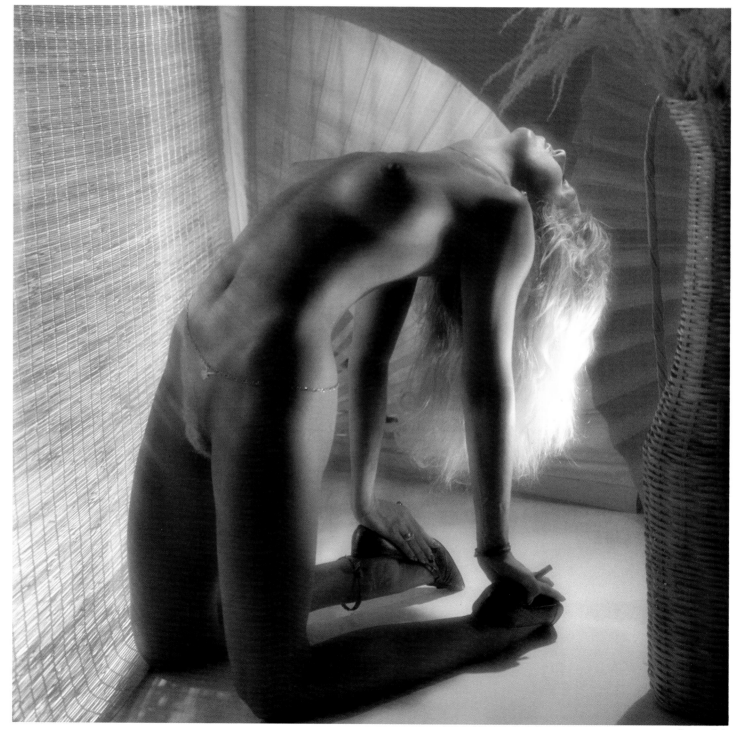

Image 14

achieve this, we controlled three conditions: we had the subject assume a seated pose; we had her turn her head and gaze away from the camera and the intended viewer; and we used strong side lighting on the subject's breasts. A major change in any one of these factors would have produced a markedly different photographic effect. This is one of the reasons why it is so important to have a preconceived idea of what you want to do, prior to the exposure of any film.

Always use caution and thought in the placement of props. If they are placed too close to a subject, the subject will appear crowded and the feeling of space will be lost. If they are placed too far away from the subject, their significance will be reduced, if not lost completely.

Often even the subject's expression is a very important element in a figure study. For example, if this subject had been smiling, a completely different photo would have resulted. When in doubt as to what kind of facial expression you should have a subject adopt, you are generally better advised to go for a pensive, meditative, tranquil and serene look rather than an excessively happy and exuberant one.

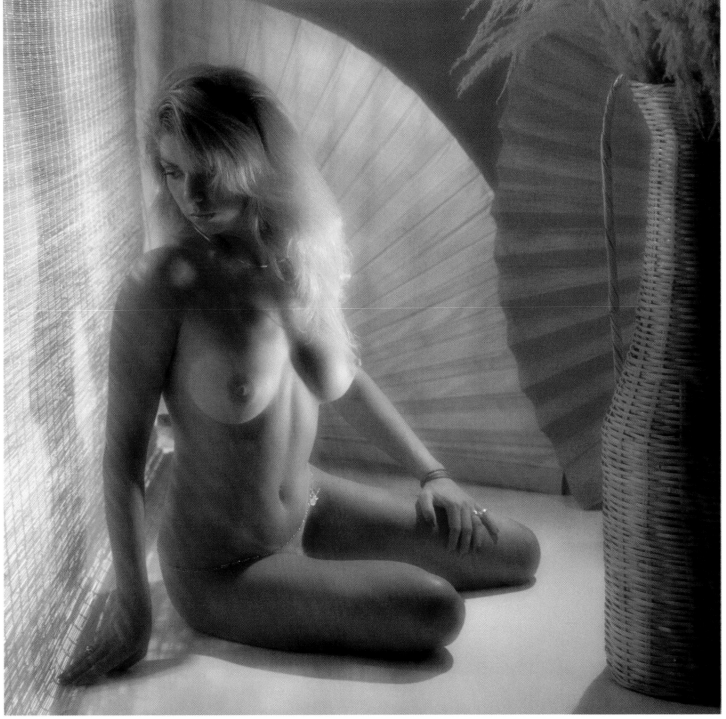

Image 15

For Image 16 and the following two images, we worked with one major prop—a fish net. For psychological reasons which we won't attempt to fathom here, there always seems to be something especially exciting and attention-getting about a subject who is covered by something and yet is clearly and visibly nude.

We have shot this same pose using only white lighting and no netting. The result was far less impressive; it seemed cold, stark and barren. We want you to be aware of the difference a prop of this nature and colored accent lights can make to certain images.

Unlike Image 16, where the subject was posed on a rock, Images 17 and 18 use no such crutch for compositional support. As a result, the images are less dramatic and more tranquil. Because the subject's head and body are turned toward the viewer in Images 17 and 18, the appeal of the images is a more personal one, even though the subject is not looking directly at the camera. In fact, in Image 18 her eyes are closed.

For Image 18 we changed to a netting that is coarser and more open. The subject now appears lightly covered rather than encased. Also, while we allowed the viewer's attention to wander freely over the subject's figure in the previous two photos, in Image 18 we introduced a deliberate point of focus by placing a starfish near the subject's midriff.

We have intentionally maintained detail in the shadow areas in these photographs. This gave the images a light atmosphere, creating the impression that the subject was very comfortable under her covering. Had we permitted the shadows to go black, the images would have taken on a more severe look, so that the subject might have appeared entrapped by the netting.

Notice also that, in each image, the subject is enclosed not only by a net but also by a very clearly defined and limiting circle of light. The visual reinforcement of a statement—in this case the reinforcement of the "enclosure" statement made by the net with the enclosing light circle—can be very effective in a photograph.

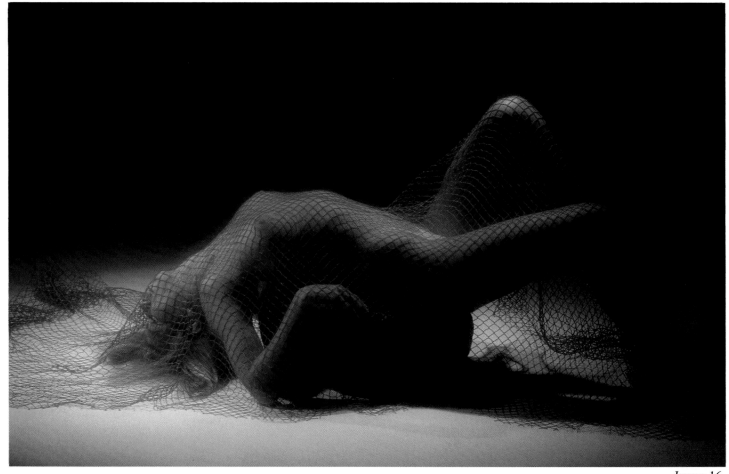

Image 16

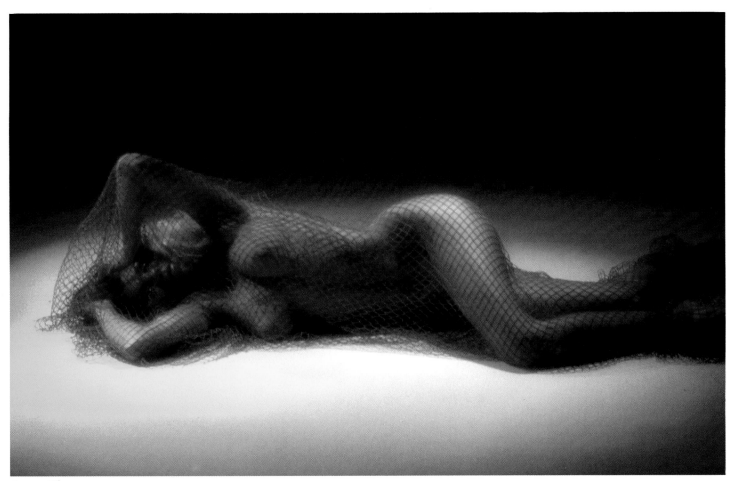

Image 17

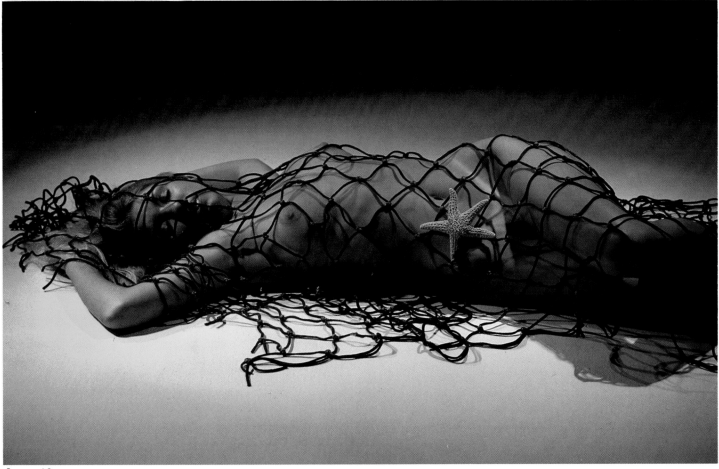

Image 18

Images 19 and 20 were taken in our barn setting. A scene such as this is so easy to set up and tear down that it is a pleasure to work with. All we need is a few bales of hay, a prop or two—such as a cowboy hat and boots—and we're ready to shoot.

Here, we started with a white background sweep. We put a five-inch bowl light on a boom stand, above and slightly behind the subject, for a main light and added a couple of kicker lights, gelled yellow, for accent lights. One background light, gelled yellow, was placed on the floor directly behind the subject.

The white background has not actually photographed as white because we allowed no illumination other than that from the yellow-gelled background light to strike it. We set the intensity of that light to produce the colored tone you see in the images. As the background light falls off and gets less intense from the center of the background toward the edges, it degrades into an even darker tone.

Although we could have chosen a number of different colors to accent our subject and light the background, we thought that the warm tones

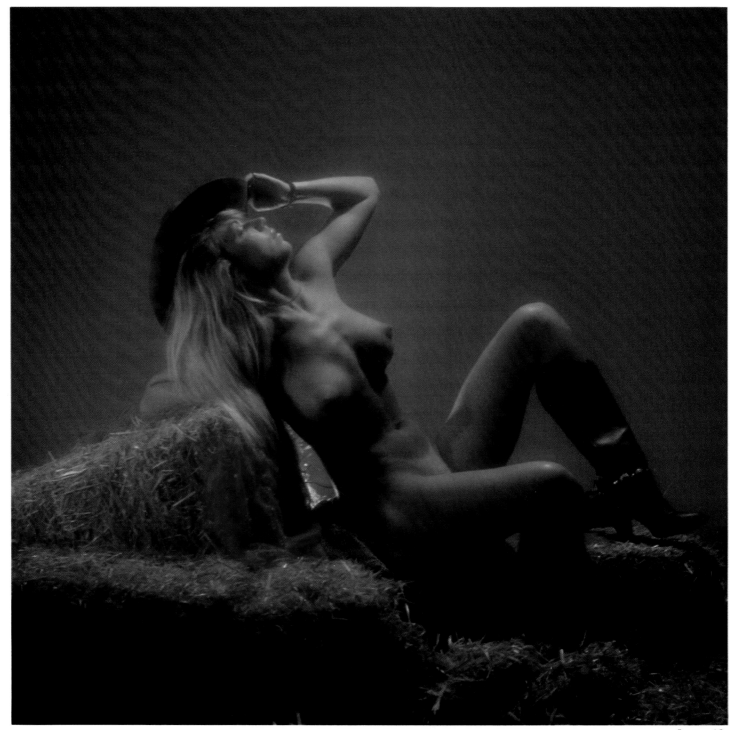

Image 19

we used were most in keeping with the color of the hay.

In Image 19, the placement of the body caused the high main light to skim across the subject's breasts in a way that makes her bust the main point of attention. The fact that the face is receiving as much light as the upper torso does not alter the main point of interest—the subject's bust. This is due mainly to the fact that the subject's face is bathed in a soft, shadowless light while the subject's chest has much higher contrast. Contrast will usually draw viewer attention more readily than a flatly lit area.

In Image 20, we wanted the lighting to cause a viewer's attention to be confined to two main areas of the subject's body—the gently arched back and the breasts. Accordingly, the high main light was placed slightly behind the subject so that her back and buttocks could be rimlighted. The accent light was placed at a low angle, 90 degrees to the left of the camera-subject axis, and directed toward the subject's breasts.

Most of the face was intentionally hidden and the legs were allowed to go into shadow, so that the viewer would keep his attention where the main thrust of the illumination was directed.

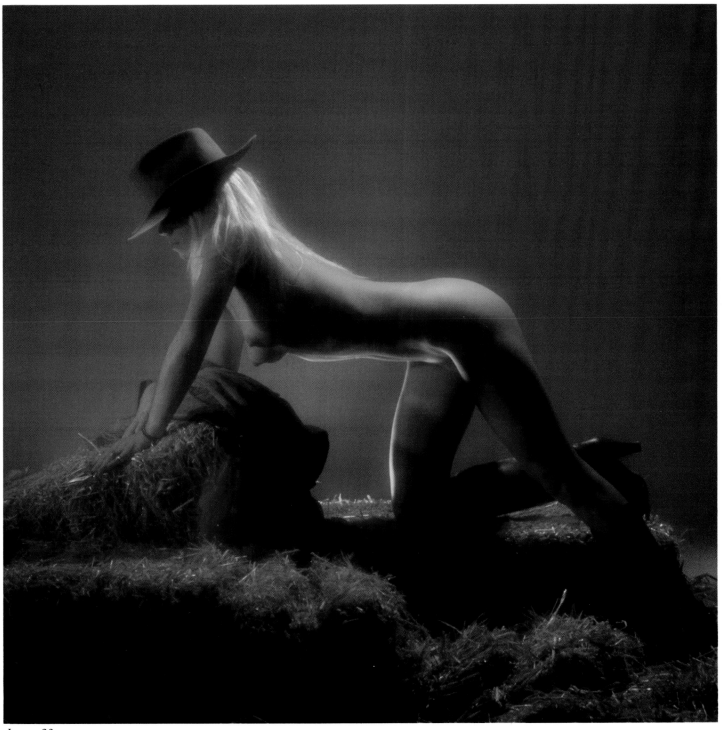

Image 20

Images 21, 22 and 23 were created in a setting we call the "marionette scenario." The setup was rather elaborate, involving seven lights. It is not a very versatile concept, supporting only about six practicable poses. Nonetheless, it's a concept that is fun to work with and very suitable for figure photography.

We attempted to create the effect that the subject—the marionette—was on stage in rather classy surroundings. Toward this end, we used wine-colored satin drapes for a curtain and had the puppeteer, who is barely visible in the background, wear a tuxedo. Although it was important that a viewer perceive the puppeteer's presence, we did not want to light him so prominently as to cause distraction from the main focal point—the female subject's figure and pose.

To give the subject a theatrical and festive "marionette" appearance, we painted a couple of circles on her body. Since we did not want to use colors that might be too distracting, we chose simple black and white. The body paint we used was *Tempura*, available in a variety of colors from most art supply stores.

One caution on this material: it dries out rather quickly and has a tendency to crack. Therefore, once such paint is applied to a subject's body, be prepared to start photographing immediately.

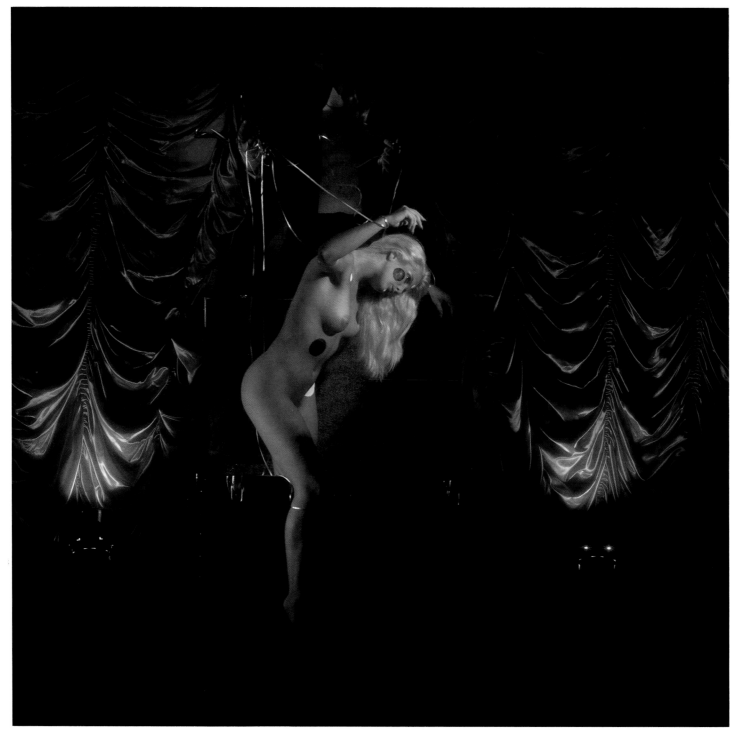

Image 21

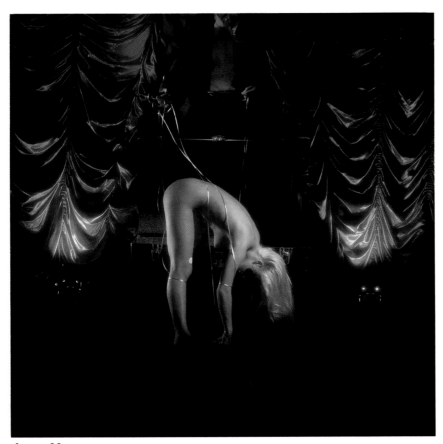

Image 22

Once the cracking process starts, you will have no choice but to have the old color washed off and to start anew.

To make our puppet's strings prominent, as well as festive looking, we used silver ribbons. For the puppeteer's hand controller, we used two wooden paint spatulas, hot-glued them together in the shape of an X, and painted them matte black.

Although top, background and accent lights were used to shoot these images, we wanted to create the impression that the subject was lit by a "theatrical" spotlight. Accordingly, we used an adjustable electronic-flash spotlight as our main light source. It was positioned at about 45 degrees to the right of the camera position.

When you stage a series of "action" photos, such as this set of three, be sure to introduce sufficient variety in the poses, to tell a story and keep the viewer interested.

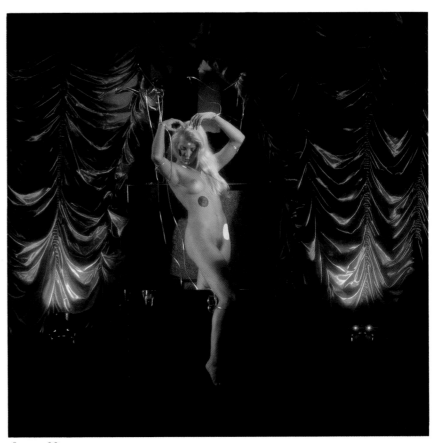

Image 23

In today's fast-paced, troubled world, we thought that we would provide a light-hearted change of pace by photographically creating a spoof on the very poignant topic of terrorism. That was the basis for Images 24 and 25, which we have entitled "Airport."

In Image 24, the body language—the subject's open and unguarded stance—suggests strength, tension, toughness, preparedness and readiness for a confrontation. The two weapons that she is holding underscore this impression and support and add to the subject's overall strong appearance. The fact that the guns are subtly concealed in deep shadow seems to make them even more menacing.

However, there is a pictorial incongruity: the soft lines and curves of the subject's body. It seems totally inconsistent to have such softness and grace present such a threat. But therein lies the spoof. We are pictorially poking fun at a very provocative topic.

Even though the subject's eyes are directed toward the viewer and in spite of the total, frontal nudity and the unguarded pose, and in spite of the sad humor of the situation, we consider this a fine figure study rather than an exploitive one. What's the difference? In a subtle case such as this, we can only say, "we can't explain it verbally, but we sure know it when we see it—and so will you." If you are a sen-

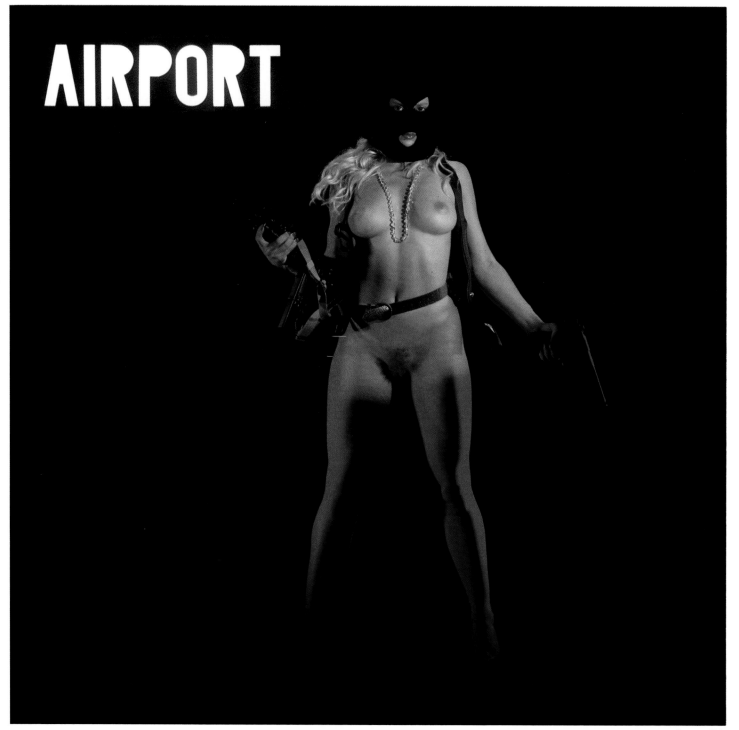

AIRPORT

Image 24

sitive, creative and caring photographer, a photograph that doesn't "make the grade" will make you feel uncomfortable.

It is interesting to note that the nudity is almost essential to make the spoof work. If the subject had worn clothing the incongruity, and thus the humor of the situation, would have been lost. One might then have interpreted the image as one documenting or promoting terrorism. This, of course, is far from the image we wanted to create.

While the subject seems to be threatening a confrontation in Image 24, the pose and attitude in Image 25 seems to indicate an "after-the-fact" situation. The subject is not preparing to take some sort of action but, to the contrary, has apparently already engaged in a confrontation and is now contemplating what has occurred. In Image 24, you could imagine that the subject is quietly saying, "I dare you!" In Image 25, however, the impression is that she is saying, "See, I told you so!"

It never ceases to amaze us how many different photographic interpretations one can derive from the same subject, in the same setting, using the same lighting—simply by making a pose change. It is a very powerful photographic tool. When a posing change is also accompanied by a major change in lighting, the possible photographic interpretations become legion.

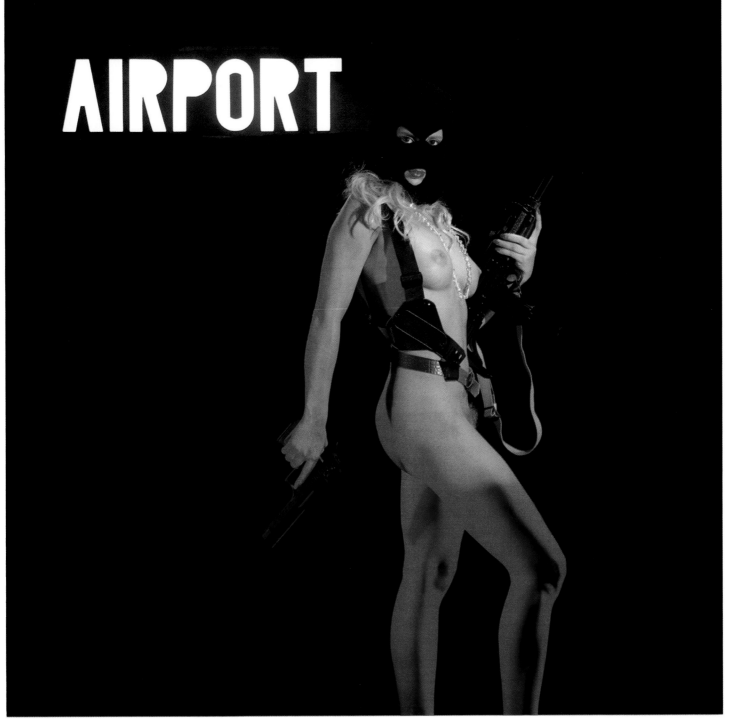

Image 25

We created these three images on our permanent bedroom set. We wanted to create images that had the bedroom as background and a doorway in the foreground, so we specially added a temporary, dark doorway.

Image 26 projects a strong feeling of tranquility as well as spatial depth. The dark, plain foreground does a lot to give the image this added three-dimensional quality. A viewer almost gets the impression that the subject's head and upper body are about to pop right out of the page. This extreme sense of depth is enhanced further by the fact that the subject's lower half is located in a very light zone.

Exposure was based on the light falling onto the subject and the background area, and not on the black doorway in the foreground, which we wanted to record with absolutely no detail. The resulting impression is that the subject is lying in an open doorway between two rooms.

Image 27 is almost identical to Image 26 except that a second subject has been added. Because of this added foreground interest, and the partial obstruction

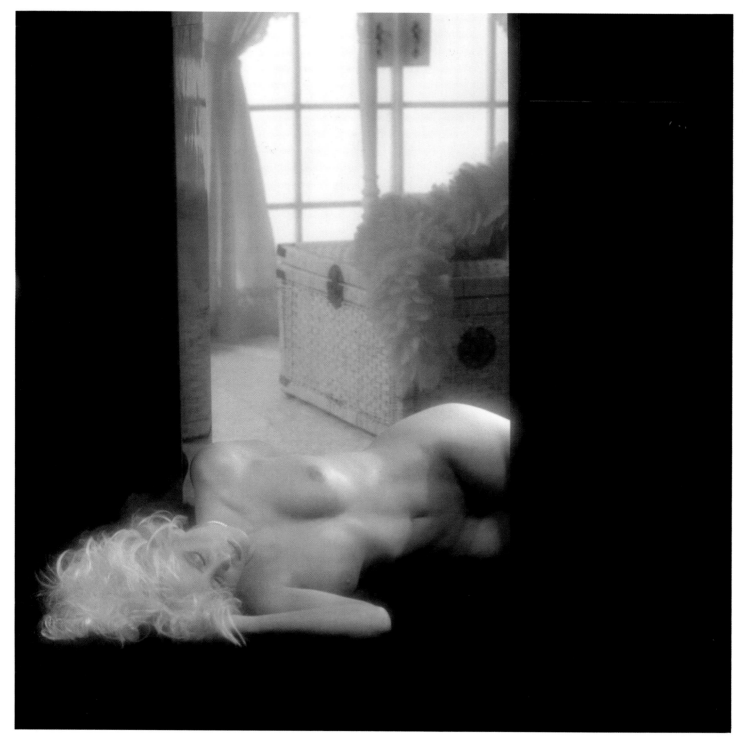

Image 26

of the background area by the second subject, less depth is perceived in the image. Both subjects were lit equally, forming one integral point of interest.

Care was taken to compose this image very carefully. You'll notice that the subjects' bodies are not in contact with each other. The "contact" is implied. Actual, physical contact would have led to an entirely different photographic interpretation.

The lighting consisted of a main and an accent light on the camera side of the doorway. These lights were carefully shielded and snooted, to keep unwanted spill light from the black doorway. For Image 27, a second snooted light was placed behind the right side of the doorway, to add illumination to the seated subject.

A four-foot silvered umbrella, with a pink gel, lit the bedroom behind the doorway. Two other lights, each with a pink gel, were placed outside the bedroom window, with their illumination directed into the bedroom. The main light's output was adjusted to emit one f-stop more light than the other lights.

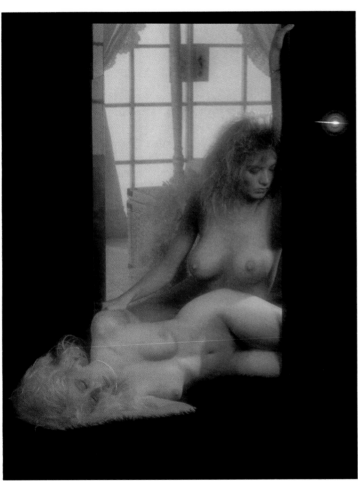

Image 27

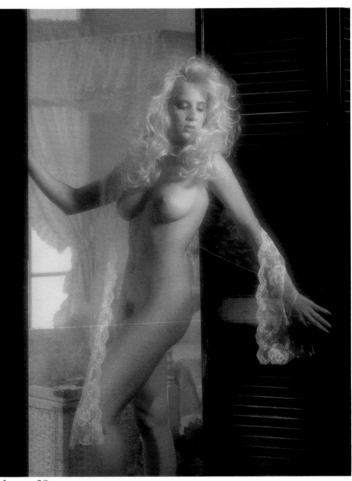

Image 28

The key word to describe Image 29 is "drama." This drama has been created deliberately with the use of fog, vibrant red background and rim lights, an exuberant stretching pose, contrasty subject illumination and a contrasty, partially black and partially bright, background. For shots such as this, deep and vibrant color gels—deep reds, dark blues and even saturated greens—are very effective. Paler, pastel colors are much less effective in creating images with drama or an air of mystery.

Our experience has shown that it is not advisable for all of the illumination in a shot to be colored. Somewhere in the photo scene, generally on the subject's body, some natural white light should be present. Otherwise the image simply becomes monochromatic and dull. The white light actually helps to accentuate the effect of the colored lights.

An image with this type of setting takes virtually no time at all to set up. The black "wall" against which the model is posing is simply black material, suspended from a Century stand. Immediately behind the black wall was an assistant, holding onto the subject's left hand, so that she could feel comfortable while leaning backwards and not fear losing her balance.

A top light, in a five-inch bowl reflector and on a boom stand, was placed above the subject, near the left edge of the picture area. It was directed onto the subject's face. A four-inch snooted light was placed about 90 degrees to the left of the camera and directed onto the subject's buttocks and legs. Another similar snooted light, but with a red gel, was placed directly behind the black wall and directed onto the subject's midriff. The artificial fog was lit by a snooted, red-gelled light, placed on the floor behind the subject and directed upward.

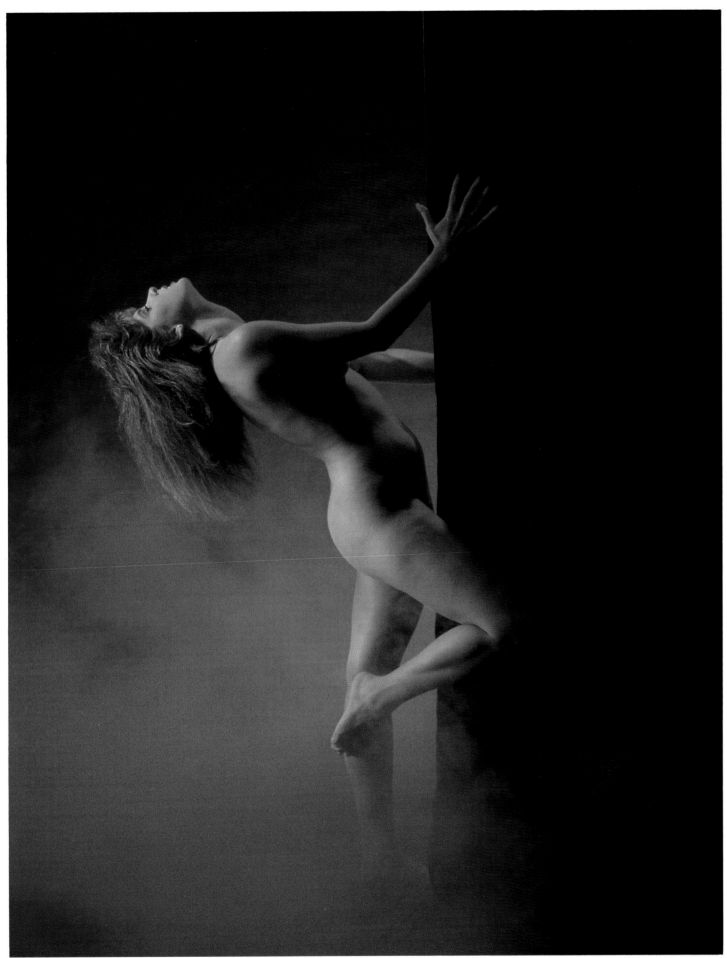

Image 29

Several special factors serve to make this an almost surrealistic image: the subject's head being completely hidden from view; the low-key setting; the distorted shadow of the subject on the door she is facing; the eerie color produced by the green-gelled light; the subtle use of fog.

The power of a pose can be a very strong photographic tool. No matter how attractive your subject may be or how curvaceous her figure, just placing her in a fabulous setting and painstakingly setting up the lighting is not enough. If the subject assumes an inappropriate or ungainly pose, or if you position her on the set without careful thought, the resulting images will be disappointing.

For example, it is interesting to note that if more of the subject's body had been made visible in this image—such as by using a fully frontal pose—and if her head had been included, the result would have been completely different in character and concept. This could easily have led to a sexually exploitive image rather than an artistic and dignified one.

The lighting was simple but very effective. The main light, without gel, was directed onto the subject frontally from the left side of the camera. It was placed in such a manner as to illuminate the subject but avoid lighting the door. Gelled green illumination was used from beyond the dark wall on the right side to rim light the subject's back, arm and legs, to give the door its deep-green glow and create the shadow on it, and to highlight the rising fog.

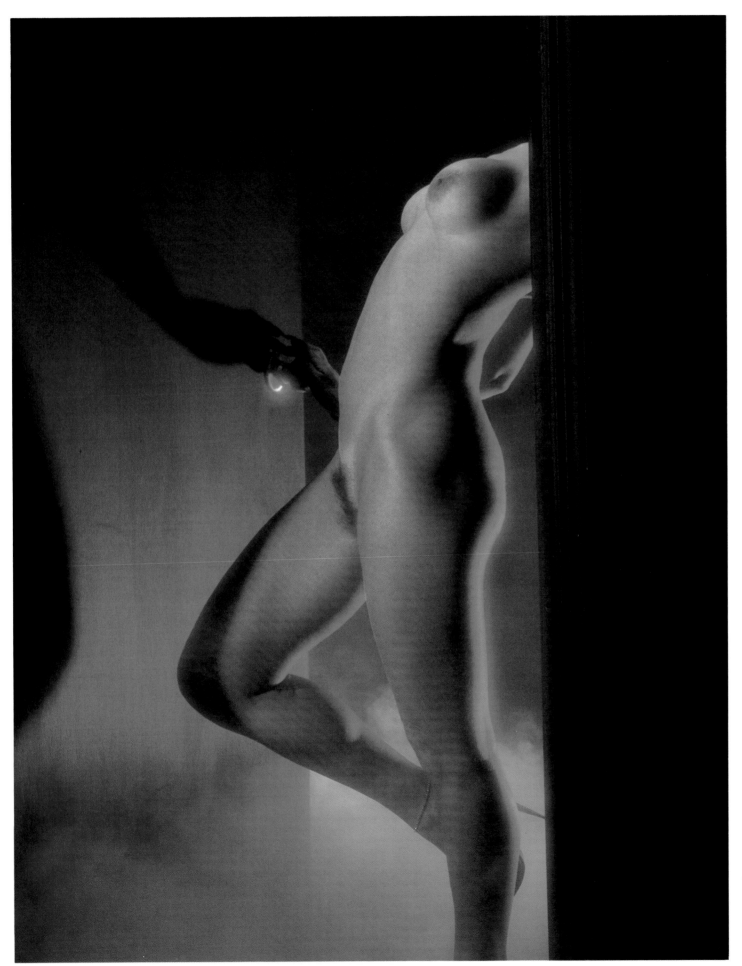

Image 30

The attractive young lady featured in Image 31 was very petite. For the purpose of this image, we wanted to make her look taller. To help us attain this goal, we used a low camera angle. The vertically and diagonally placed ropes provide an up-down orientation for the viewer which also helps to add apparent height to the subject. The low-lying fog conceals the lower part of the subject so that a viewer of the image is not immediately aware of the subject's stature. There is a wide variety of such visual tricks that you can use to make a subject look taller, shorter, heavier, thinner, and so on.

To avoid excessive distortion of our subject from the low camera angle, we used a medium telephoto lens and shot from a distance of about 20 feet.

You'll notice that the ropes give no clear scale indication that might reveal the subject's exact size. If we had posed her with a more familiar object, such as a chair, a table or a bookshelf, the viewer would have clearly seen the size relationship between the subject and the prop and thereby deduced the subject's size.

In addition to everything we have just said, there are other features and factors in this image that strongly suggest vertical direction and thus height. The subject is looking upward and her face is lit prominently from above. Her arms are extended in an upward and downward direction. And the ropes not only are oriented in a basically vertical direction but they are carefully placed to form a triangle or arrow that clearly points upward.

In addition to concealing much of the subject's lower half for the purpose described above, the fog also introduced an air of drama and mystery to the image.

The ropes, in addition to providing the compositional effect mentioned above, added a feel of motion and graphic impact. Their texture and straight lines also contrasted well against the subject's smooth skin and rounded figure.

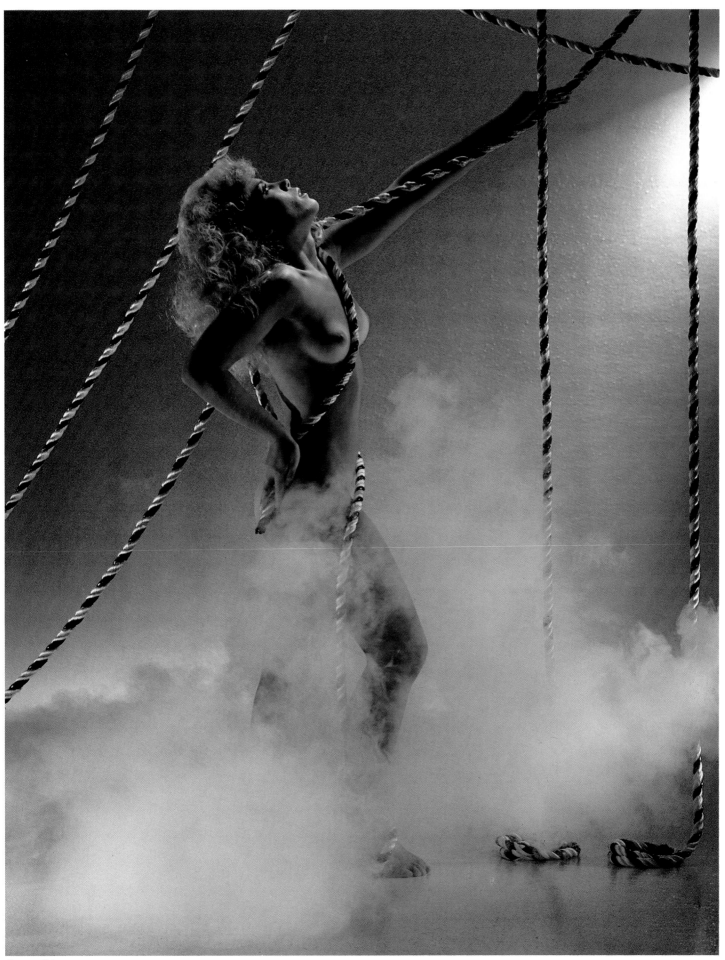

Image 31

To be assured of consistently good photographic results, it's essential for you to be familiar with the theory and competent in the application of basic photographic rules and principles. However, you should also know when and how to break the rules in order to achieve specific creative effects.

When discussing an earlier image, we commented that, when we use colored gels on our lights, our usual rule is to allow at least one light—most often the main light—to remain ungelled. Allowing at least some white light to strike the subject enhances the effect of the colored light. Following this rule leads to optimum photo results most of the time.

Image 32 clearly breaks this rule. If we had introduced white lighting, the desired effect would have failed completely. The image's entire character would have changed drastically from a surrealistic to a straight, documentary photograph—an effect we did not want.

Most manufacturers of gels provide dozens of different colors to choose from, and often several tone and hue variations of each. Choosing a color scheme for a nude study is a very subjective matter. The only way you can arrive at color combinations that you like is by experimentation.

When working with colored gels on your lights, be bold and don't hesitate to mix colors, even if the mixture seems to violate the "normal" rules of color coordination.

For this image, a deep magenta gel was used on the background lights and orange-red gels were used on the main and fill lights. These colors were chosen to suggest energy and vitality. The slight discord between the colors helps to suggest the strain and effort of the physical workout the subject is engaged in.

The main illumination on the subject was from her front and her back—to the left and right sides of the camera position. The resulting shadows, running down her arm and leg, strongly suggest motion and muscular activity.

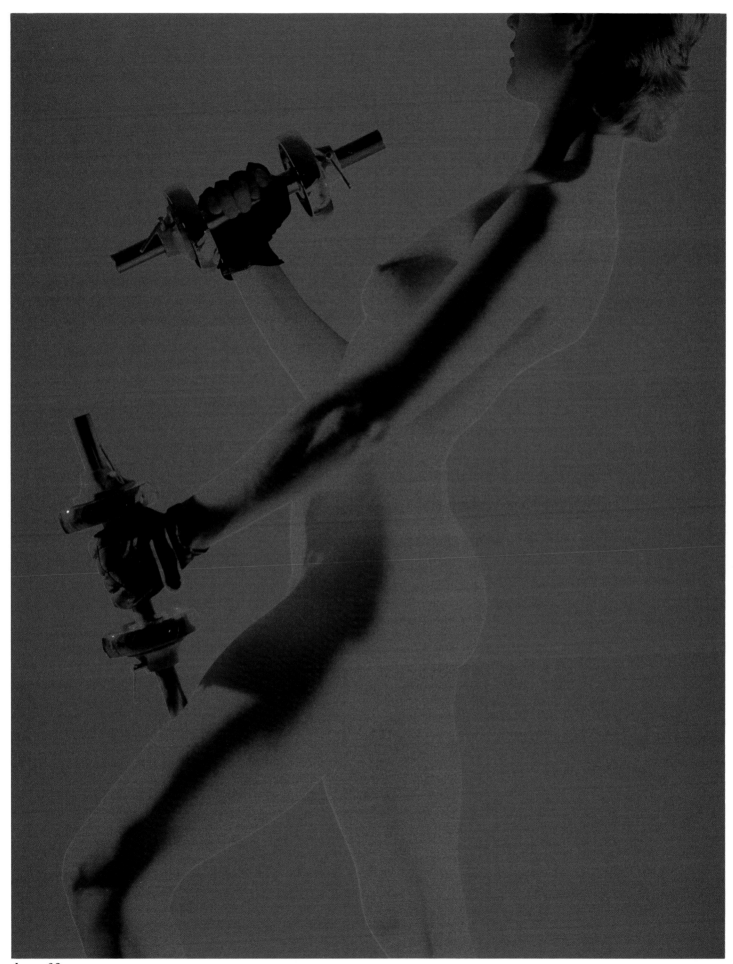

Image 32

A home environment can offer many potential settings for nude studies. One of the first things we look for when we examine a home is mirrors. We love working with them. However, there are some precautions that you must take when working with them.

First, make certain that you see no part of your own reflection in your camera's viewfinder. Also be sure that none of your lights or lighting equipment are reflected toward the camera. This will require choosing the light locations carefully, bearing in mind the basic rule that the angle of incidence is equal to the angle of reflection. If light strikes a mirror at a 20-degree angle, it will reflect from that mirror at a 20-degree angle.

Depending on the quality and tone of the mirror, the reflected image of a subject may be anywhere from one-half f-stop to two f-stops darker than the subject herself. If you are only recording the reflection, then base your exposure on the reflected image. If both the subject and her reflected image are to be recorded, you must compromise. You might consider lighting the reflected parts of the subject more strongly than the direct view of the subject, to compensate for light loss through the mirror.

In such a case, you should also be sure to light the subject in such a way that the lighting appears flattering on the subject's reflection as well as on the direct view of her.

We like to work with multiple mirrors, so that we can create multiple-image effects, as shown in Image 33.

With the incredible image sharpness provided by today's camera lenses and films, most female subjects are recorded much more "forgivingly" and kindly with the use of a soft-focus filter. Also, the use of soft lighting is often advisable. Without these precautions, images tend to be very stark and literal, revealing any flaws that might exist on a subject's body. Although this kind of "documentary" photography has its rightful place, it is not one we favor for our figure work.

Although Image 34 is a fine photograph, we have included it here for a somewhat negative reason: it, in fact, breaks the rule we have just discussed. For our taste, the image is too sharp and the lighting too harsh. We have not done total justice to our beautiful subject.

When we work with only one mirror, as we did for Image 34, we attempt to have the mirror reflect an aspect of the subject's body that is not seen directly by the camera. This makes the resulting image more interesting. Notice that we placed our lights so that both the subject and her reflection were presented with excellent modeling. It's almost like photographing two separate people! We used two main lights. One light, positioned to the left of the camera, was directed solely onto the subject's back and buttocks. The second light, which was carefully snooted, was placed even farther from the camera-subject axis on the left side and directed onto the subject's left side—the side that the mirror reflected.

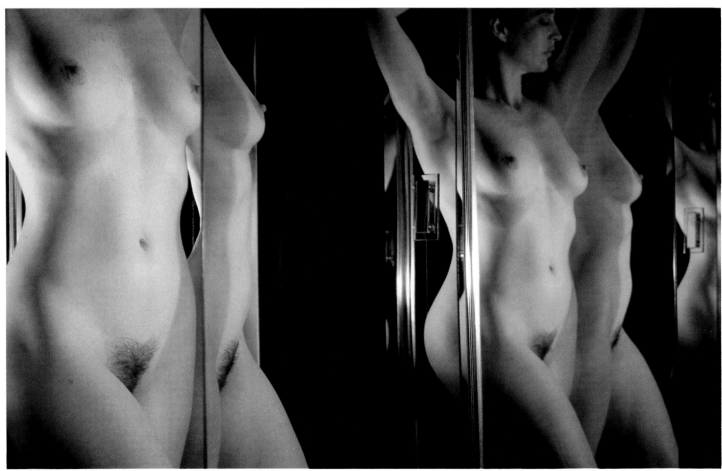

Image 33

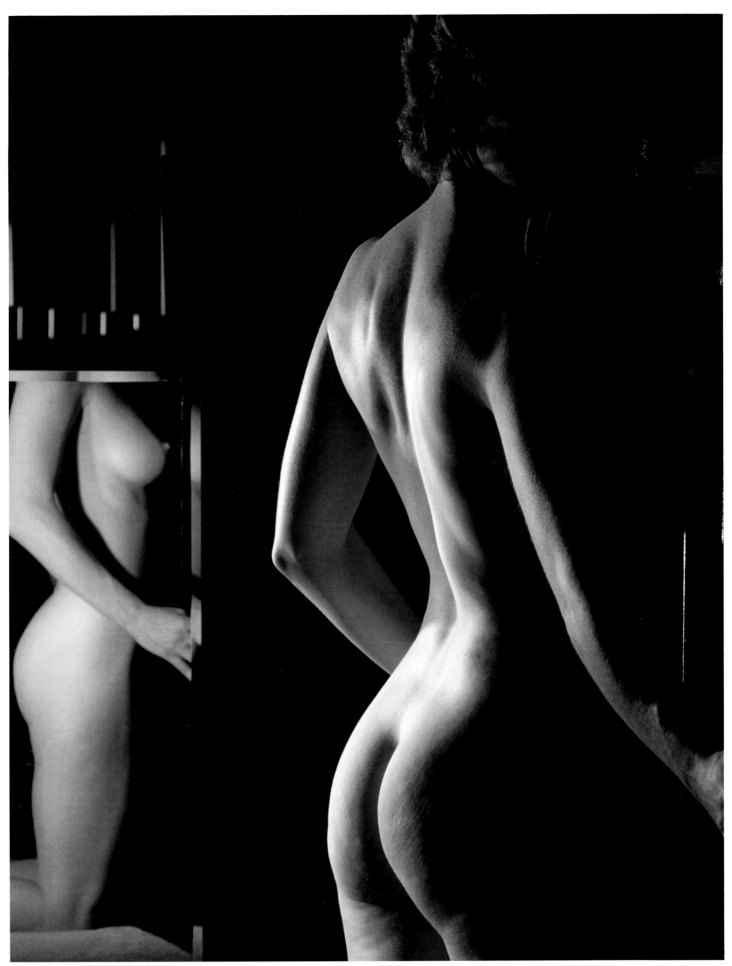

Image 34

Even though you may have thoroughly scouted a subject's home and have definite ideas of where and how you are going to shoot, always keep your eyes open for other shooting possibilities that may have gone unnoticed before. Sometimes conditions change, and you may observe something that did not exist during your previous visits.

In this particular case, we had finished photographing the subject in front of some upstairs mirrors and were on our way downstairs to try some additional shots there. As we began walking down the stairs toward the living room, the sun broke through the clouds and streamed through the living room window. We loved the strong, graphic shadows this produced on the steps.

Since the sun was clearly destined to hide behind more clouds, we had to work quickly. We immediately had our subject lie down on the steps and hurriedly but carefully positioned her so that the shadows from the stair rails would fall onto her body exactly where we wanted them. After we had made just a few exposures, the light became diffused again and the shadows were lost. Image 35 is one of the images that resulted.

One electronic flash was used as fill light. It was placed to the right of the camera-subject axis and directed toward the back of the subject. It was covered with an amber gel and its power was adjusted to provide one *f*-stop less light than the natural light striking the front of the subject.

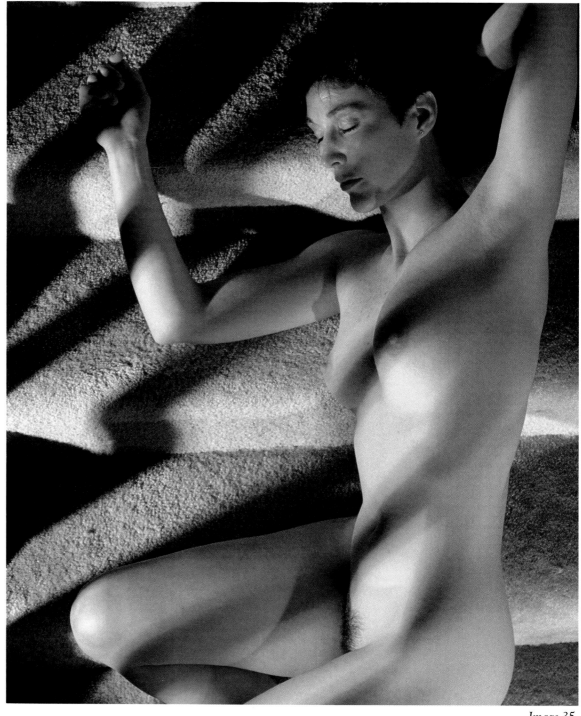

The subject's ability and enthusiasm as a model and the photographer's capabilities as a director and stimulating influence must combine to generate an attitude that complements the specific photographic situation. Without the right attitude, achieving fine figure photos will be difficult.

Experience shows it is easier to acquire this positive modeling attitude from women than from men. With few exceptions, such as Image 36, we prefer working with female subjects for figure photography.

Our female subjects, although they are nearly all non-professional models, seem to clearly understand what we ask for, consider our aims reasonable, and work hard to achieve the photographic results we want. Men have a tendency to feel "silly" or awkward while they are being photographed nude. They are much more self-conscious, tend to become flippant and often will not want to adopt a pose that seems less than "macho."

In this case, we had an excellent, cooperative subject to work with. To make him feel more comfortable we placed him into an environment that he could relate to. In order to further the concept that he was perspiring from working out, we sprayed his body with a solution of water and glycerin. As a result of this environment and his efforts, the photo is fabulous.

The low-key setting and low-key lighting helped to graphically reinforce the atmosphere of masculinity and strength.

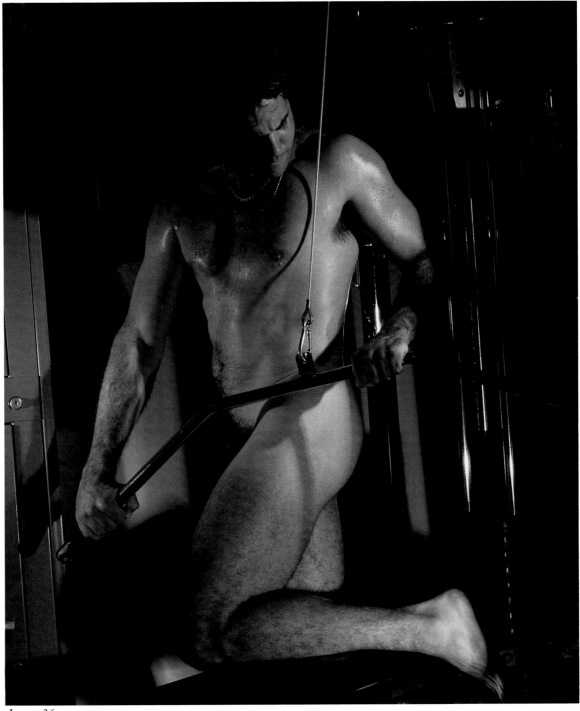

Image 36

As we have indicated before, when we use colored gels on lights we will generally leave at least one light—usually the main light—color-free.

For Images 37 and 38, we used a four-light setup. Three of these lights had a magenta gel. One of these lights was placed on the floor behind the subject, and directed onto a dark background. The second light was placed about 90 degrees to the left of the camera-subject axis and the third light was placed about 110 degrees to the right of this axis.

If we had used a magenta gel on the main light, as well—even with its power adjusted brighter than

the other lights—the images would have been dull and unstimulating. A viewer would have had some difficulty figuring out precisely what portions of the subject's body we wanted to emphasize. Allowing white main lighting to strike a limited area of the subject causes a viewer's attention to immediately go to those highlighted areas.

The three gelled lights had their power adjusted to emit one *f*-stop less light than the white main light.

In both Images 37 and 38, the white lighting has been deliberately limited to a very specific area to achieve a special graphic effect and impact. To be

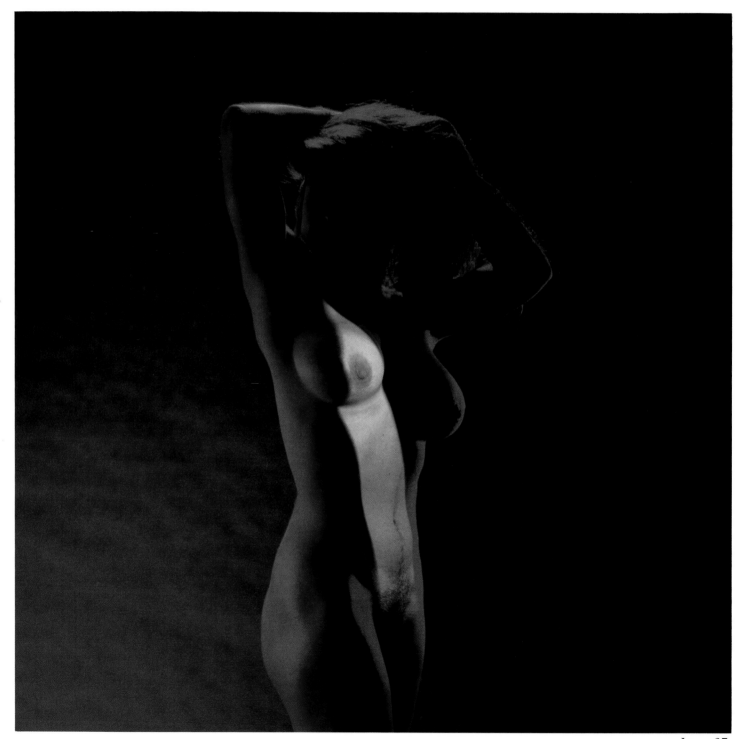

Image 37

truly effective, such a limited light area must also have a clear, sharp outline. This calls for hard lighting from a small source and the use of gobos, flags and barn doors to limit the illumination to the desired areas. This is an inexpensive way to limit the lighting area on a subject but it is by no means the fastest or the most effective.

By far the easiest way, but a much more expensive one, is to use a light that is designed for such an application. For these two images, we used a Bowens Monospot. Such a light projects a circular beam and will accept a multitude of grid patterns: venetian blinds, trees, circles, streaks, and so on. Even without such pre-cut grid patterns, there are other ways to control the light outline. There are arms on the light housing that allow you to control the shape of the light, to make your own patterns: a square, triangle, rectangle, and so on.

As we've mentioned elsewhere, sophisticated and expensive equipment can make your job easier, faster and sometimes more effective. However, you can also achieve excellent results by much more primitive means; it may just be a little bit slower and more cumbersome.

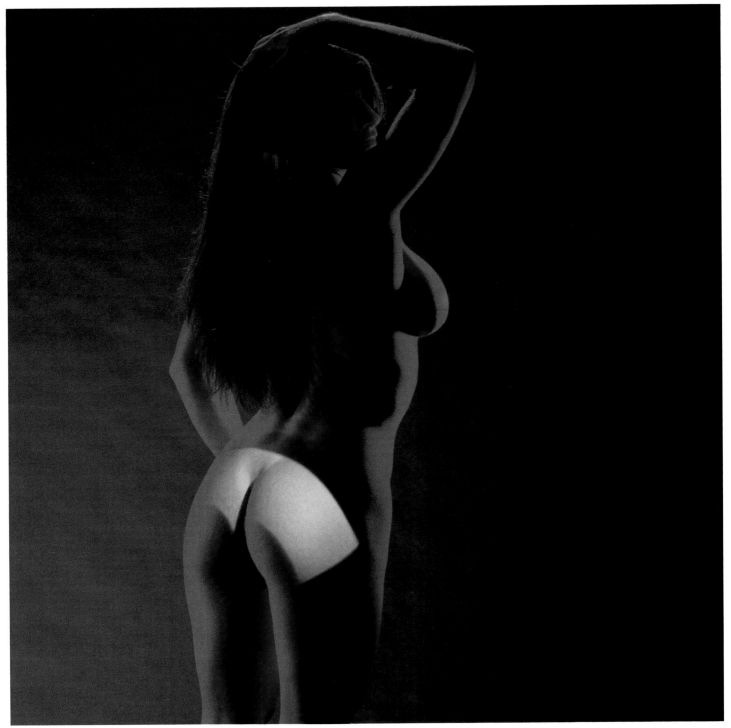

Image 38

Artificial fog always makes for interesting photography because it is so unpredictable and non-repeating. Because of this unpredictability, we suggest that you make a number exposures of each setup before moving on to other poses or lighting situations when you're using artificial fog. Because the fog has a tendency to soften an image, we rarely use a soft-focus filter when shooting with fog.

Experience has shown us that it is advisable to have physical contact between the subject and a major prop in a fog environment. Otherwise you could end up with an image that looks disjointed, almost as if it should have been two separate photos—one of the subject and one of the prop. In Image 39, we placed the subject close to the horse and had her touch its ear by extending her arm. This provided enough contact to unify the image into one concept.

In Image 40, physical contact is achieved by having the subject actually lean against the horse. Notice that, for best rendition of both the subject and the horse, each had to be lit separately. The subject was best flattered by a high light from the right side while the tone and texture of the horse's head was best brought out by a light that was low and a little to the left of the camera position.

In Image 41, we show the entire figure of the subject and the horse's head with its pedestal. Nonetheless, we still thought it advisable to maintain contact between the subject and the prop. Because we wanted to record the full human figure, it was necessary to keep the density of the fog somewhat lower than in the other two photographs.

The most convenient way to generate fog is with a machine specially designed for the purpose. These machines can be rented from theatrical supply houses. A word of warning: not every source of fog is safe to breathe. We only use fog fluid that is guaranteed safe and we advise you to do the same. There are other ways of creating fog, too. For example, you can use dry ice or smoke pellets. Each has its own advantages and disadvantages.

Once a small chip of dry ice is placed into a container and water is added, fog will spill out of the container and hug the floor, much like a ground mist. The effect is beautiful but short-lived and one container, with one chip of dry ice, will not cover a very large area of floor space. If you have a large area to cover, you have to use several containers, a lot of dry ice, and be prepared to work quickly.

Dry ice is not readily available, is not cheap, and will not store well. In a standard freezer, it'll last no more than about 16 hours before it melts. This forces you to purchase dry ice just before a photo session, and this is can be inconvenient if not impossible.

Smoke pellets—sometimes called smoke cookies—are a viable alternative. They are available at stage and theatrical supply houses and are particularly good for outdoor use, where there may be no electrical outlets available for a fog machine. You only need a small portion of one "cookie" to produce a sizeable amount of fog. A word of caution: the cookies burn, so don't place one on a floor in your studio or home without first putting it into a safe container, such as an ashtray.

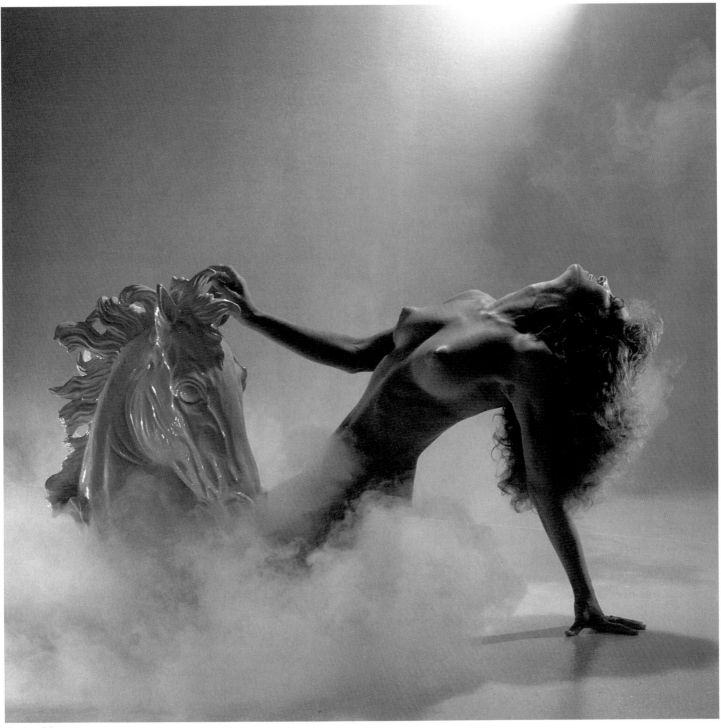

Image 39

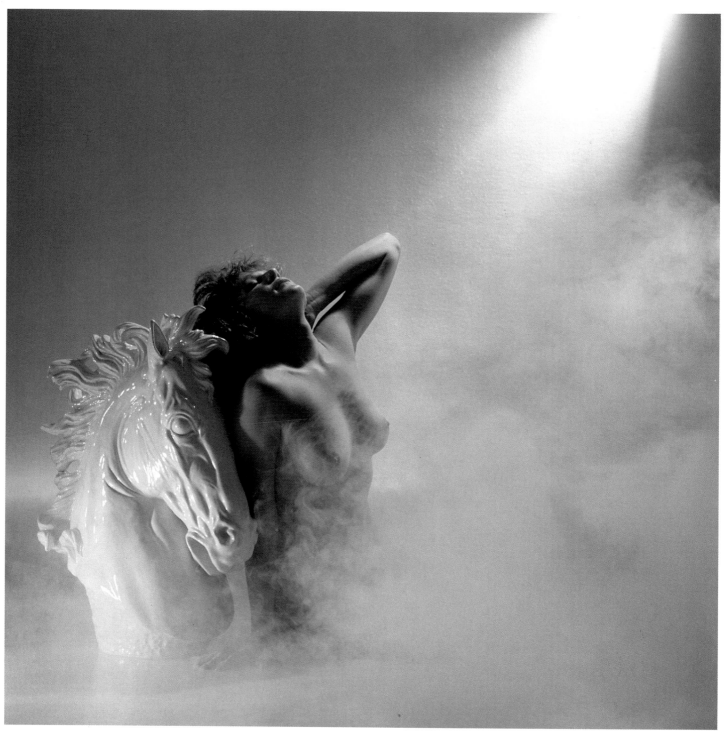

Image 40

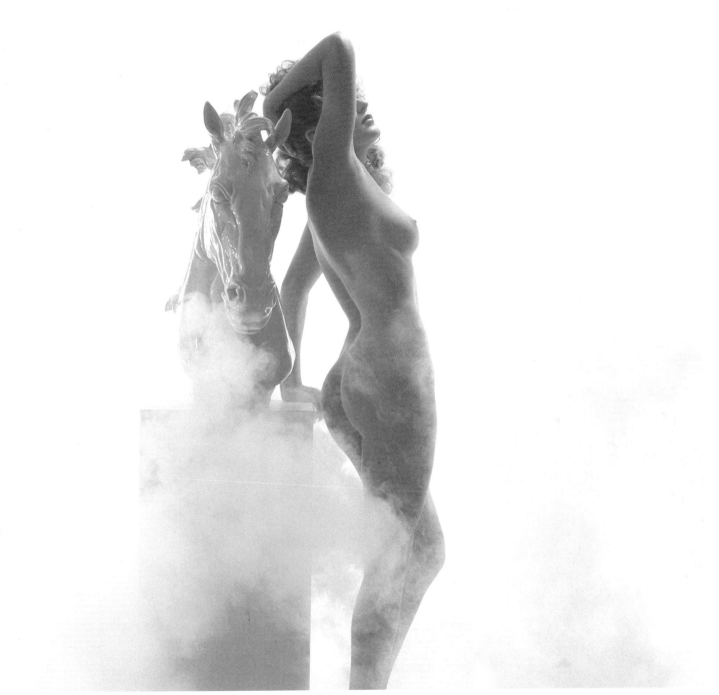

Image 41

We like to give each of our studios settings, whether permanent or temporary and makeshift, a name. For example, we have shot on a "rain forest" set, in our "fireplace" location, in our "attic," our "barn," and so on. We have found that giving a setting a name seems to make the images more meaningful to our boudoir and figure-photography subjects. A subject feels as though she has been involved in something special, rather than just having her photo taken in some random spot. Painters have titled their works for centuries. Why shouldn't the photographic artist do the same?

For Images 42 and 43, we used our "autumn leaves" scenario. As you can see, it is very simple and easy to set up, and yet very effective.

We do not live in an area where falling leaves are prevalent, nor do we have friends in the North who have volunteered to ship foliage to us! It wouldn't help us anyway, since we like to use this autumn concept all year long! So we have had to resort to the next best thing: silk leaves from a local artificial-plant store.

Each time we set up this scene, we empty our bags of leaves and arrange them a little differently. A lot depends on the subject we are using, how much of her body we intend to show in the final image, and what kind of effect or mood we intend to create.

In Image 42, the lower portion of the subject's body is at rest while the upper portion is raised. This pose suggests motion and alertness on the part of the subject. In contrast to the "active" subject, the leaves are lying at rest. There is no motion in them. A few "fallen" leaves have been carefully positioned on and around the buttocks area of the subject. They add credibility to the scene and also help to direct viewer attention to those areas of the subject's body.

In Image 43, the subject's body is horizontal and at rest while the leaves are in motion. The two images are very similar and yet generate different feelings and responses in a viewer.

Only two lights were used. One, housed in a five-inch bowl reflector and with an amber gel, was placed on the floor to the far side of the subject, just beyond the left image edge. It was directed at the left side of the white backdrop. As you can see, the illumination dropped off toward the right side. This created an effect almost suggestive of a sunset.

The main light, also housed in a five-inch bowl reflector, was suspended from a boom stand and placed almost directly above the subject. Notice the wonderful modeling this provided on the subject's buttocks and her back. The main light was not color-gelled.

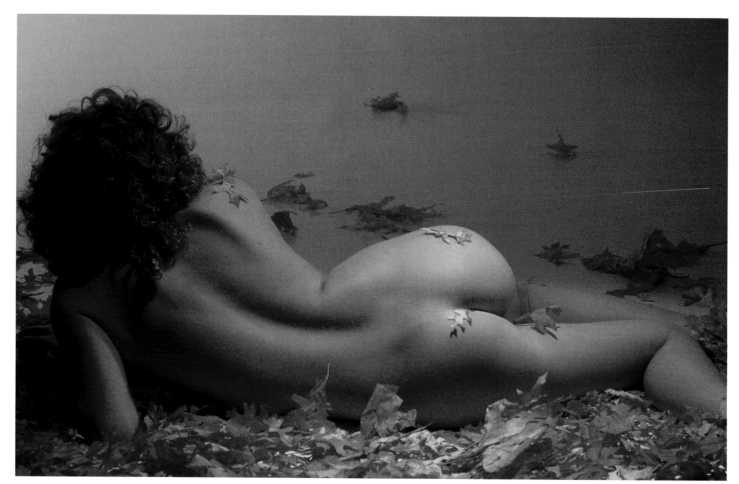

Image 42

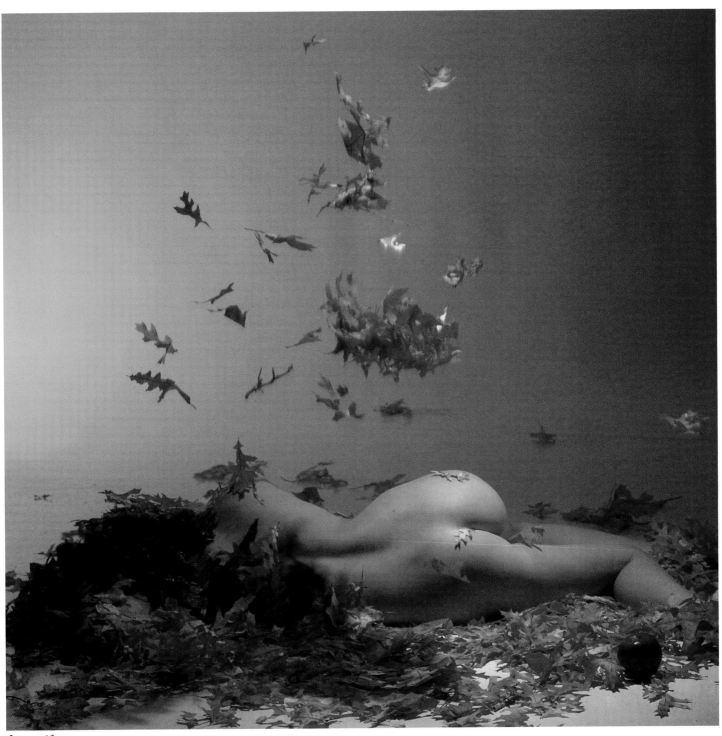

Image 43

Sometimes it takes time and patience to prepare a subject psychologically for a nude photo session. However, once the photography is over and the results are seen, most subjects are anxious to become involved in further photo sessions.

When you work with two subjects, you'll find that the initial apprehensions and fears are usually even greater, especially if the two people have never met each other prior to the photographic session. When we have a photo concept that calls for the use of two persons—of the same or the opposite sex—we make certain that they meet at our studio well in advance of the day of the actual photography. This makes them feel more at ease and also assures us that they can relate to each other well enough for successful photography.

In this particular case, we had photographed the female subject on several previous occasions but never the male. She was totally familiar with our work but he was not. In spite of this, and largely because of the pre-shoot conference we had with them both, the two worked beautifully with each other and helped us achieve some very special images.

As we've indicated elsewhere, in figure photography the demarcation between true art and exploitive or "clumsy" images is a very fine line. Obviously, when you are photographing two subjects of the opposite sex together you must shoot with even greater care, skill and sensitivity. Be especially careful how you address and direct the sub-

jects. Any inappropriate remark—deliberate or otherwise—could adversely affect the photographic results as well as your reputation.

We have done statue concepts before, using different materials to cover a subject's body. For Image 44 we used moist ceramic clay, a material that was new to us. We never use a new substance unless we have actually tested it on a subject first and then photographed it, to see how it's going to look. We tested the clay on one of the intended subjects several days before the actual shoot.

To save time, and feeling confident that the substance was going to work well, we took a risk and applied the material onto only a small section of the subject's body. It looked smooth, clean and great.

On the day of the actual photo session, as our assistants began applying the material to the subjects' entire bodies, we noted a condition we had not previously seen—the applied material was drying too quickly and was cracking. Every time the subjects changed poses, the material would crack and pieces would fall off. Although this was not what we had intended, we got some interesting results. You can see the effect particularly well on the male model. We like this photo okay—but we're going to test new materials more thoroughly in future!

A final observation. Notice how, while most of the image is in a magenta light and the female subject is almost in silhouette, a small area around her bust is highlighted with unfiltered, white light. This provides a clear focal point for a viewer's attention.

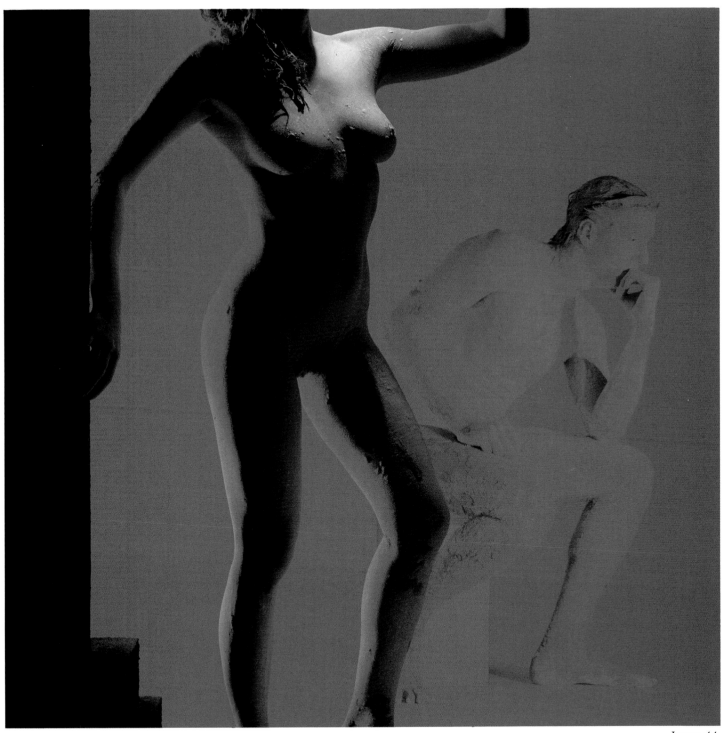

Image 44

The imaginative photographer of the human fig-ure can call into play all kinds of props and set-tings. The device we used to get the effect you see in Image 45 was nothing more than a simple shower curtain.

The patterned curtain actually played two distinct parts—that of the actual setting and that of an opti-cal effects device. When you shoot through a tex-tured material such as this, be sure that the subject's pose is such that the various parts of her body are distinctly recognizable. In addition to careful posing, this also usually demands fairly bold lighting.

An interesting and charming effect produced by the particular material used here was the limitation of the curtain's pattern to the areas where the sub-ject's body appeared. Against the plain background, the pattern is virtually invisible.

Notice, once again, the highlighting with unfil-tered white light of parts of the subject against an otherwise red background and largely shadowed fig-ure. The background lights were covered with red gels. The curtain, of course, was almost colorless—otherwise the white highlighting would not have worked. The curtain itself would have functioned as a color filter.

Clearly no soft-focus filtration was needed, since the texture of the shower curtain itself diffused the image very effectively.

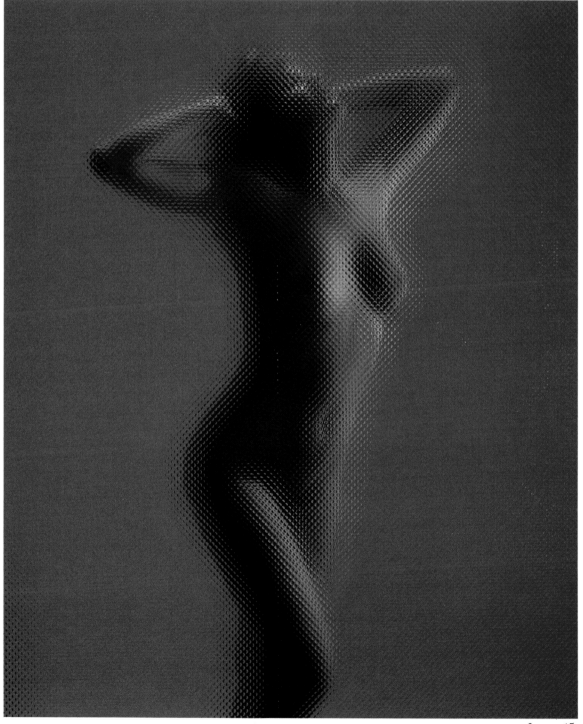

Although we have been working with horizontal blinds in assorted colors and sizes for several years we recently started using vertical blinds, in order to achieve a slightly different photographic look in our figure studies.

We have small and large vertical blinds in various colors, but our favorite one is the very tall and wide black one featured in this image. We can use a large blind such as this as either a foreground prop, as we have done here, or a background.

You have considerable creative control over how you wish to present such a blind. You can shoot it in silhouette, with no light striking it from the front; you can illuminate the wide slats from the front with either hard or soft light of various colors; or you can illuminate the slats partially, as we have done here. Notice, by the way, that the frontal light on the slats need not necessarily come from the camera side of the blind. In this particular case, the illumination on the slats came from behind the blind, on the lower left side.

To make the subject look active and graphically interesting, we posed her so that some of her lines countered the vertical flow of the slats of the blind. Her right arm, her extended fingers and the upper half of her leg all help to create these "dynamics." Even her head, which is almost entirely hidden, is clearly identifiable as being tilted from the vertical.

By highlighting the subject partly with red light and partly with unfiltered white light, instead of with light of one color overall, we have added further interest and life to the image.

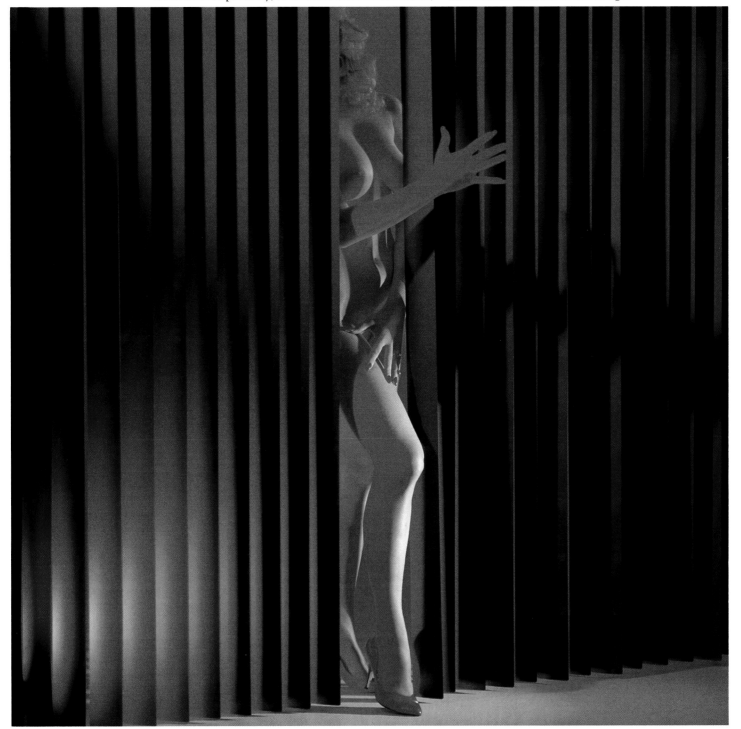

Image 46

Images of nude couples, such as depicted in Images 47 and 48, can be very charming, but they are not at all easy to produce. Just think about the situation. We are asking two strangers to appear nude together in the intimate setting of a shower. Not only that, but we are confronting them with two or three other strangers—a photographer and assistants. Finally we are placing a camera before them in order to record the event. And all of this is happening in totally strange, unfamiliar surroundings.

The two subjects you see in these images had never met each other prior to our photography session. Their busy schedules did not permit it. The

scenario we were using and the photo concept we were after involved some pretty intimate poses. We informed the subjects that we wanted the resulting images to depict them thoroughly comfortable with each other and, in fact, romantically involved, much as a loving husband and wife would be in a real-life situation. This required a great deal of concentration and playacting on the part of both of the subjects. As you can see, their efforts were very successful.

This is a very challenging form of figure photography. If the images aren't good, they are almost certainly unacceptably bad. There is very little mid-

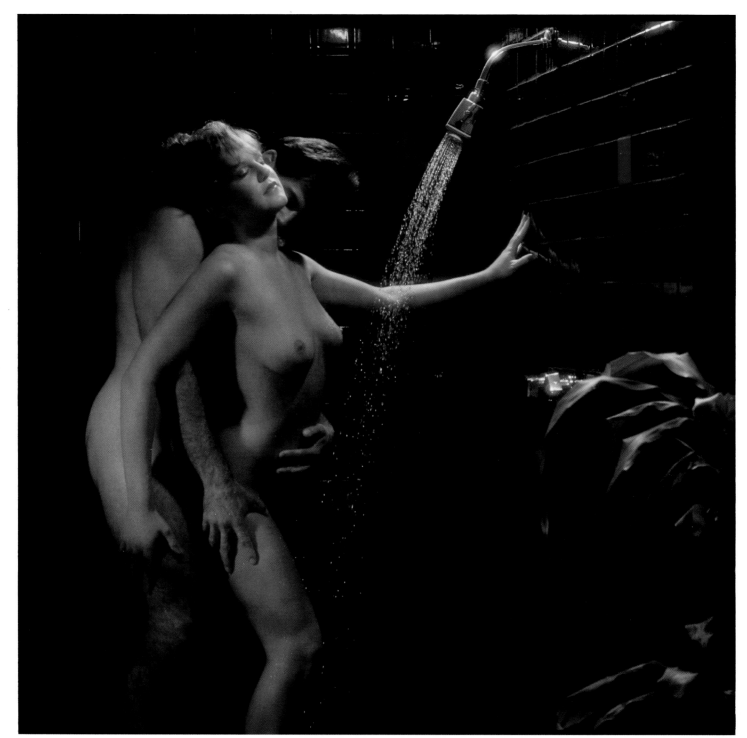

Image 47

dle ground here. We believe that these two images have a wonderful innocence and charm and we're very proud of them. We also salute our two models; we're very proud of them, too!

Running or flowing water seems to be very appropriate and effective in figure photography. It adds atmosphere and gives an image a feel of motion and activity.

To highlight the water, you must usually light it separately. You cannot just light the faces and bodies of the subjects and hope that the same light will illuminate the water effectively. Generally it won't!

For these two photos, we used backlighting to make the water come alive with a sparkle. In Image 47, the same light that backlit the water also illuminated the woman's face and rimlighted her left arm. In Image 48, that light also lit the man's face and rimlighted his arms.

When you're photographing two subjects, you must be sure to light each one in an effective and flattering manner. It's not dissimilar from the technique, described earlier, for lighting a subject and her reflected mirror image. To achieve the desired effect in Images 47 and 48, we used three additional lights—one in a five-inch bowl reflector, high on a boom stand, and two four-inch, snooted accent lights.

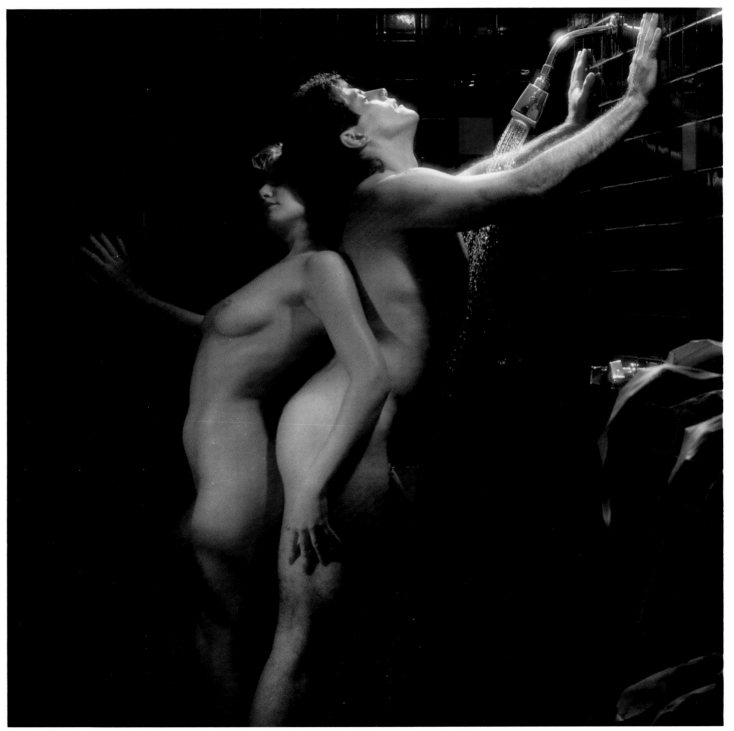

Image 48

Many of our figure-photography subjects like to be photographed in silhouette. Such images can be very flattering to the human form or outline while being less blatantly revealing than a fully lit nude study.

Because a subject is less readily identifiable in a silhouette, such images often have an air of mystery about them. This anonymity also makes such images ideal for display in a home or office. Someone close and dear to the subject can hang such a picture without fear of embarrassment to the subject or possibly some viewers.

We have done a lot of experimenting with venetian blinds as a foreground prop, white lighting on a white background as the only source of illumination, and colored lighting, when shooting silhouettes. In addition to shooting full silhouettes, we have also taken photographs that show the subject only partially in silhouette. Image 50 is one such example.

We have tried using yellow light for the background, but the resulting images lacked the drama appropriate for a silhouette. We've also tried amber and green backgrounds, but the images seemed to lack a certain "punch." A deep-blue background could produce stunning silhouettes, full of mystery. Such a background might well have worked for the two images reproduced here. However, we chose the sunset effect of the circular, red background.

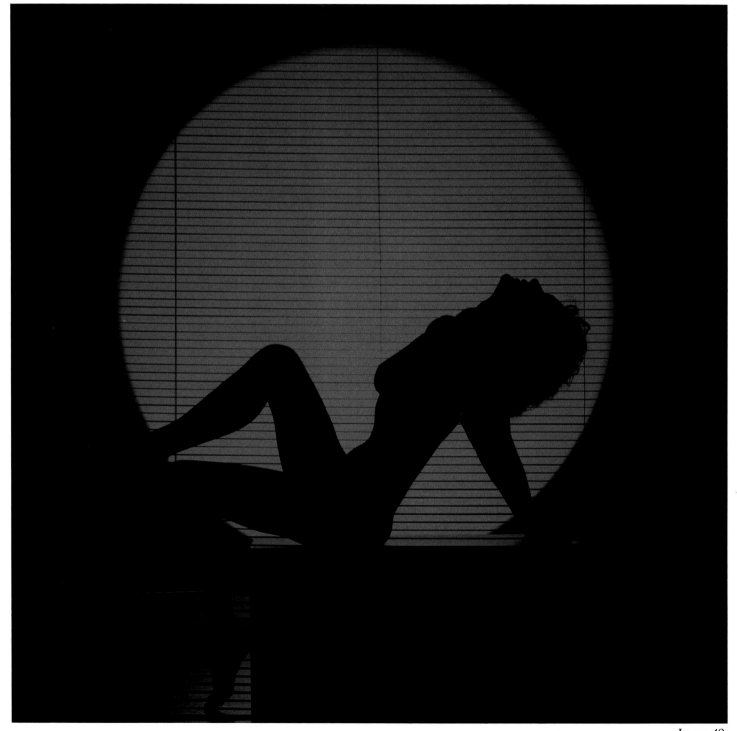

Image 49

We had tried to illuminate the entire background area with red light but the color overpowered the subject. When we confined the color to a central circle, the final images had much more impact.

Images 49 and 50 both used the same background and the venetian blind as the foreground prop. The obvious difference between the two is that Image 49 is a full silhouette while Image 50 shows the subject in partial silhouette. The main light for Image 50 was in a five-inch bowl reflector and mounted on a boom stand. It was aimed down at the subject almost vertically. Notice that this light is not color-filtered but is natural, white light. The lower half of the subject retains its dark outline and so remains in silhouette while the lit upper half takes on some modeling and shape.

In spite of the added illumination for Image 50, the subject is not readily recognizable and the image thus retains a quality of anonymity.

When you photograph a full silhouette, always remember that you must rely on outline alone to provide the viewer information about the subject. This means that you must pose the subject very carefully, avoiding any limb overlaps or turns of the body that would appear clumsy or ambiguous to the viewer. In Image 49, notice how distinguishable the subject's two legs, arm, bust, hair and face are, even though her entire body is in total darkness.

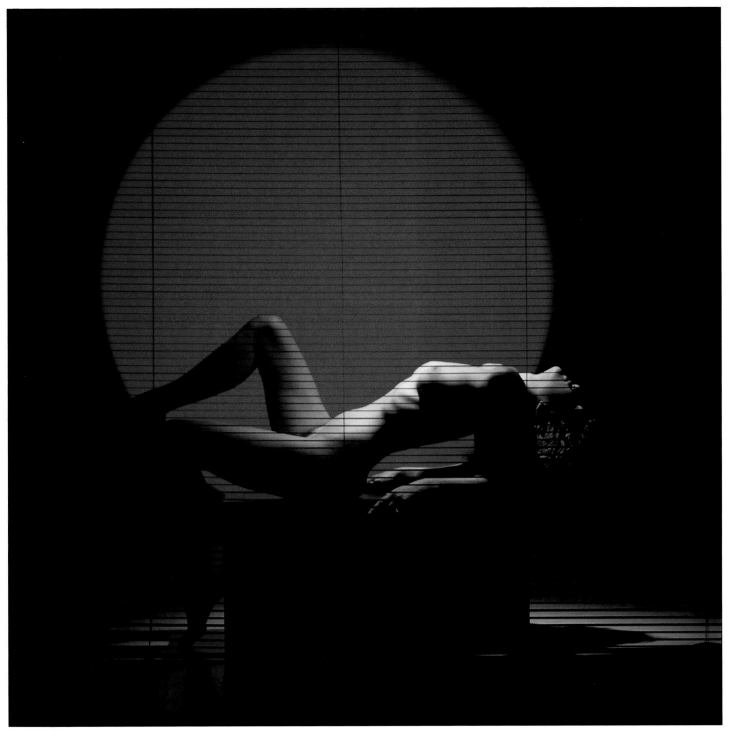

Image 50

Achieving a pose that appears natural to the camera demands some very special skills on the part of both a model and her photographer. Sleeping in real life is not necessarily the same thing as adopting a convincing and yet esthetically pleasing "sleeping" pose for a camera. A good and experienced model will have a pretty good idea what the camera is "seeing" and will pose accordingly.

However, the ultimate control rests with the photographer, who is actually at the camera position. The photographer must judge what looks believable and what doesn't, what appears esthetically pleasing and what doesn't, what expression, lighting and props are appropriate, and so on. The photographer must convey his needs clearly to the subject. That's the art of "direction."

In Images 51 and 52, the subject was lying on a bed quilt on the studio floor. Because of the tight crop, a viewer has no reason to assume anything other than that she is on a bed. Such selective cropping can be very useful in all fields of photography, not just figure work.

To get a full view of the reclining figure and to keep all parts of the body in the same plane, for overall image sharpness and to avoid unwanted distortion, we shot down vertically from a six-foot ladder.

Image 52 was not taken from a closer viewpoint than Image 51. We simply changed to a lens of longer focal length. This was the most convenient way to change the image crop. It prevented the need to change the rather precarious, high camera position we had adopted. The longer lens and accordingly distant viewpoint also enabled us to avoid any unwanted bodily distortion in the image.

Soft, gentle illumination seemed appropriate for this soft scene. For both images, the main-light source consisted of two electronic flash heads in a 4x7-foot light panel. The subject was facing the full length of that panel. For a fill source, a white 4x8-foot foamcore reflector was laid horizontally on the side of the body opposite the main light. Because of its size and close position, it filled in the shadows for the entire length of the subject's body. To retain the overall soft effect, the shadow side was only one f-stop less bright than the highlighted side.

To create a more dramatic, contrasty effect, we could have moved the fill reflector away from the subject to a location where the shadow side of the subject gave a meter reading of two or three f-stops less light than the highlighted side.

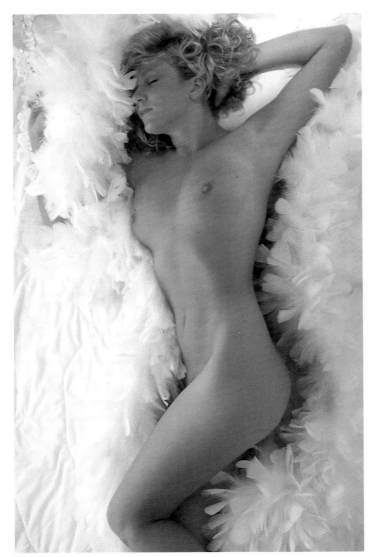

Image 51

Image 52

111

A swing is a great prop for female figure photography. We have several swings in our studio. Some have hard, wooden seats. However, for most of our boudoir and figure photography we prefer to use a swing that has a pliable seat of such a material as canvas or leather. As these two images show, these seats follow the contours of a subject's body beautifully, becoming an integral part of the subject rather than appearing as a separate, conflicting item.

A swing suggests a light, happy atmosphere. This is why we like a white swing, bright props and a light and colorful background.

A swing is also suggestive of action. A vertical swing, with a subject seated in a static, vertical position, would lead to a very dull, boring photograph. To put action and excitement into these two images, we had our subject lean backward, asked her to let her head fall back, raise one leg and let the other one drop, and hold onto the ropes at different heights.

In Image 53, an added prop was included in the form of fog. In Image 54, we adorned the subject with a sheer-nylon cape and used a fan to blow it. Both the rising fog and the billowing cape strongly suggest motion.

Notice that the fog, rising about the figure, gave Image 53 a decidedly softer look than Image 54, for which no fog was applied.

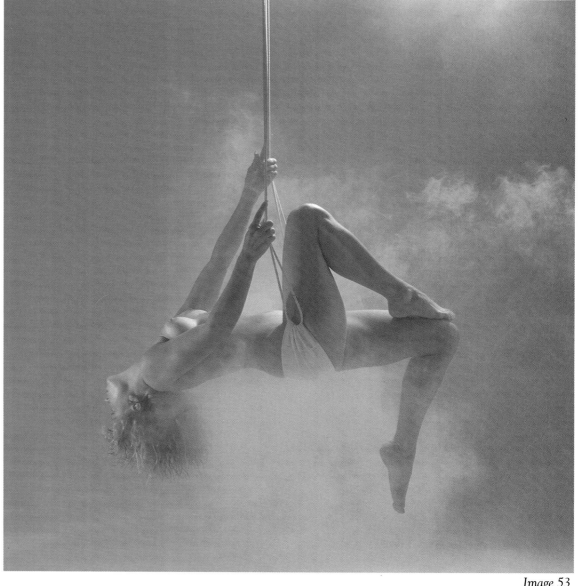

Image 53

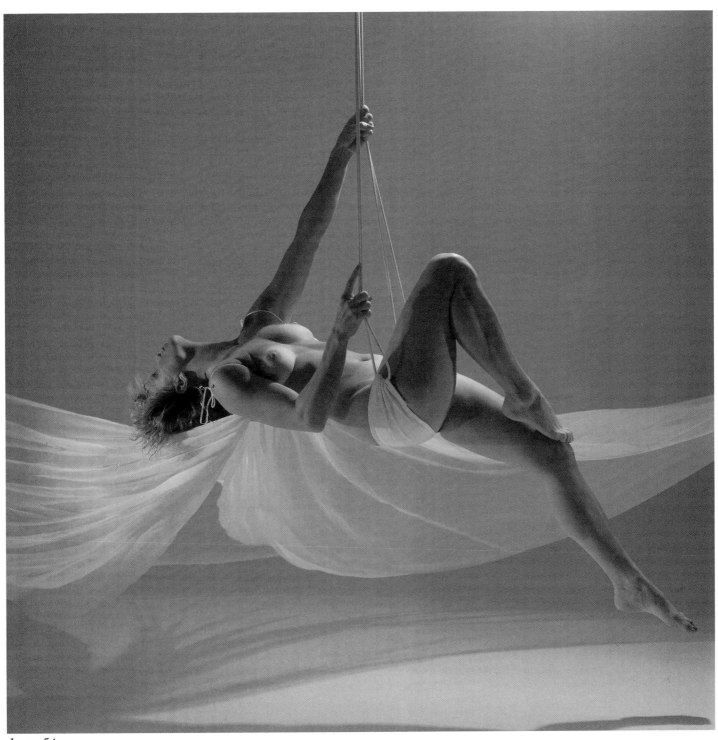

Image 54

This is one of our favorite photographs, largely because it offers a viewer a wide range of possible interpretations. Trying to generate this kind of viewer involvement in a somewhat mysterious scene always makes such a shoot particularly exciting and stimulating for us. In addition to having an air of mystery, we think that the image reproduced here also has attention-grabbing color and drama.

The interpretation any individual viewer might give to this image would say as much about the viewer as about the image itself or about us, as its creator. In many of our images, we very deliberately want to generate certain impressions or stimulate certain thoughts or feelings. In others, such as this one, we like to create a fantasy scene and leave the actual telling of the story to the viewer's imagination.

To give the viewer's imagination as free a rein as possible, we have done everything we could to envelop the image in mystery. The subject's face is hidden, as is much of her body. She is in an indeterminate, horizonless setting, surrounded by smoke or fog. Her body and her outstretched fingers suggest motion, and yet she is lying face down and clearly restrained with a rope.

Many of our subjects truly enjoy being involved in this kind of allegorical photographic story telling. We enjoy it too. It exercises our imagination—including that of the viewer!

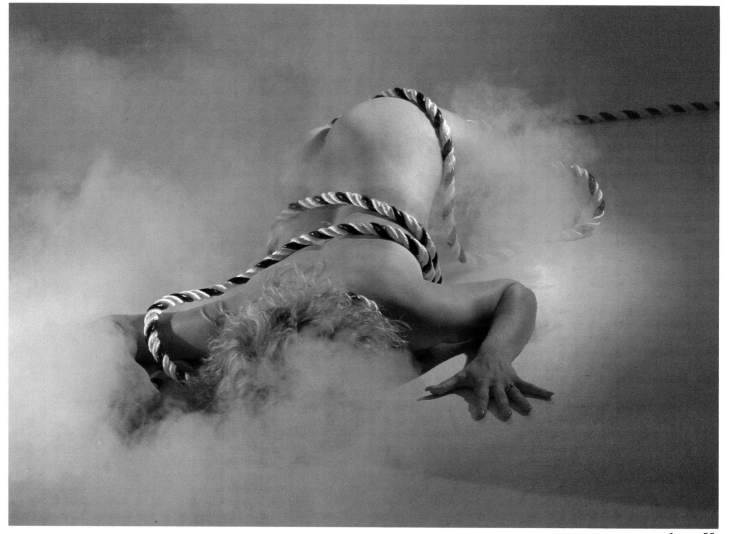

Although this image appears to depict a genuine romantic moment, this couple had never before been photographed together in this intimate fashion. However, they did know each other, which was a great help. If you plan to shoot two total strangers in this manner, be sure to have them meet each other before the actual shooting session.

Although the male subject was initially somewhat nervous and apprehensive, he quickly began to relax as the session progressed. The more at ease he felt, the more comfortable the woman also became. This photo and many other lovely images resulted.

We cannot overemphasize the importance of a believable and sensitive attitude and pose in this delicate form of figure photography. The couple must be prepared and able to playact and project a real-life romantic situation. If this is not achieved, your results will not only be bad, but will in all probability look ridiculous.

In this photograph, we wanted the couple to appear perfectly relaxed and totally involved with each other, as though no one else in the world mattered. The image bespeaks of love, tenderness and caring and would have failed had the subjects not acted out their parts so well.

As a happy aside, we can tell you that the couple became engaged a few months after this photo session and later got married. We wish them well!

Initially, we had wanted to photograph the couple by natural light only. Once we had them posed, however, we had to abandon the idea. The large form of the male subject—who is a weight lifter—blocked most of the direct light, coming from the window, that was intended for the female subject's figure. Accordingly, we resorted to using the daylight as a fill and background light while using one electronic flash as main light.

The flash was placed behind a "light panel" consisting of a white 3x6-foot bed sheet , located about 45 degrees to the left of the camera-subject axis. The illumination was such as to give the skin a smooth, soft texture while also providing distinct shadows for modeling the contours of the woman's body.

This combination of softness and directional light was achieved because the bed sheet was thick enough to diffuse the light and yet also thin enough for the flash source to be clearly discernible. It is not dissimilar from the conditions that exist under a light overcast outdoors, when the sun penetrates just enough to generate distinct shadows.

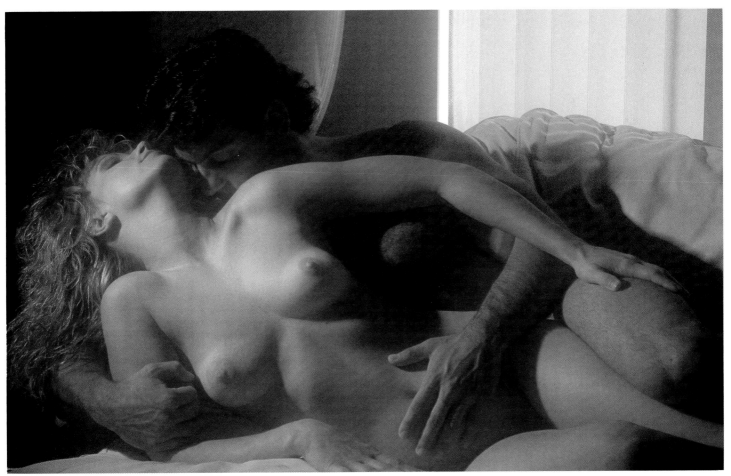

When you're going to shoot at an unfamiliar location, check the location out carefully in advance. Ask what furniture you can move and what props might be available, and find out the nature of the electric power supply.

For Images 57 and 58, we used only the available daylight. We wanted the subject illuminated by the strong, natural light filtering in through the slatted blind over the window. To add some light to the shaded lower area of the subject's body, we used a circular three-foot golden reflector close to the subject's knees, to reflect warm fill lighting into that area.

In Image 58, notice the imaginative and effective use of the corner of the couch as a posing prop. The back-leaning pose that this invited was very flattering to the subject's shapely figure.

Once you find a suitable location where all the elements work for you, exhaust the setting's photographic potential before moving on to another location. In these two images, all we did was to change the camera angle and distance and alter the ratio between the natural daylight and the fill illumination from the golden reflector. For Image 58, we moved the reflector back about two feet, to increase the contrast level between the highlighted and the shadowed areas. As you can see, such minor alterations can lead to images that have a completely different feel and atmosphere.

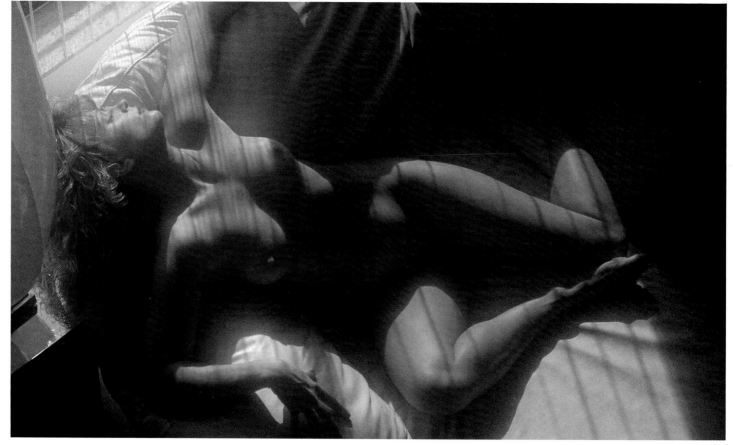

Image 57

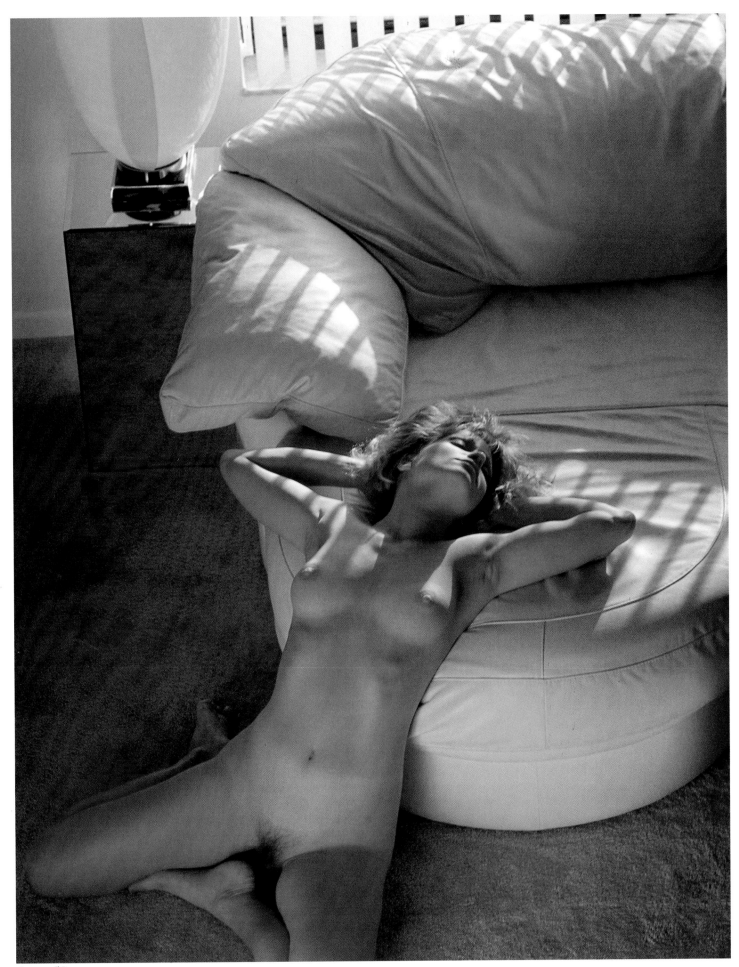

Image 58

This sequence was taken with the subject on the same couch as featured in Images 57 and 58. We could not resist demonstrating once again the value of exhausting a setting's potential before moving on to other locations. We think that Images 59, 60, 61 and 62 dramatically demonstrate the point: after the "obvious" shot has been taken, change your camera angle, lens focal length, camera-to-subject distance, lighting, props, filtration and so on. You decrease the possible pictorial variety and do an injustice to yourself and the subject if you don't make such readily available changes as you go along.

For these four photos—all taken within a few moments of each other—the changes we made were relatively minor. And yet, they managed to give each individual image its very own, special "feel" and look.

There were certain basic things that were common to all of the photos: the same subject was used throughout; we used a 35mm camera and Ektachrome 64 Professional film; the daylight coming through the window acted as the main light; the subject remained on the white couch; the shutter speed remained at 1/8 second.

Now let us see what we changed to make the images so different. For Image 59, which was the initial shot, we used a 100mm macro lens. A white, 3x6-foot foamcore reflector was placed close to the subject to fill and lighten the shadows. The lens aperture was set at f-5.6.

For Image 60, we changed the camera angle and the camera's distance from the subject and made the image vertical rather than horizontal. We removed the fill reflector and decreased the exposure by closing the lens by one-half f-stop.

In Image 61, we altered the subject's pose, put back the white fill reflector and slightly closed the vertical window blinds to create strong, graphic lines on the subject's body. For Image 62, we introduced a prop—a dried palm leaf—and removed the foamcore reflector once again.

Look at these four images again, to see the obvious changes we made: different crops, different camera angles, vertical and horizontal formats, different lighting and contrast, different poses, with and without prop, and so on. And we should tell you that this series consisted of several more images than the four reproduced here!

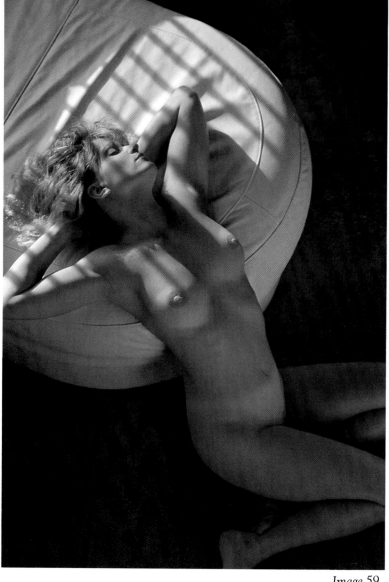

Image 59

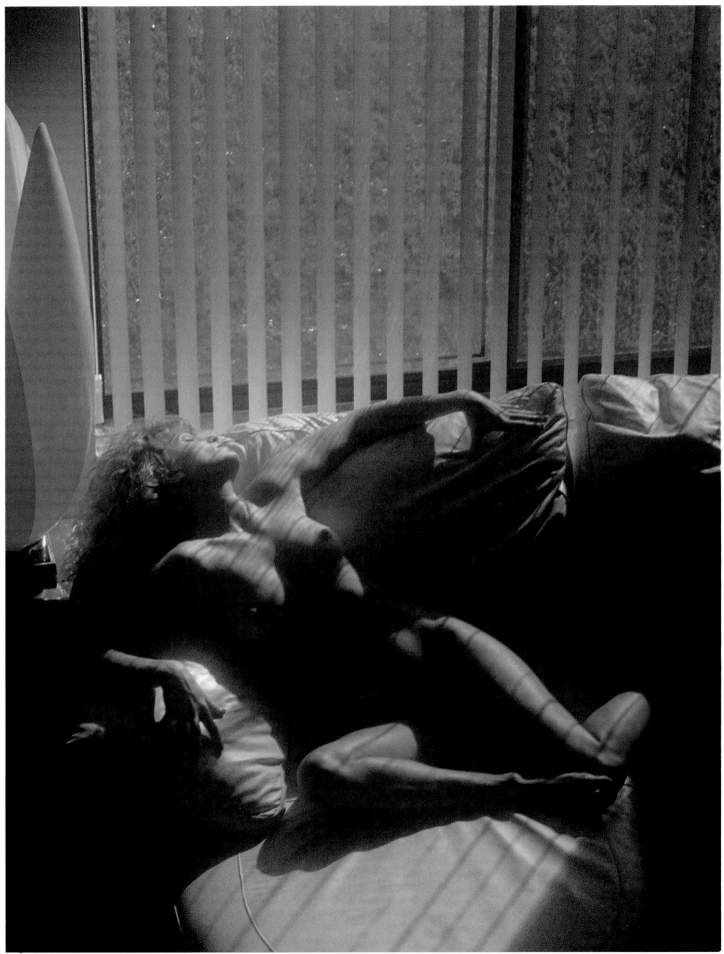

Image 60

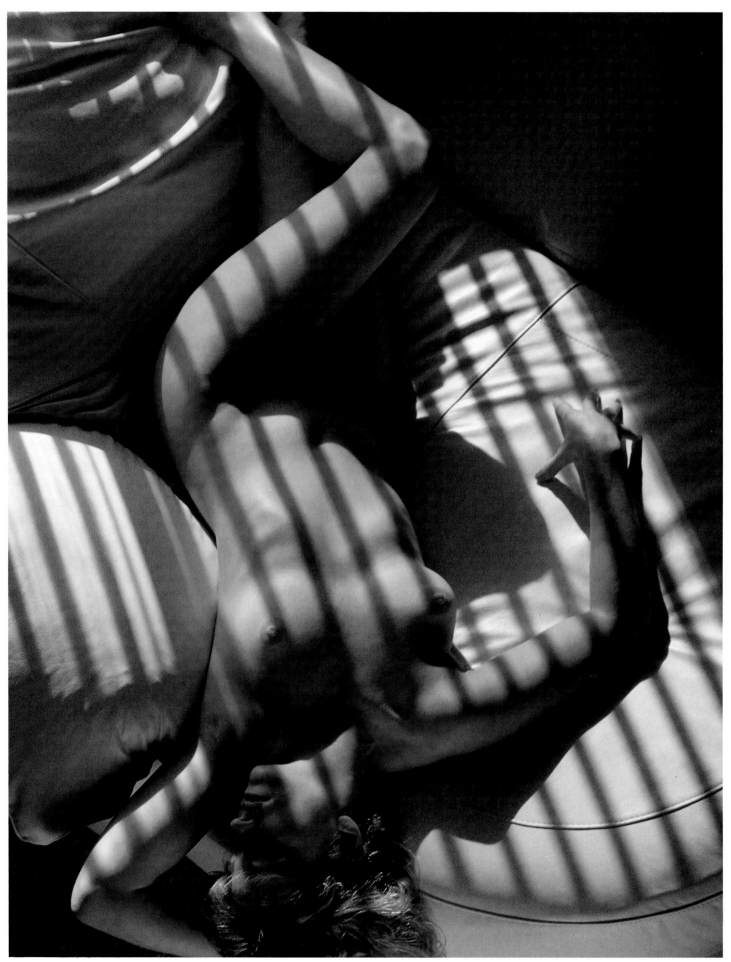

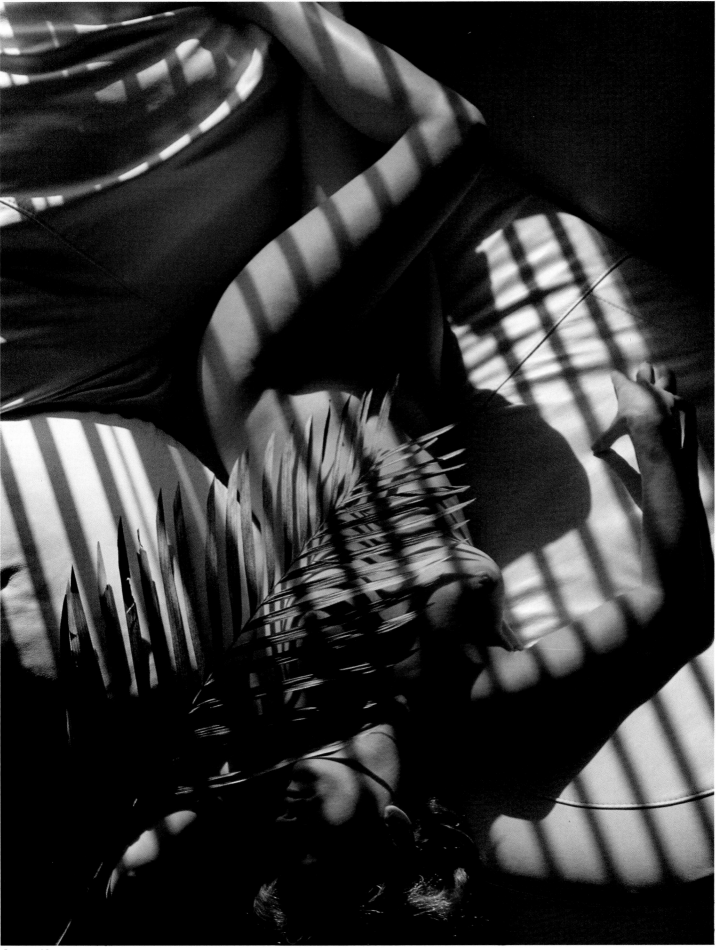

Image 62

Images 63, 64 and 65 demonstrate the pictorial variety that can be achieved with a single, fixed light source—in this case, daylight. The photos show how the graphic shadow lines created by the vertical blind were used to play an integral part in the overall composition. By making simple posing changes, we caused the shadow lines to fall differently onto the subject's body. The lines become an integral part of the subject's body, emphasizing the modeling of her form and highlighting specific areas. Because different parts of the body have been accentuated and highlighted, each image has its own individual appearance and character.

In Image 63, the shadow lines cause emphasis to be placed on the subject's bust and the upper portions of the legs. The lines "contain" her, almost as a rope would.

In Image 64, her neck and the upper chest area, above the bust line, have been singled out. This pattern creates the effect of a necklace, rather than a rope. The back-leaning pose further helps to draw viewer attention to the neck area.

In Image 65, the subject's torso, from her shoulders to her legs, is the feature of main interest. Her stature is enhanced by the shadow line that continues to run down the length of her leg, making her look taller than she actually is.

Compositionally, notice how the "lined" subject is enveloped by an environment of additional lines, formed by the blind, its shadows on the floor and behind the subject, and the louvered doors.

These images were taken with a 35mm camera and a 100mm macro lens. Daylight through the blind was the only light source. A white, 3x4-foot foamcore reflector was used to lighten the shadows to a greater or lesser extent.

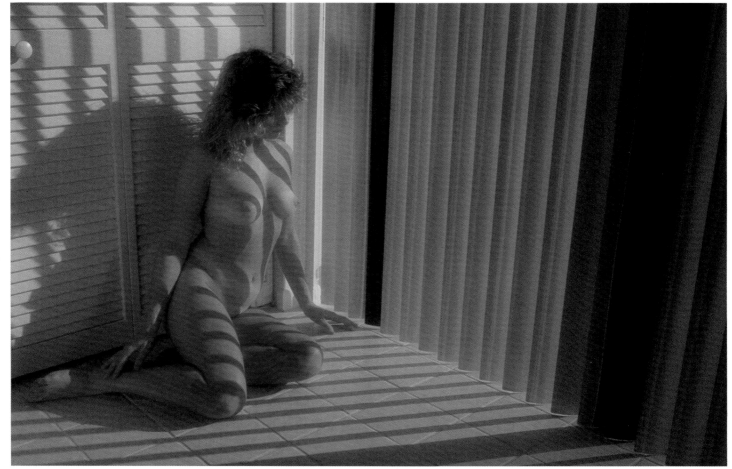

Image 63

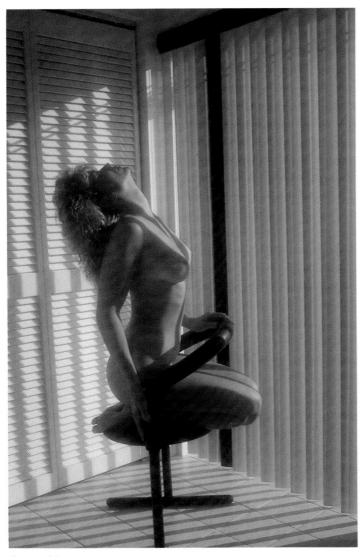

Image 64

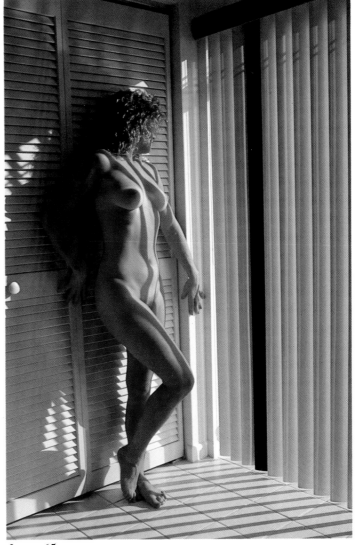

Image 65

123

Mirrors are always great props for figure photography. We love to work with angled or multiple mirrors that enable us to produce multiple images. When you work with a single mirror, as we did for Images 66 and 67, you lose a lot of the potential for variety, but you can still produce some lovely photos.

When working with a mirror, you have three options as to where to place the point of optimum focus. You can focus on the subject, allowing the reflected image to go "soft," you can focus on the reflected image, allowing the original subject to go "soft," or you can manipulate the point of focus and depth of field, to get both in sharp focus.

Limiting total sharpness to either the subject or her reflection alone can lead to somewhat dreamlike, ethereal results. Getting both the subject and her reflected image in sharp focus generally leads to a more realistic, "documentary" result.

Another decision that must be made involves lighting. You must think almost in terms of photographing two subjects—the real one and the one seen in the mirror. You can emphasize either one of them and subdue the other or you can give them equal treatment. Whatever approach you choose, it's important that each view is presented in a flattering manner.

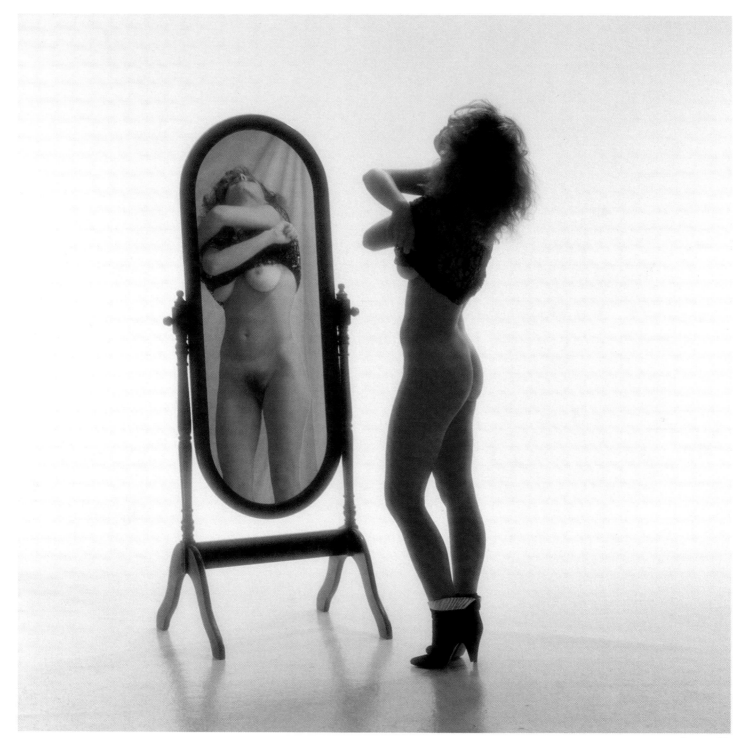

In these two images, we chose total sharpness on both the subject and her reflection. We also chose to give slight lighting emphasis to the reflected image rather than the direct view of the subject. Notice, however, that the direct side and back views of the subject in the two photographs are also lit in a very attractive manner. They are just a little darker than their reflected images.

When setting up your lighting and calculating exposure for a subject such as this, be sure to allow for the light loss that might be caused by the mirror itself. This loss can vary from virtually unnoticeable to considerable, depending on the nature of the mirror.

When working with a mirror, remember that the reflected image also needs an attractive background. It is often best to keep it simple, especially when the mirror is relatively small and almost filled by the subject's reflection, as was the case here.

Keep the background in the mirror sufficiently different from the background behind the mirror, otherwise the viewer of your photo might be confused. If the two backgrounds are too similar, the mirror may look more like plain glass or a window! In these images, we differentiated the two backgrounds by having the one in the mirror noticeably darker and a little textured.

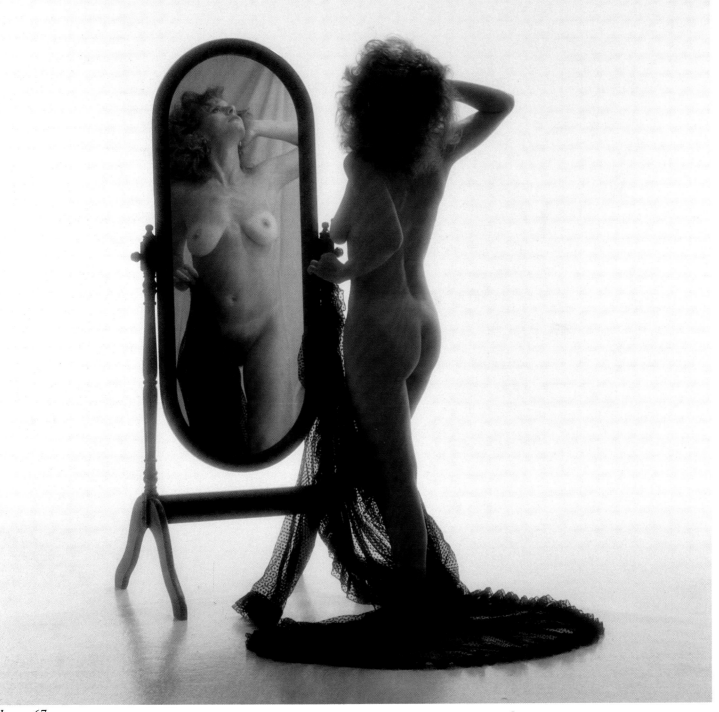

Image 67

The next four photos represent one of our favorite sequences. The images have a soft, delicate, feminine and timeless quality. When you're working with a plain, non-distracting background, the subject's pose and attitude alone must be able to "carry" the image. There are no other elements in the scene to rely upon. If the pose is dynamic, the entire image becomes dynamic; if the pose is static and boring, the image will fail.

A horizontal pose can look lifeless and static unless you take special steps to avoid this. With the use of dramatic lighting, suitable props and certain pose variations, such images can be made very appealing.

In these four images, the lighting on the subject was not dramatic but we used a high-key setting, and this is always very flattering for figure subjects. For Image 68, the only one in which the subject is in a horizontal pose, we asked her to raise her two legs to varying degrees. We also used some gauze material to carefully drape her body diagonally. Diagonal lines are always effective in adding life and a feel of motion to a composition.

To soften the images, we used a No.3 Softar soft-focus filter on the camera lens. The high-key lighting and background helped to further soften the effect.

Light gauze is a very suitable prop and drape for figure studies. It is readily available from most fabric stores and comes in a variety of colors—usually in pastel shades. We get this material in a 40-inch width, usually buying a 50-foot length at a time. We can then fashion the material into any design we think will fit any specific photo session.

As Images 68 through 71 show, making minor pose changes and using the gauze imaginatively can generate a lot of different looks and moods. It is wrong to think that visual variety can only be produced by major changes to a setting. These images should help to convince you of that.

The main light for these photographs was a four-foot umbrella, placed about 45 degrees to the right of the camera-subject axis. The fill light was a 3x4-foot soft box, its power adjusted to emit two f-stops less light than the main light. Another light, in a five-inch bowl reflector, was suspended from a boom stand, above and slightly behind the subject. Its power was adjusted to emit one f-stop of less light than the main light. Two three-foot umbrella lights gave the illumination for the white background. To ensure a pure white background, in keeping with the high-key effect we wanted, their power was adjusted to emit two f-stops more light than the main light.

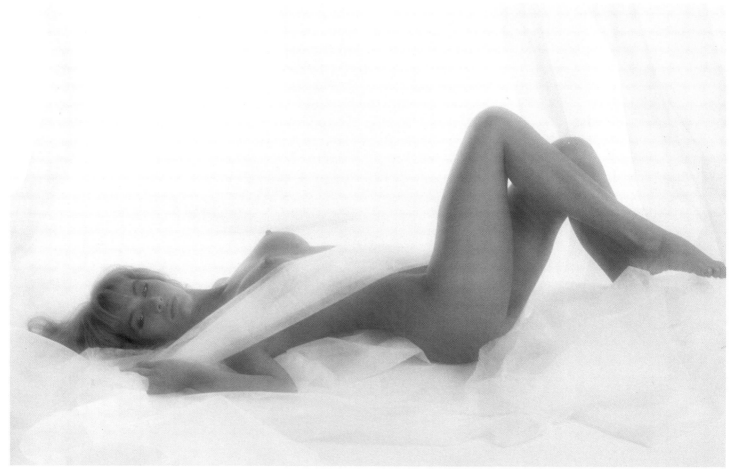

Image 68

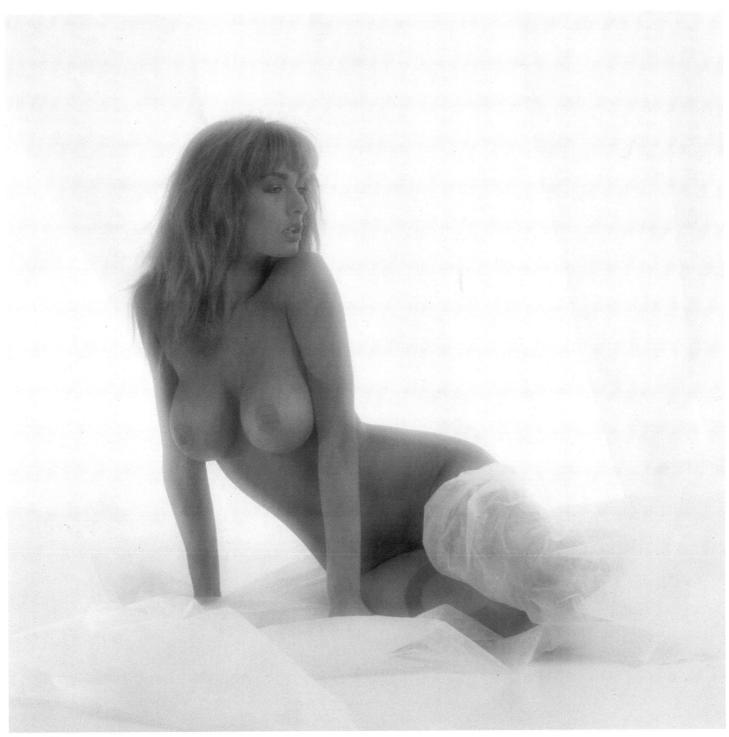

Image 69

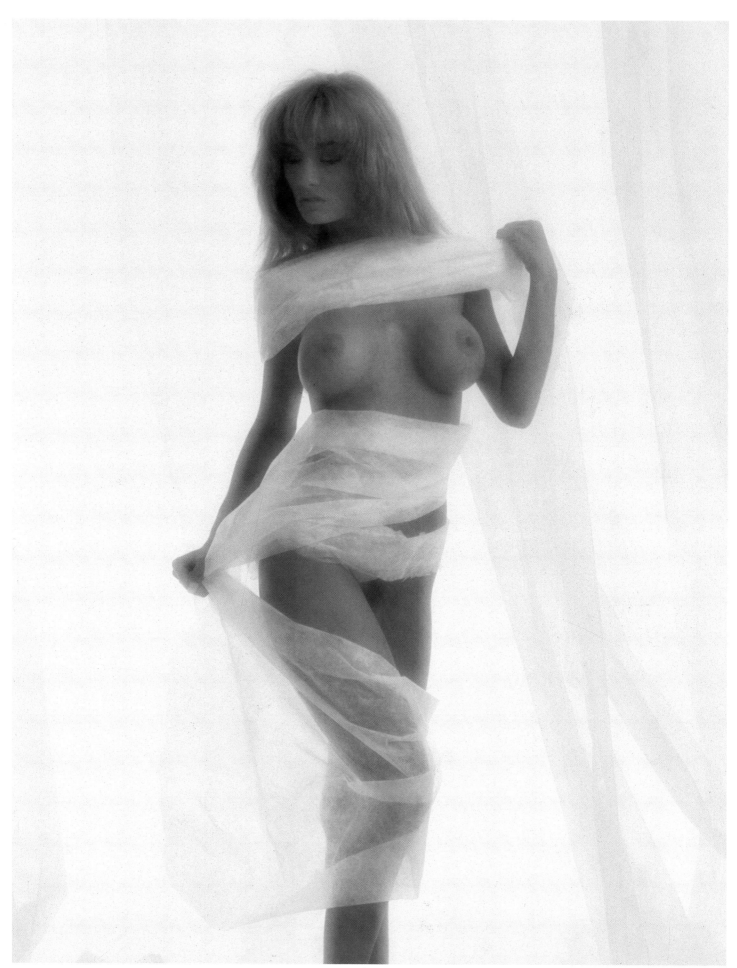

Image 70

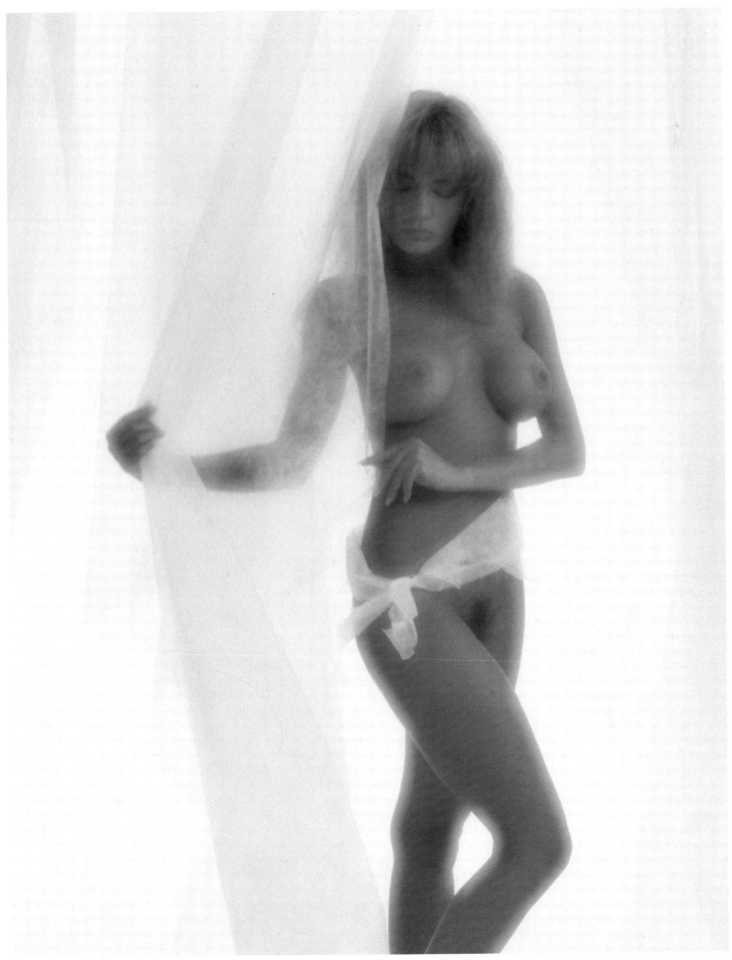

Image 71

There can be several good reasons why you may want to photograph a figure study in which the face is not clearly visible. You may wish to concentrate viewer attention totally on the body, you may want to create an "impersonal" study that is representative of womanhood in general rather than of one specific woman, or you may be producing the image for a subject who would like the photo displayed but does not want to be readily recognizable.

There are many ways of handling this situation. You can have the subject pose so that her face is turned from the camera or is hidden by another part of her body. You can hide the subject's face in shadow or create a total silhouette. You can use a suitable prop to conceal the face. Or, as we did in Image 72,

you can hide the face behind the subject's own hair.

For Image 72, our main aim was to emphasize two of the subject's features—we wanted to draw viewer attention to her hair and her backside. We placed magenta-colored netting in front of a black background and used two magenta-gelled lights to illuminate the netting. The main light, in a five-inch bowl reflector, was above and slightly behind the subject. We also used one magenta accent light, placed about 80 degrees to the left of the camera-subject axis, to draw attention to the subject's hair. To retain the subject's true blond identity, we were careful not to light the entire hair with the magenta illumination.

As you can see, Image 72 is very much represen-

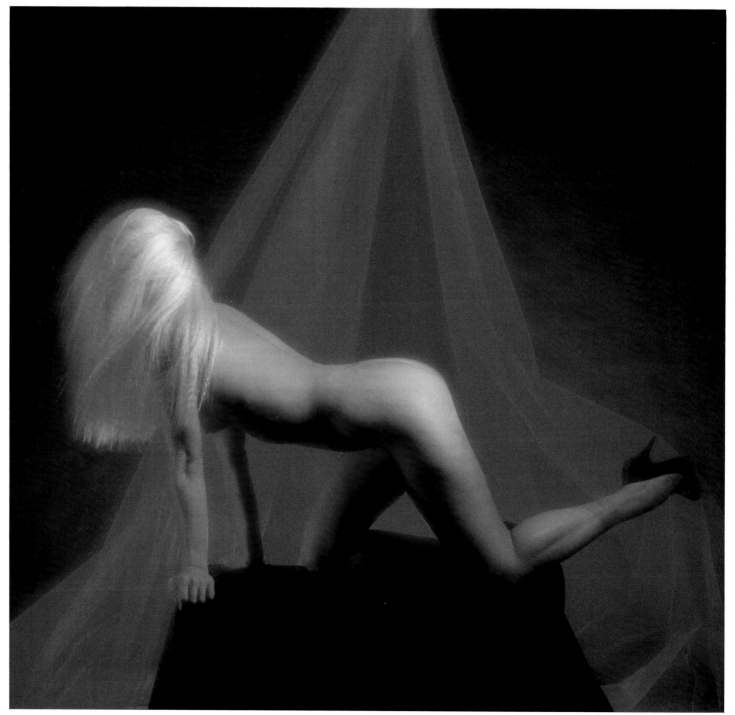

tative of "women" in general rather than of the specific woman who posed for us.

Once we had established the lighting and general concept for Image 72, it was a simple matter to create the variation you see in Image 73. Notice how we added life and vitality by having the subject raise both her legs to different angles and drop her head back. We covered the high main light with a magenta gel and added a snooted accent light at about 80 degrees to the right of the camera-subject axis. We also added a fog effect.

As you know by now, when we use colored lighting, we normally like to have white, unfiltered light illuminate at least some portion of the subject's body. In this case, the snooted accent light, to the right of the camera, was not color-gelled. Although the resulting rim light on the legs is not white, it is not as deeply magenta as other areas—for example, the bust. This subtle color variation is achieved by carefully balancing the power of the various lights used. The beautiful variation over the subject's body, not only of color but also of tone, adds further life and vitality to this image.

The evocative pose, the high-heeled shoes, the overall magenta atmosphere and the rising fog all give Image 73 a strong yet subtle sensuous quality. Compared with Image 72, where we primarily relied on two parts of the subject's body to give the image impact, this ethereal photo relies on the entire photo scene to achieve its result.

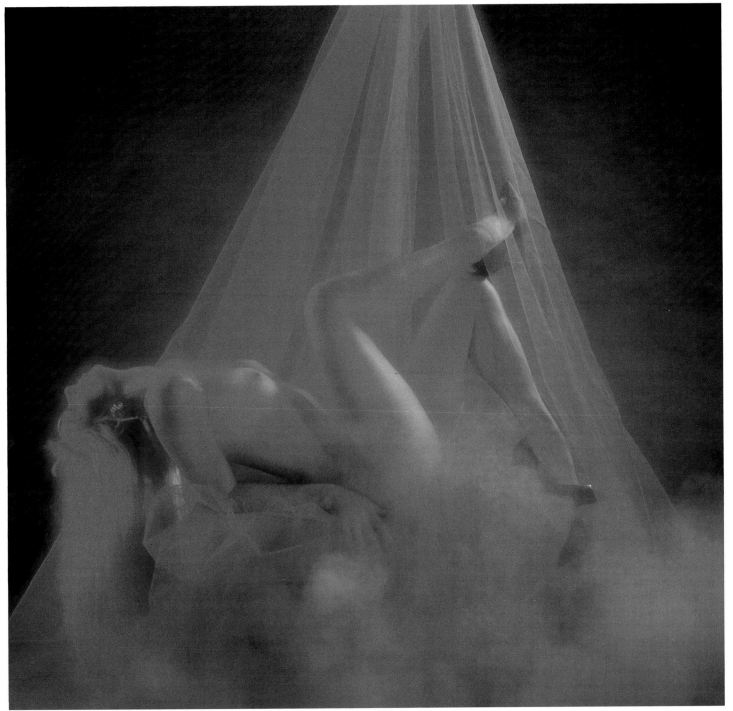

Image 73

Aprop as simple as a vertical pole can lead to some very stunning figure studies. To complement the glistening pole in Images 74 and 75, we applied baby oil to the subject's body. Not only did this help to beautifully highlight the skin, it also gave the subject a very convincing "athletic" appearance. By way of contrast, we used a black background.

You can create many different, attractive and believable poses with a vertical pole. The subject can have her back to the pole or face the pole; she can turn, lean, bend, stretch or do a wide variety of other things. She can even partially wrap herself around the pole, as our subject did in Image 74.

Although almost any vertical pole could be used, we use one called the *Auto Pole*, made by Lino Manfrotto and Co. They are available or can be ordered from professional camera stores. Each pole has a rubber suction top and bottom and expands easily from approximately six feet to nine feet in height. This allows the pole to be jammed into place between floors and ceilings of different heights. Once in place, the pole offers a very sturdy vertical support.

Although these poles are primarily designed for holding up studio backgrounds, we have found a number of other uses for them—one of them illustrated here. When using a pole as a posing prop, be quite sure that it is secured firmly enough to take any weight and stress the subject may place on it.

In Image 74, notice how the flowing, hanging hair

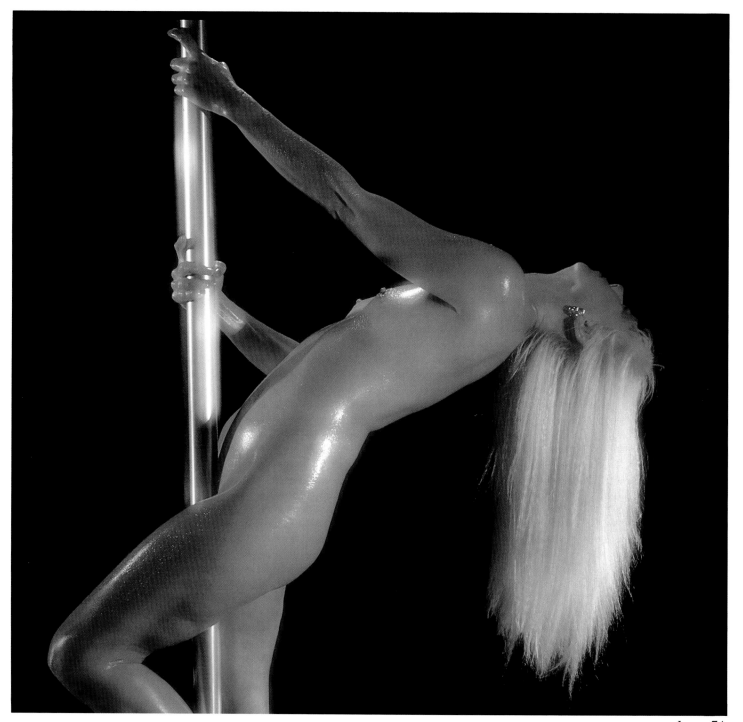

Image 74

adds life and a sense of motion to the image. This is one typical reason why long hair is particularly desirable in figure work—it adds a readily built-in and very versatile posing and compositional "prop." Of course, black hair would not have worked in this particular case, with the black background.

For nude photo studies, direct eye contact by the subject with the camera is not always appropriate. By having the subject's eyes directed elsewhere, more emphasis is given to the subject's body and the subject is seen more as a symbol of womanhood than as one specific woman. An open smile is also rarely appropriate. A serious, pensive look is generally much better.

For boudoir or portrait photographs, intended as personal visual communication with those close and dear to the subject, a happy smile is just fine. However, for nude studies—unless their purpose is of a purely personal nature—the broad smile is generally not suitable.

In Image 75, where the subject was just standing, apparently resting between exercises, the eye contact with the camera seems quite appropriate although a downward or upward glance would have been just as effective. Each would have evoked a different response from the viewer. However, we feel that an unrestrained, wide smile would have appeared totally incongruous.

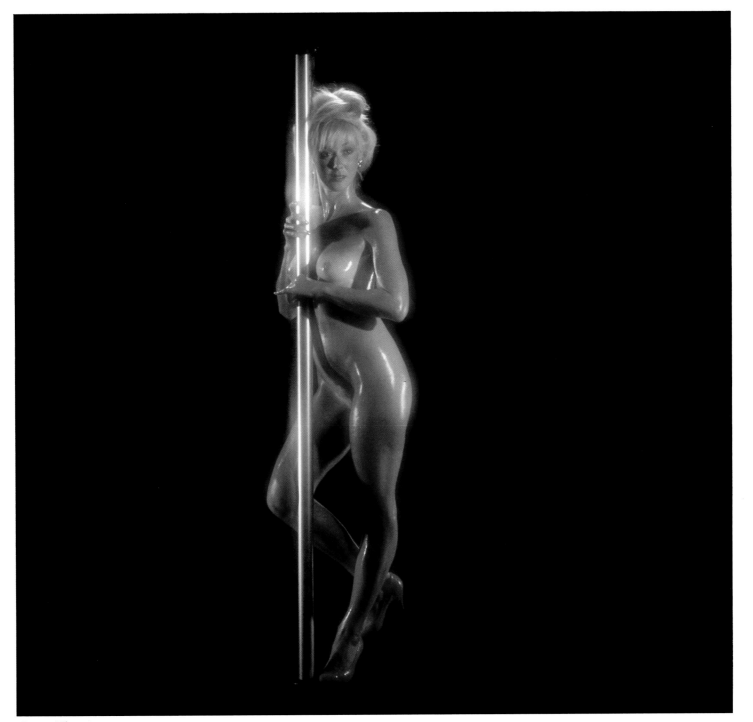

You should carefully think out what you want to convey in your figure photographs long before a subject is chosen and actual photography begins. You should also be mindful that some concepts may not work with an unclothed figure, just as others won't work with fully clothed subjects.

Some beautiful boudoir images would completely fail if the subject were depicted nude rather than with even a minimal amount of clothing on her body. In like manner, some stunning nude images would fail if the subject were even only scantily dressed or draped.

In Images 76 and 77, we wanted to give the viewer a feeling of metamorphosis or transition. Much like the concept of birth, or of the caterpillar changing into a butterfly, we wanted the viewer to sense that the subject was moving or evolving from one state of existence into another. Images with such a concept in mind would have failed totally, had the subject been wearing any clothing at all. These had to be pure nude studies.

A pose such as the one adopted for Image 76 is very difficult and you should not expect all models to be able to achieve it. In fact, any pose in such a flexible and mobile "hammock" is not at all easy.

A great advantage of the net, fashioned into a hammock, was its flexibility. Like the flexible swing seat featured in a couple of earlier photos, it adapts beautifully to the shape of a subject's body and thus virtually becomes one with it.

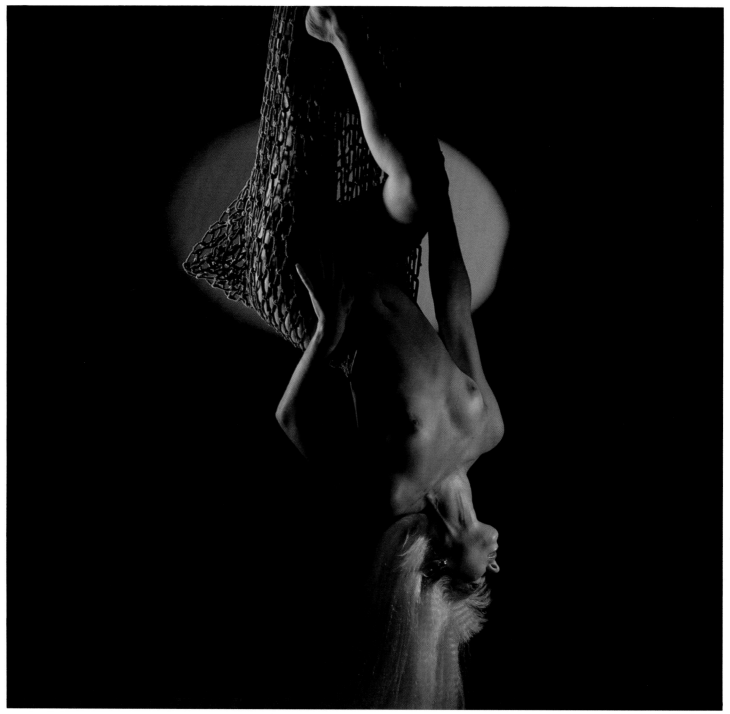

Image 76

When we prepare a setting such as this one, our most important concern is the subject's safety. For this setup, we had two very large hooks securely anchored in our studio ceiling. We then bought the strongest fish net we could find and secured it to the hooks. After both were in place, Sheila and I tested the netting to make certain that it would hold our combined body weights.

At the time of the photo session, we had two assistants stand close to the subject, just out of camera view. They were prepared to immediately jump to the subject's assistance, should there be any indication that she was going to fall or that the netting was going to tear. The subject was very aware of our concerns and efforts and this helped to put her mind at ease.

Notice how the background lighting was designed to help tell our story of transition or metamorphosis. If the circle of illumination had been large enough to contain the entire subject, it would have suggested "containment" rather than "transition." The much smaller circle, in each photograph concentrated around the subject's lower half, was strongly suggestive of a "growing out of" the seat of the netting, into a larger world.

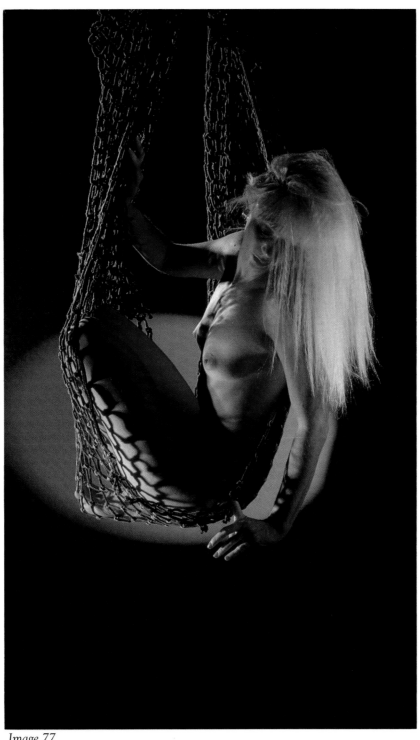

Image 77

Image 78 is not only timeless and dramatic and sufficiently impersonal to be readily interpreted as representative of womanhood in general, but it will also support several different interpretations.

For example, upon casual examination one could think that the image was nothing more than a dramatic and mystery-enshrouded representation of a subject's torso. However, upon closer scrutiny one could also arrive at a deeper meaning—that the subject was evolving from some lesser life form to her present physical state; that she was being lifted, by some extraneous force, from an unknown place to a higher plane of existence.

This is one of the reasons why an image of this type is so well received by viewers. It can be admired just for what it is or it can cause a viewer to become an active participant, providing his own story or meaning.

This is also the type of image that demands enlargement. The larger it is portrayed, the more impact the image has. This is not a basic requirement for all images by any means. With experience, you'll be able to tell—from contact sheets or from slides—which images you think should be enlarged and to what extent.

Although Images 78 and 79 were shot within minutes of each other and involved the same basic subject, setting and lighting, the photos are very different in appearance and concept. Although the blue lighting, the fog and the woolly prop surrounding the subject give Image 79 the same quality of mystery that is evident in Image 78, the subject is now clearly recognizable and is in a more "worldly," upright pose. Instead of the limited view of her torso being the primary and symbolic point of interest, the subject's entire body becomes a much more realistic point of interest.

It is important to know how to manipulate and vary a setting, the lighting, poses, props, camera angles, and so on, not only to get the greatest visual variety from a specific setting, but also to achieve variety in mood, effect and meaning from one image to the next.

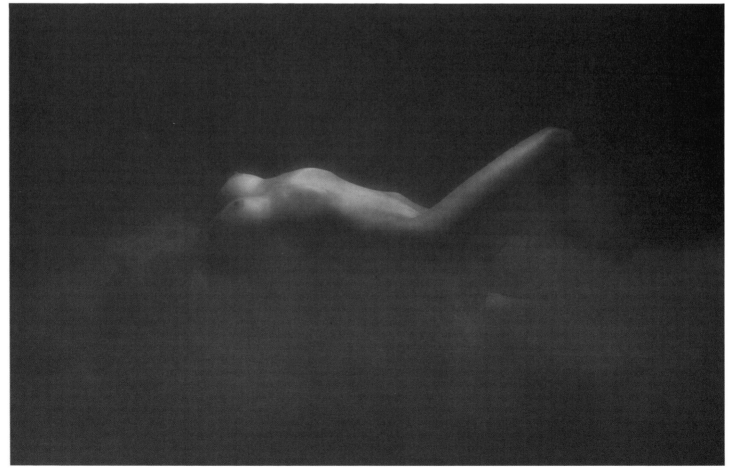

Image 78

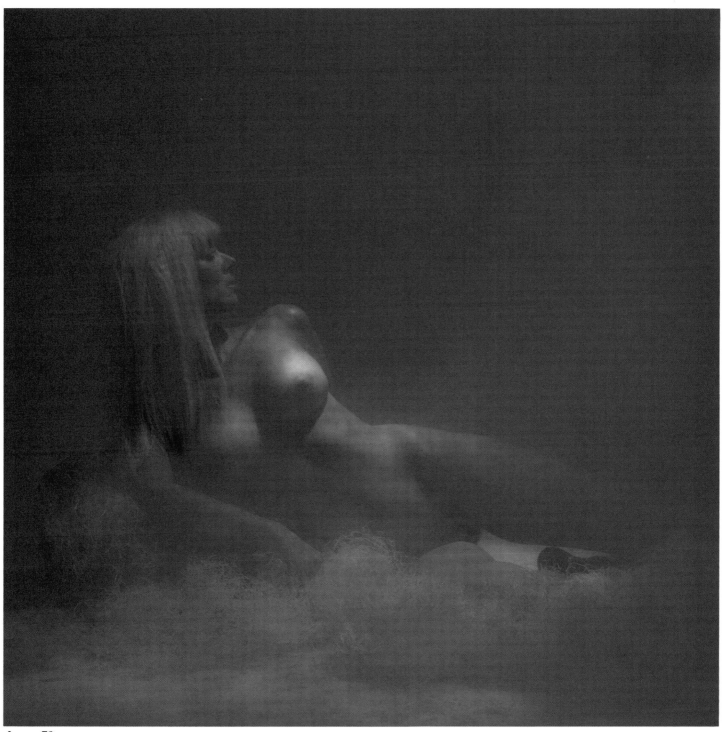

Image 79

Although some soft-focus filtration devices can be homemade—petroleum jelly smeared onto a clear-glass filter or crumpled cellophane placed over a lens, for example—we usually do not follow this practice because it tends to lead to inconsistent results. You never seem to get precisely the right amount of petroleum jelly smeared onto the clear filter, nor in exactly the required location. The cellophane never seems to be crumpled in exactly the same manner on consecutive occasions, and so on.

However, we always keep our eyes open for new and different techniques and effects. Such was the case with Images 80 through 83. We burned a small hole in the center of a small piece of a plastic drop-cloth and placed it over the camera lens. The effect produced images in which much of the subject was pin-sharp while the remainder went soft. The thin, plastic material we used is available from most paint-supply stores and costs less than one dollar for a 9x12-foot sheet.

Images 80, 81 and 82 were all made with the same lighting setup. For Image 83, only one slight lighting alteration was made: a red gel was placed over the main light.

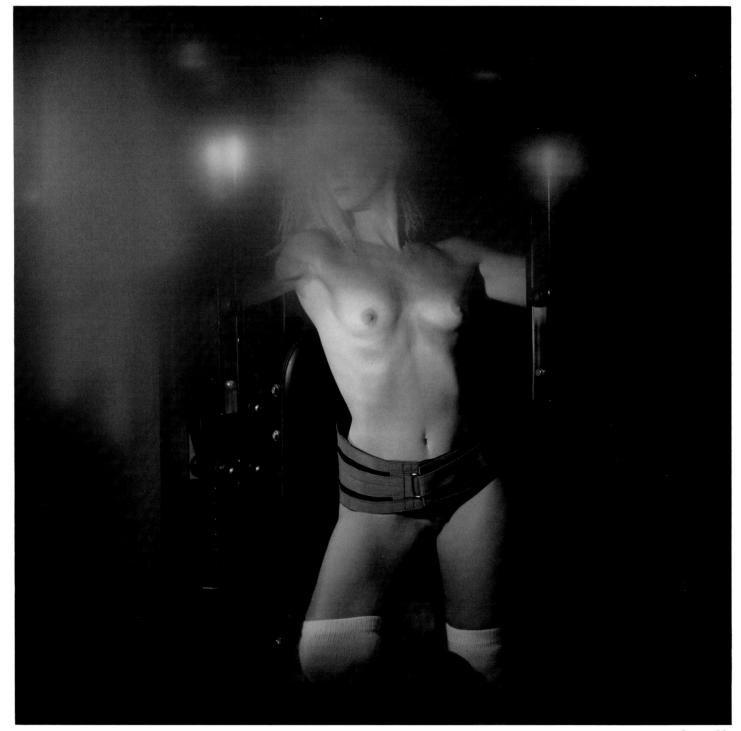

Image 80

The bright highlight on the upper left side of each image is a reflection from one of the exercise-machine parts. This reflection, caused by the main light, was allowed to remain in the photos because it added to the overall atmosphere. It also helped to accentuate the soft effect we were trying to create around the subject's head area in all but the last photo. In some cases, as you can see, it even functioned as a back light, to highlight the hair.

Why did we want to soften the area around the subject's head? Because we wanted full emphasis placed on the body that was being exercised. Why did we not show the exercise machine in greater detail? Because we wanted viewer attention concentrated on the figure of the exercising subject rather than on machinery. It was enough to suggest the equipment by clearly showing the blue belt and some highlighted parts. Why did we use harsh side lighting rather than a soft, frontal light? Because we wanted to dramatize the motion and activity that were taking place.

Why are we telling you all this? Because it underscores, once again, the importance of deciding exactly what you want to achieve before you ever reach for the camera's shutter button!

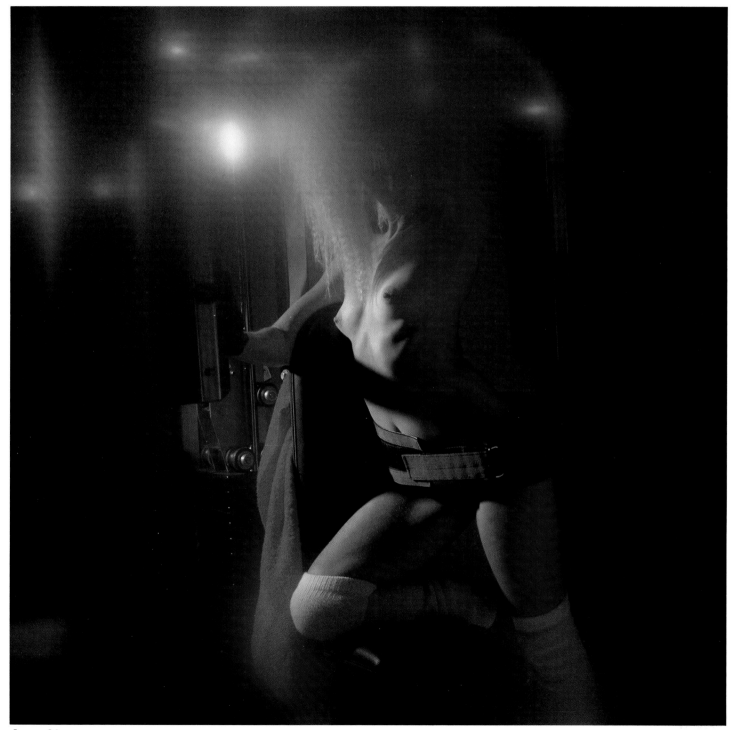

Image 81

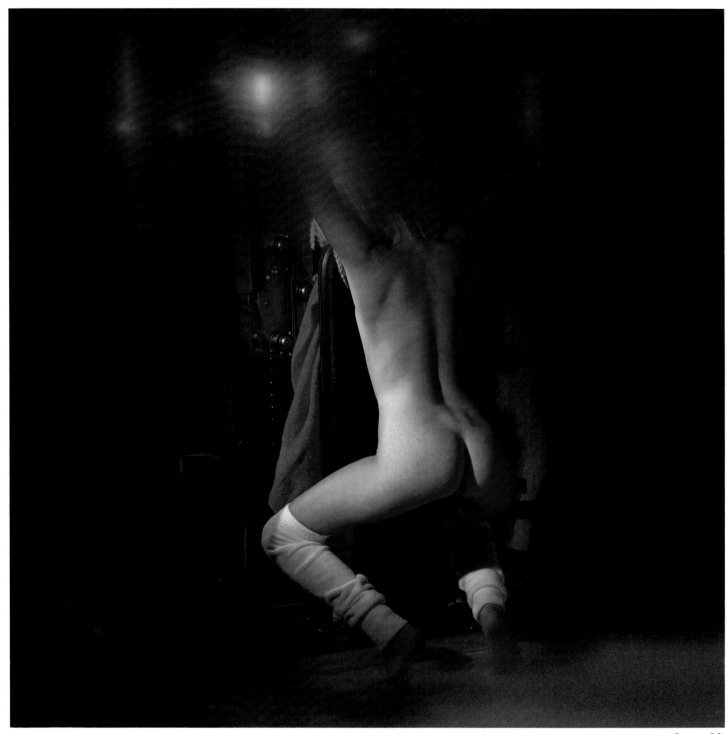

Image 82

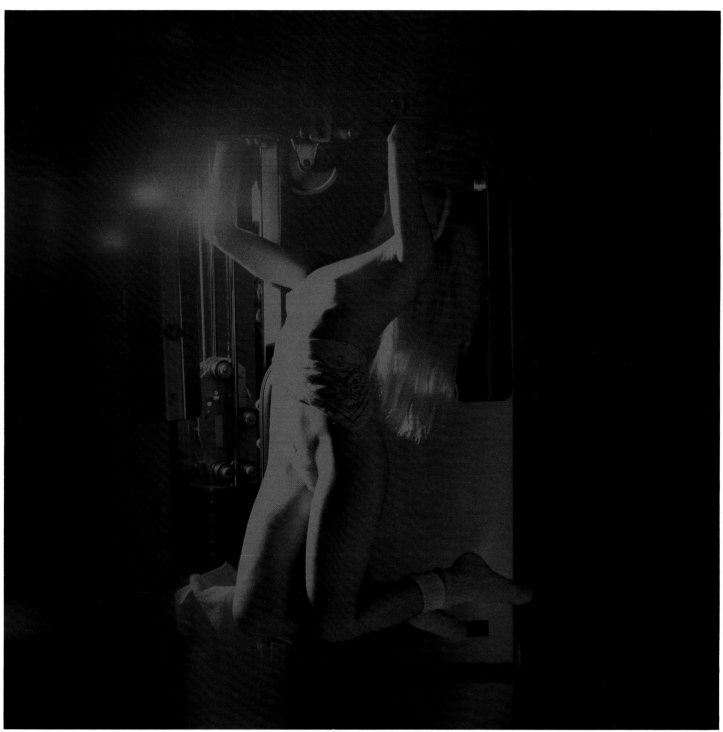

Image 83

In Image 84, we wanted to create a visual concept of a subject lying at peace in a room in the early-morning sunlight, contemplating the day that was just beginning. We wanted the subject's entire being to reflect a total lack of strain and tension.

Although our subject was not a professional model, she was able to adopt the mood beautifully. To help her relax and get into the mood for this shot, we used a bit of "Method" acting technique. When everything was set up and the subject was in her pose, everyone except my wife Sheila left the room. While soft, light-classical music played in the background, Sheila began talking to her in a very quiet manner and tone, keeping the conversation very light. After about 15 minutes had elapsed,

Sheila indicated to us that the mood was just right and I and an assistant entered the room and quickly captured this lovely image.

The lighting was kept simple. We used a Bowens Monospot flash, to the right of the camera position, as main light. We put a "window-pane" grid over the light to create the window effect and placed a yellow gel over the light. This light was directed at the lower portion of the subject's torso, her legs, and a portion of the white background sweep. The light was intentionally not focused critically, so that the window-pane pattern on the background would go soft, so as not to be too prominent and distracting.

A second light, on the floor and about 90 degrees to the left of the camera-subject axis, was in

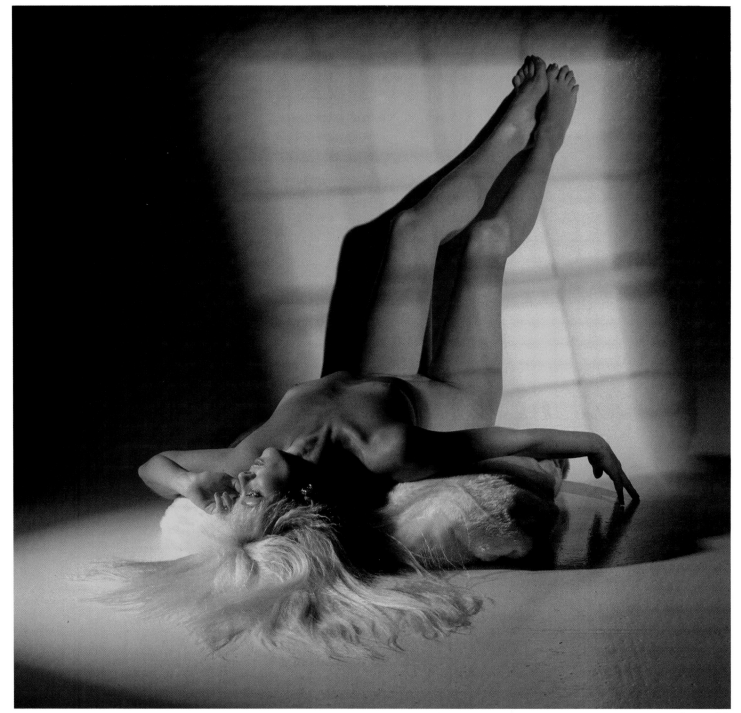

a bowl reflector with a four-inch snoot and a yellow gel. It was directed onto the subject's hair, face and shoulders. Its power was set to equal that of the main light.

Sometimes a subject will quite naturally and spontaneously adopt a new pose that you had not planned. When an unrepeatable, natural pose presents itself, don't waste valuable time trying to rearrange the lighting, the setting, the props, or making other major changes. If you do, the image will almost certainly be lost forever. After we had taken Image 84, the subject stood up, very close to the white background, and started to stretch. As she did, we noted the appearance of the strong, graphic shadow of her form on the background. The shad-

ow, which had the potential for emphasizing her very natural and typical early-morning stretch, intrigued us, as did the fact that she still had that beautiful, tranquil facial expression.

In order to move quickly, we simply raised the lights to a higher position, to accommodate the subject's standing pose and get the shadow to create what we considered an optimum pattern on the background.

Image 85 is a photographic example that not so much reflects our ability to "create" an image as to "see" one when it happens naturally. If you stay alert, you'll notice that such opportunities present themselves all the time—especially when you have a sensitive and expressive subject, such as we had on this occasion. So, be watchful, and be swift!

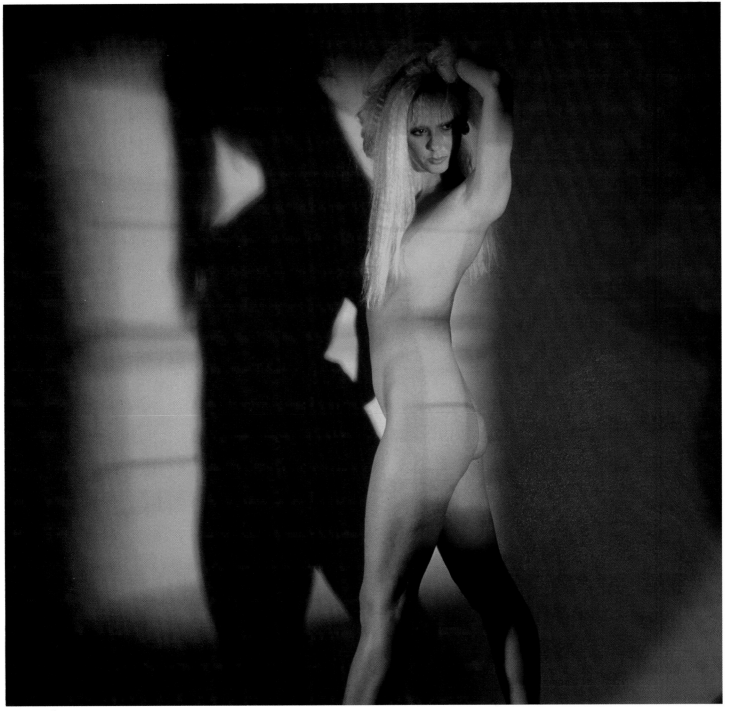

Image 85

We enjoy working with both horizontal and vertical blinds because they give us the ability to create some very stunning, different looking figure studies. Once a blind is in place, there are two ways in which we can light the scene so that it appears that the subject has shadows falling onto her from the blind.

We can light the blind with hard, frontal lighting, to create sharp shadows on the subject's body. However, we don't favor this approach because it forces us to work with the subject in very close proximity with the blind, restricting our posing options within the photo scene. Also, when the blind is illuminated directly from the front, it becomes too prominent in the photo.

We prefer to take another approach which gives us more control and better results. We put no frontal light on the blind at all but place a Bowens Monospot flash, with a "blinds" grid pattern over it, behind the blind. This light, not the blind, creates the shadows for the subject's body.

This procedure allows us the luxury of placing the subject and the blind wherever we want them, while still giving us the ability to control the shadow pattern on the subject. In the end result, if you do it properly, a viewer will think that the shadows on the subject's figure were caused by the blind in front of her.

This is the technique we used for Image 86. We placed the Monospot main light behind the blind, almost 90 degrees to the right of the camera-subject axis. We shielded the side of the light with barn doors, to keep any of its illumination from striking the real blind.

We wanted to attract viewer attention to two features in this image—the subject's hair and her back. Her back was already clearly defined and emphasized by the main illumination. To highlight the hair, we introduced a light with a four-inch snoot and a yellow gel, placing it about 90 degrees to the left of the camera-subject axis. Its power was set to equal the power of the main light.

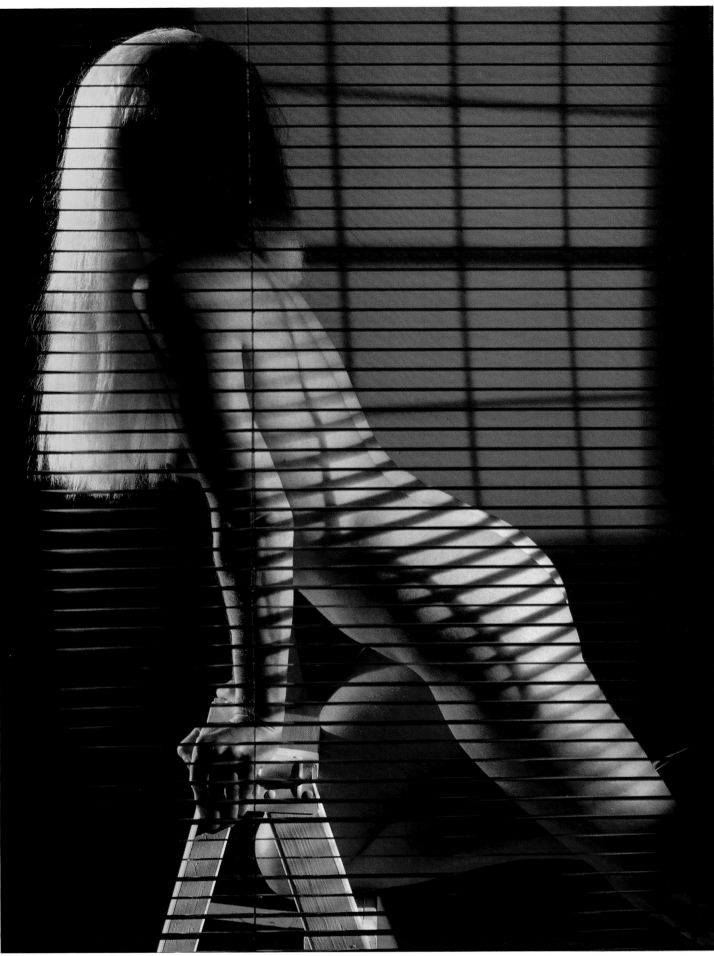

Image 86

Images 87, 88 and 89 were all lit in the same manner as Image 86. Let us now say a few words about the window effect that we projected onto the background. This was easily accomplished with the aid of another Bowens Monospot flash, this one having a "window" grid pattern inserted into a holder just in front of the light.

This light was placed to the right of the subject, beyond the camera's angle of view, and directed at the background. The barn doors on the main light were used to shield the background from any unwanted light from that source.

In order to keep the window pattern from overpowering the subject and distracting attention from her, we adjusted this light's output to one *f*-stop less

light than was coming from the main light.

As these photos show, once you have established the basic setting—the blind in front of the subject, the projected shadows on the subject, and the background window pattern—you have considerable scope for pictorial variety within those confines.

A viewer can interpret the window in one of two ways. He can imagine it to be a real window, located behind the subject. Or, he can see it as a projection onto the background of the blind located in front of the subject, by light coming from a window behind the camera location. The more you can draw viewer fantasy into your images in this manner, the more eye-catching your photographs are likely to be.

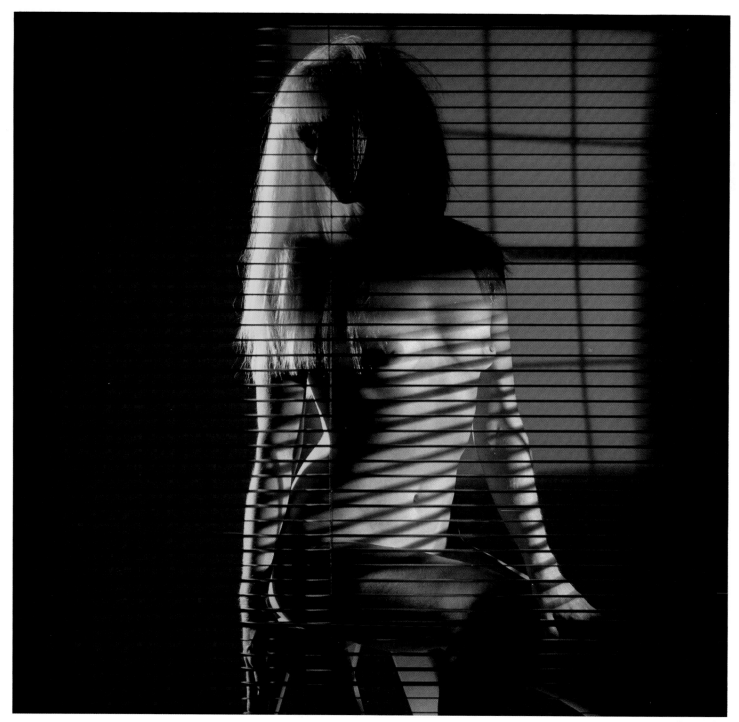

Image 87

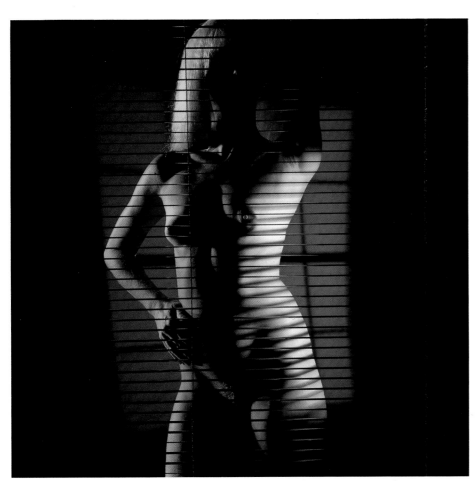

Image 88

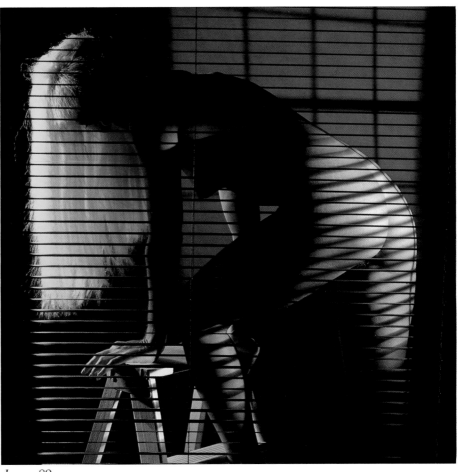

Image 89

Of course, we all think that it would be nice to have unlimited access to the most famous professional models in the world, a large budget for sets and props and for visiting distant and exotic locations, and all the time we might need to produce the "special" photographic art we see in our mind's eye. Most of us don't have those luxuries.

We'll end this portfolio of photographs, and this book, by showing you a series of delightful images that prove what can be done with quite modest means. The subject, like most of our delightful and talented models, was an untrained non-professional. The setting and the props, as you can see, were simple in the extreme. The entire low-budget shoot took no more than a couple of hours—about the endurance limit for most non-professional models anyway, when they are involved in a physically demanding shoot such as this.

As we've indicated elsewhere in this book, one of the nice things about figure photography is that it can be accomplished in very modest and plain settings. Often, in fact, a plain backdrop is adequate if not even ideal. In this case, with the use of only a few inexpensive props—a couple of old ladders, a paint roller or two, a couple of empty paint cans, a plank of wood to put between the ladders, a bit of white paint for the subject's body and a plain high-key background—we were able to capture some dynamic images.

In a setting of this kind, we're able to achieve about 20 totally different poses without the subject ever leaving her basic position on the set. Each one of the images reproduced here has its own special appeal and features a different aspect of the subject's figure. Incidentally, soft high-key lighting, such as was used here, is ideal for a subject who will rapidly adopt different positions during a shoot. The absence of deep shadows enables you to work without constantly having to move lights to adapt to the subject's bodily positions.

In each of the images in this series, the subject's eyes are directed at some point within the set rather than at the camera and viewer. This integrates her well with the setting she is in and allows the viewer to see her in that context. We wanted to present the setting as a very integral part of the images and not just a useful posing prop.

To give credibility to the concept that the subject was painting, Sheila dabbed white paint on parts of the subject's body. We have found *Tempera*—a water-based, non-toxic paint—ideal for such body applications. It is readily available from most art supply stores, is inexpensive, easy to apply and easily removed with soap and water.

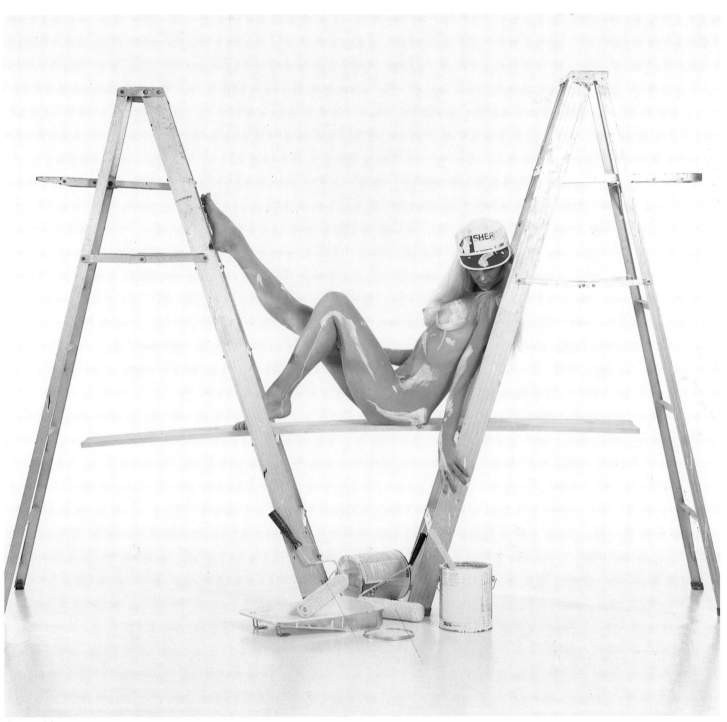

Image 90

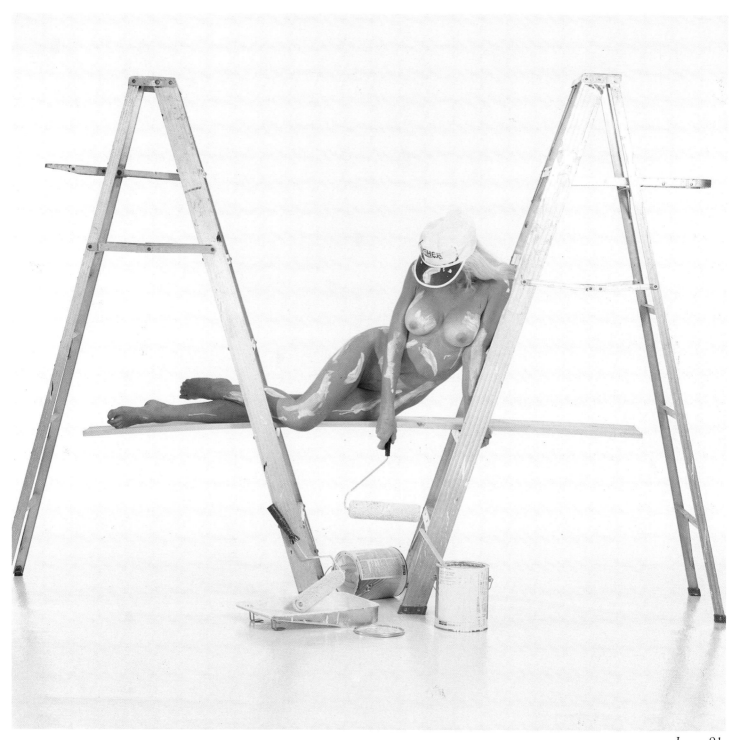

Image 91

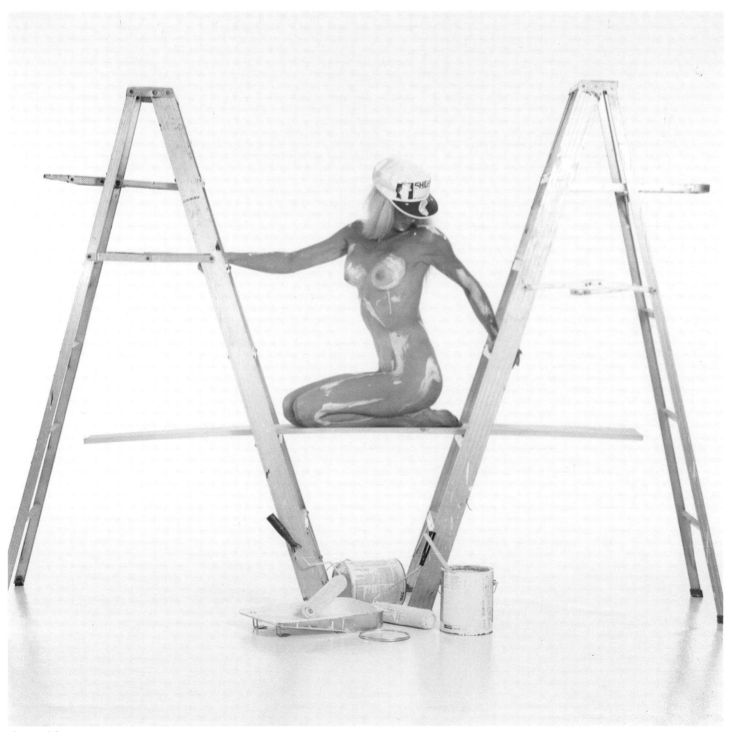

Image 92

151

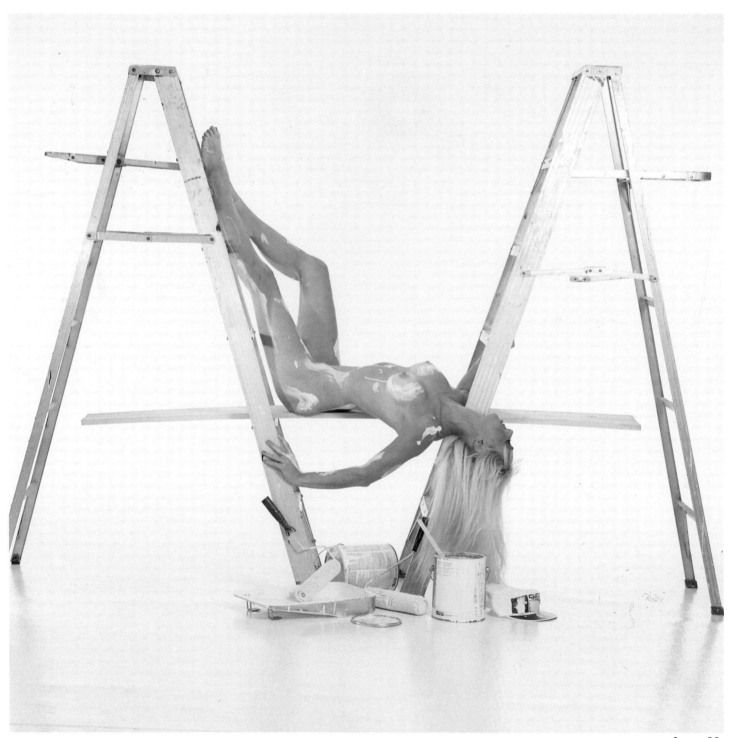

Image 93

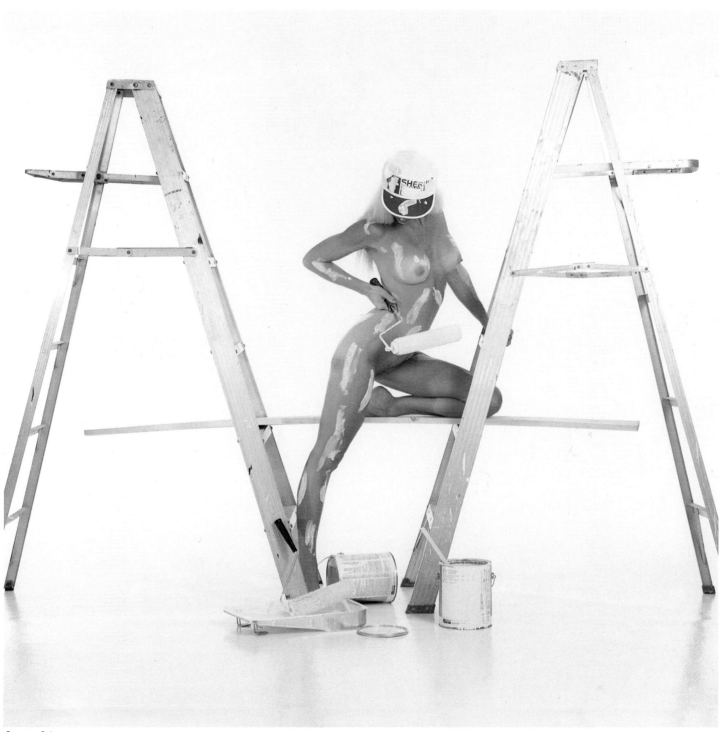

Image 94

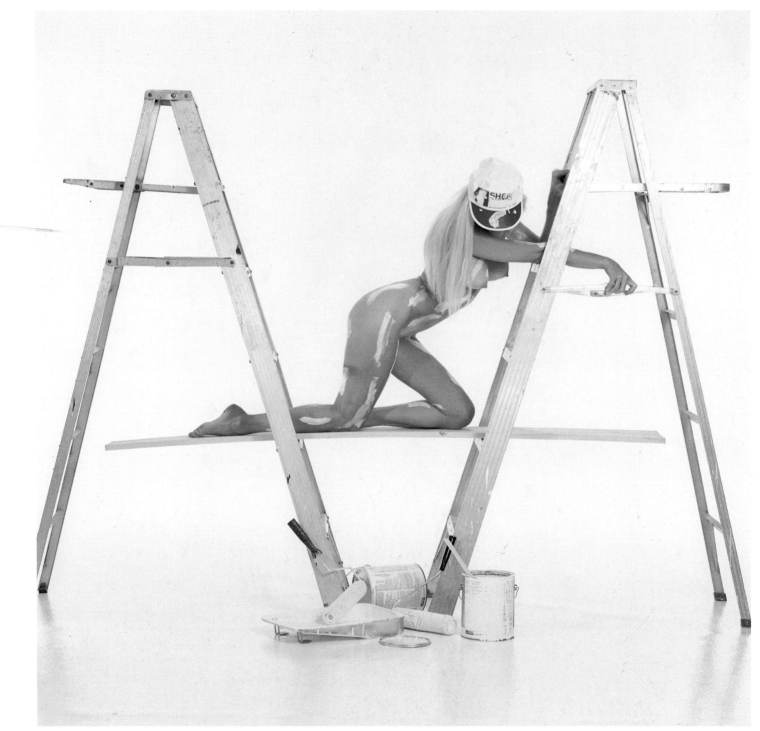

Image 95